Location of Photographs (Central Points)

THE EARTH FROM SPACE

THE EARTH FROM SPACE

Dr Johann Bodechtel and

Prof Dr Hans-Gunter Gierloff-Emden

translated by
Hildegard Mayhew and
Lotte Evans

ARCO PUBLISHING COMPANY, INC.
New York

Published 1974 by Arco Publishing Company, Inc.
219 Park Avenue South, New York, N.Y. 10003

© 1969 by Paul List Verlag KG, Munich

Library of Congress Catalog Card Number 72-97584

ISBN 0-668-02960-9

Printed in Germany

Contents

Preface

The scientific and technical advances, which led to the exploration of the moon, have made it possible for the first time to observe and to photograph the earth from space. Reconnaissance and the interpretation of photographs of the earth and to an increasing extent the moon and the other planets in the solar system taken from manned and unmanned satellites are some of the most important tasks of space flight.

In this book, sample pictures, typical of the earth, have been compiled and interpreted with the help of text and maps. The relationship between the human environment and the forms of the earth's surface, climate and geology cannot be made clearer than in these space photographs of the earth which often cover areas of more than a million square kilometres.

As a contrast to the colourful mosaic of the pictures of the earth's surface are photographs of our satellite, the moon, with its bleak and uninviting landscape. The completely different circumstances under which the surface of the moon was, and still is being formed, are described and explained with the help of the knowledge that has been gained in studying the earth.

Intensive research, outstanding technical development, and the enormous investment of the American space authority, NASA, together with the personal effort of the astronauts, have made it possible to provide scientists with this extremely valuable material.

First of all we would like to thank the Press Department (USIS) of the US Embassy in Bonn. Attaché P. Nieburg and Mr O. M. Artus gave us the opportunity of viewing the extensive picture archive and choosing suitable original NASA photographs. No effort was spared to get additional picture material direct from the NASA authorities in America and make it available to us.

We would also like to express our thanks to the Paul List Verlag and especially Dr Elisabeth List, whose advice and suggestions contributed much towards the success of the book. Further thanks are owed to Mr G. Edelmann, who has produced such vivid and detailed drawings and interpretation maps from our sketches.

H. G. Gierloff-Emden *ff* *B. Dufe*

Space experiments as milestones in geography, geology, meteorology and cartography

The earth has become more open: extensive exploration and planned aerial analysis of the earth have been made possible through modern methods of remote survey. The first stage was photography from aircraft. Aerial photographs were usually prepared in order to provide perfect pictures of the surface of the earth – ones that could be analysed, and used to produce topographical maps. Representatives of several sciences such as geography, geology, meteorology, pedology, agricultural science and forestry discovered very soon that these pictures were of tremendous importance to them. Thus aircraft surveys and the interpretation of aerial photographs together with photogrammetry developed rapidly. With the conquest of space, satellite photography and the interpretation of pictures for mapping purposes, pictures grew in importance. Besides the normal black and white and colour photographs, new photographic methods, film and filter combinations were developed, which guaranteed the high quality of space pictures, and made possible large scale and detailed interpretation of aerial and satellite pictures.

The earth is becoming crowded: the population explosion forces us to plan ahead. Aerial and satellite photography makes co-ordination of planning possible on a world-wide scale, and may also offer an opportunity to plan in advance scientific outposts in the planets and moons. Without aerial photographs or satellite pictures, which make it possible to survey vast areas and recognise large scale relationships of various natural features, further, rapid and economic progress is improbable.

Artificial satellites opened up a new era of scientific research. The signal that started the competition of the great world powers in space travel was given on 4 October 1957. It also began a competition for future economic and political power, for on that date Russian scientists under Professor Leonid Sedow succeeded launching Sputnik I into orbit. Manned space travel, which until then had been believed to be a fantasy, became reality, with Russia's Vostok and America's Mercury spacecraft, and with the further development of space flight techniques began scientific research and exploration of our planet and its neighbours.

Black and white as well as coloured photographs of the earth taken from perspectives that were previously unknown were published in the press, in magazines, on television and in books. During the Gemini flights space photography reached such perfection and quality, that from then on it became one of the most important elements in programmes of manned space flight.

The automatic transmission of photographs by unmanned satellites have improved year by year. The pictures taken by the same methods as those used in television transmissions are already of such high quality that their resolving power, even over a range of 100 million kilometres (the pictures of Mars from the latest flights of Mariners 6, 7 and 9 are examples) allows considerable detail to be picked out. It is these automatically transmitted pictures from unmanned spacecraft, which – although less spectacular than the colour photographs taken during manned space flights – make it appear possible that man might eventually step on to the surface of Mars. The photographs of the unmanned spacecraft of the Lunar-Orbiter and Luna series (American and Russian respectively) made precise mapping of the surface of the moon possible and so created the basis for the landing by the American astronauts, Armstrong and Aldrin, on 21 July 1969.

Development is continuing. American and Russian craft are transmitting from Mars and Venus data and pictures which will be indispensible in preparations for future manned expeditions. Weather satellites circle constantly around the earth and are already an essential aid in meteorology and climatology.

Some important space experiments
Explorer 6 (USA) 7.8.1959, first picture of the earth from space
Luna 3 (USSR) 4.10.1959, first pictures of the moon's far side
TIROS 1 (USA) 1.4.1960, first weather satellite, 22,952 pictures
Vostok 1 (USSR) 12.4.1961, first manned space flight

Transit 2 and Solrad 1 (USA) 22.6.1960, navigation and satellite geodesy

Anna 1 B (USA) 31.10.1962, geodetic data

TIROS 7 (USA) 19.6.1963, 120,000 pictures

Nimbus 1 (USA) 28.8.1964, first three-axis stabilised weather satellite

Ranger 8 (USA) 17.2.1965, hard landing on the moon in the Mare Tranquillitatis, 7,137 pictures

Ranger 9 (USA) 21.3.1965, landed in the moon crater Alphonsus, 5,814 photographs

Gemini III (USA) 23.3.1965, colour photographs of the earth

Gemini IV (USA) 3.6.1965, 100 colour pictures of the earth

Gemini V (USA) 29.8.1965, 175 colour pictures of the earth

TIROS 10 (USA) 2.7.1965, photographs of hurricanes (storm centres), 400 pictures daily

Secor 5 (USA) 10.8.1965, geodetic satellite, distance measurement of islands in the Pacific

Gemini VI (USA) 15.12.1965, 60 colour pictures of the earth

Gemini VII (USA) 4.12.1965, 250 colour pictures of the earth; first infra-red photographs

Luna 9 (USSR) 31.1.1966, soft landing in the Mare Prozellarum, transmitted photographs for
 3 days

ESSA 1 (USA) 3.2.1966, first operational weather satellite, automatic picture transmission

Gemini VIII (USA) 16.3.1966

Gemini IX (USA) 3.6.1969, 160 colour pictures of the earth

Nimbus 2 (USA) 15.5.1966, TV and infra-red photographs, weather satellite

Lunar-Orbiter 1 (USA) 10.8.1966, moon orbit, photographs of the back of the moon

Gemini XI (USA) 12.9.1966, 102 colour pictures of the earth

Luna 12 (USSR) 22.10.1966, moon orbit, pictures of the moon surface

Lunar-Orbiter 2 (USA) 1.11.1966, moon orbit, transmitted 205 pictures

Gemini XII (USA) 11.11.1966, 160 colour pictures of the earth

Luna 13 (USSR) 31.12.1966, soft landing, transmission of data about the soil structure of the
 moon

Lunar-Orbiter 3 (USA) 10.3.1967, moon orbit, 182 moon pictures

Surveyor 3 (USA) 17.4.1967, soft landing in the Ocean of the Storms, examination of the soil

Surveyor 5 (USA) 8.9.1967, moon landing in the Mare Tranquillitatis, 19,000 pictures, examina-
 tion of the soil

Surveyor 7 (USA) 7.1.1968, soft moon landing in the crater Tycho, examination of the soil and
 picture transmissions

Zond 5 (USSR) 15.9.1968, first circumlunar flight, unmanned, with earth return

Apollo VII (USA) 11.10.1968, colour pictures of the earth

Apollo VIII (USA) 21.12.1968, colour pictures of the earth and the moon, first men in lunar
 orbit

Apollo IX (USA) 3.3.1969, multi-spectral pictures of the earth surface

Apollo X (USA) 18.5.1969, pictures of the moon surface at close range

Apollo XI (USA) 21.7.1969, first landing of men on the moon, rock samples of the moon. Setting
 up of a seismometer and laser-reflector

Apollo XII (USA) 19.11.1969, second manned landing on the moon

Luna 16 (USSR) 12.9.1970, soft-landed on moon and brought core sample to earth

Luna 17 (USSR) 10.11.1970, soft-landed radio-controlled moon rover Lunokhod 1

Apollo XIV (USA) 31.1.1971, third US manned moon landing

Salyut 1 (USSR) 19.4.1971, first experimental manned space station including earth resource
 observation

Apollo XV (USA) 26.7.1971, fourth US manned moon landing

Luna 19 (USSR) 28.9.1971, unmanned spacecraft surveyed moon from orbit

Luna 20 (USSR) 14.2.1972, soft-landed on moon and brought core sample to earth

Apollo XVI (USA) 16.4.1972, fifth US manned moon landing

ERTS-1 (USA) 23.7.1972, first earth resources technology satellite

Apollo XVII (USA) 6.12.1972, sixth and last US manned mission to moon in Apollo series

Satellite techniques and technology

An exact knowledge of the orbits and of the times at which pictures are taken are vital to a scientifically precise interpretation of satellite pictures. Recent developments in photographic and in non-photographic sensing techniques guarantee the future of satellites for this purpose.

Satellite orbits

The orbit which a satellite pursues depends on several factors: the launching angle, speed and the gravitational pull of the earth and other bodies. For near-earth orbits, just outside the appreciable atmosphere, the satellite must attain a velocity of about 7.9km/sec in a horizontal direction. Failure to do so means that it returns to earth. If, on the other hand, the satellite is released from its carrier rocket with excess velocity it will assume an orbit of elliptical shape, losing speed as it climbs to the zenith, and speeding up again as it swings back to its lowest point.

If the speed of projection is greater than 11.2km/sec the satellite will escape from the earth, having overcome its gravitational pull. The achievement of escape velocity does not mean a body is free of the earth's gravitational influence. With power shut off, it will gradually lose speed due to the restraining influence of gravity; but it will always have enough momentum to continue moving away from the earth. Properly directed, it can be sent on a journey to another planet when its future path will be dominated by the gravitational field of the sun.

To achieve a particular orbit around the earth, one must choose a launch angle in which the plane of the orbit passes exactly through the earth's centre. The possible orbits are characterised by their angle in relation to the equator. If the launch angle is at ninety degrees to the plane of the equator, ie in a north-south direction, the satellite will pass directly over the poles. This orbit is especially suitable for meteorological satellites, as a satellite in such an orbit circles round the earth every 2 hours. In the course of one day twelve different segments of this planet can be observed. These together make up the entire surface of the earth, because the earth completes one revolution under the satellite orbit within twenty-four hours. (Pictures 5 and 6.)

The earth's atmosphere, even though it is very thin at great heights, can create friction, which over a long period of time causes the satellite to spiral back into the atmosphere. In the process the more distant point of the orbit (apogee) contracts so that the original elliptical orbit eventually becomes more circular. Naturally the time the satellite takes to complete an orbit also changes, the speed varies in relation to shape, position and mass of the satellite. Eventually the effect of air drag becomes so great that the satellite burns up in the denser atmosphere.

At the ideal orbit of 1,000km, from earth, the satellite is almost free of any friction, and will orbit the earth with only small orbital modification. However, at a height of 500km friction is so great that its life-span is approximately five years and if the altitude is only 100km the satellite can travel round the earth only a few times. (Figs. 5 page 6 illustrate the geometry of a typical inclined satellite orbit.)

The distance of the satellite from the earth is of great importance for the size of the area which can be photographed and measured. Some satellites orbit at approximately 36,000km (pictures 1, 2 and 3) above the equator, at which altitude they make one revolution every twenty-four hours, and therefore remain in the same position in relation to a fixed point on the earth. Their capacity to photograph or measure parts of the earth is so great that three satellites can cover over ninety per cent of its surface. For every surveying and cartographic interpretation of satellite pictures we have to know precisely the position of the satellite at the time the picture was taken, its principal point (a point vertically under the satellite on the surface of the earth – called the sub-satellite point) as well as the height and the direction of the camera's axis.

Signals from space

Satellites can often be observed with the naked eye. But these bright artificial moons travelling at altitudes between 100 and 300km move across the sky from horizon to horizon within ten minutes.

To fix their precise position the satellites are located from the ground, using radio and optical techniques. Radio signals are received by ground stations, and on this basis speed, position and orbit prediction can be worked out.

For the manned space flights of the Gemini and Apollo series, ground stations and mathematical centres were co-ordinated into a complex system of communications. This was made possible by means of the most enormous computer concentration on earth, with up to 80,000 million calculations per flight day. To control the manned space flights a world-wide network of observatories and information centres is necessary. This chain reaches from Cape Kennedy in Florida eastwards across the Bahama and Bermuda Islands, the Canary Islands, Madagascar, Australia, Guam on to Mexico and Texas. Gaps in this world-wide network are closed by ships and aircraft, equipped with special instruments. The unmanned communication satellites are also of great importance. Only this expensive and detailed control system makes an exact location of the orbit possible, as well as enabling corrections to be introduced when necessary.

Space flight maps for satellites

The movement of the principal point of the satellite is fixed on maps, which are worked out in advance for all satellite flights. Without this flight plan later interpretation of measured data and photographs is impossible. The points on the surface of the earth over which the satellite flies are joined, and this is normally done on a Mercator world map. On this map the line can be followed continuously, because the portion of the surface of the earth which is cut off from the right-hand edge of the map reappears on the left-hand side. This satellite trace forms sinuous curves. During the ninety-six minutes, which the satellite needs for its orbit, the earth rotates twenty-four degrees on its north-south axis, the satellite trace moves westwards by the same amount. This explains why in space the satellite moves along a closed and regular orbit and yet its trace on the surface of the earth appears as an undulating curve as the earth rotates beneath it.

Special maps prepared before the mission show the sequence of the individual orbits. These maps are generally made out in six colours, so that the astronauts are able to locate surface features, vegetation patterns and the distribution of land, sea and ice.

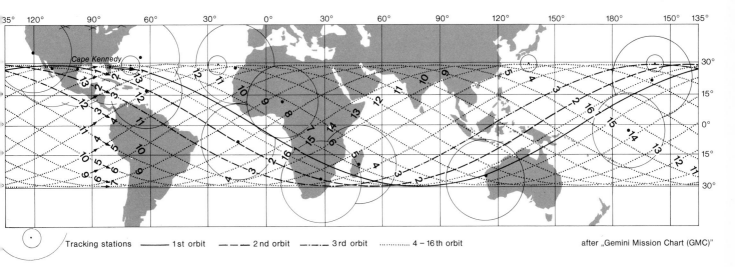

Simplified space-flight Map of a Gemini Mission

11

Gemini photographs and the polar regions

American manned space flights are launched from Cape Kennedy in an eastward direction, in order to make use of the acceleration produced on the surface of the earth as a result of its axial rotation. The launching angle has to be chosen in such a way that the orbits form an angle of thirty-three degrees with the equatorial plane. Therefore the area of the earth over which they pass lies between thirty-three degrees north and thirty-three degrees south of the equator. This does not apply to the Russian satellites, launched near the Aral Sea. Many of them have launching angles of sixty-two or sixty-five degrees with the equatorial plane. Because of the greater inclination of the orbit they cover a much wider section of the earth and come very near to the polar regions.

Dating of satellite photographs

The dating of satellite pictures causes difficulties, and traditional ideas of the calendar have to be rethought when we talk about space flight. We count twenty-four hours in a day, from midnight to midnight. In order to be able to work out dates on earth, midnight and the beginning of the new day, a dateline was fixed along the 180th meridian in the Pacific Ocean.

It is well known that even Magellan had difficulties in computing dates when he sailed round the world. When you travel round the whole of the world, you have to either count one day twice or leave one out, depending on whether you go from east to west or from west to east. This difference in time and the change becomes even more obvious when one travels by air. A satellite which orbited the earth up to twenty-four times a day, would go twelve times alternately through the past and the present as it were.

The earth revolves twenty-four degrees while the satellite is taking ninety-six minutes to circle it. When the satellite completes one orbit by reaching the meridian from which it started, it has therefore travelled further than 360 degrees, namely $360 + 24 = 384$ degrees.

For the scientific interpretation of the measurements and photographs taken by the satellite one has to know the orbit, the height and the place at any time precisely. A 'world time' has therefore been introduced. Basically all dates and times are referred to the observatory in Greenwich (longitude zero).

Distortions in satellite photography

The earth, the moon, and the planets of our solar system which have been photographed usually appear as flattened spherical shapes. On the flat plate of the camera we get a picture of a convex section of the surface of a sphere. The curvature of the surface of the earth is barely apparent in pictures which are taken at a small distance from the earth. With satellites that travel at greater altitudes, however, the spherical shape becomes very conspicuous and causes appreciable distortion. An extreme example of this is the moon photographed from the earth. The central part of the moon is not distorted but the circular edge of the moon appears increasingly mis-shapen in profile. With considerable distortion at the edge of the picture, some 200km of the moon are invisible from earth (figures, page 13). A square on the edge of the sphere is, in the photograph, projected on to a smaller flat square. So in all these pictures, the areas along the edges are progressively distorted. The scale gets smaller and smaller towards the edge as a constantly growing area has to be 'accommodated' there. As the distance of the camera from the earth increases, this photographic effect becomes more marked (picture 4). Very little distortion of this kind is found in pictures taken with telephoto lenses, which photograph a relatively small part of the surface of the earth (pictures 10, 16 and 26). Needless to say this distortion is also of great importance in the television pictures transmitted by weather satellites. If the camera is not in a vertical position in relation to the surface of the earth, the photographic relationships become more complex. The photograph suffers an additional distortion due to the angle between the photographic axis and the vertical.

Space photography

Years of development and pioneering discoveries in the photographic field have been necessary to produce pictures of the precision and colour quality as the ones taken during the manned space flights.

On most occasions a specially adapted Hasselblad-Camera 500 C was used, but a Hasselblad Super-Wide-Angle Camera and a Maurer-70mm-Spacecamera have also been employed. For the

high quality of the space photographs we have to give credit to the highly developed German optical industry. The lenses used in space were almost all specially prepared Zeiss lenses. Most of the pictures were taken with a normal angle Zeiss Planar 80mm lens. If an especially large area of the surface of the earth was to be taken, a super-wide-angle lens with a large exposure angle, the Zeiss Biogon 38mm was used (see picture 15). For special scientific research and for geodetic purposes the telephoto of the Zeiss Sonnar 250mm has proved very suitable (see picture 26). With this lens one achieves the least distortion due to the convex shape of the surface and the greatest clarity of surface detail.

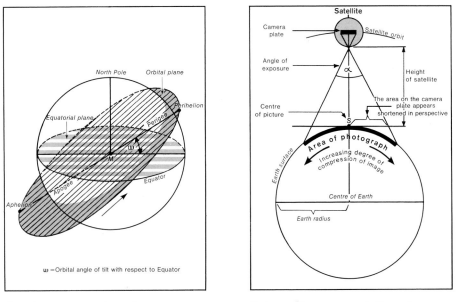

Areal representation of a tilted satellite orbit

Schematic representation of satellite photograph distortion

For infra-red and multi-spectral photography, used for the first time during the flight of Gemini VII and later intensively by Apollo IX, four Hasselblad cameras were combined into a so-called multi-spectral camera. With this battery of cameras the same area of the surface of the earth was photographed simultaneously with different films (pictures 28 and 30).

Quality of the colour photographs
Apart from the pan-chromatic black and white films, which are usually only used in connection with multi-spectral photography, almost all pictures taken in space are colour photographs of astonishing colour quality.

In traditional colour aerial photography, colour quality generally becomes less dependable as distance increases. The picture takes on a bluish tinge, associated with the bending and absorption of light by the atmosphere. This in fact is the effect which makes the sky appear blue. The extent and the nature of this colour distortion depends on the incidence of the sun, the angle at which the light reaches the object to be photographed and the distance and thickness of the reflecting layers of air. Where satellite pictures are concerned this light dispersal effect is not very great since the camera is outside the atmosphere; it applies more to pictures taken from aircraft at considerable height. It is however necessary to improve the colour quality by developing special film emulsions, the use of certain filters and special developing methods.

False colour photography
The photographs taken by the astronauts of Apollo IX introduced a special film to the public – a false colour film (pictures 28 and 30). This type of film is not prepared in the traditional manner. The layers of an ordinary colour film react to blue, green and red. A false colour film like the Ektachrome Infra-Red Aerial Film reacts to green, red and infra-red. The most striking characteristic of this film, which reproduces the landscape in 'false' colours, is the fact that it shows all vegetation in red. The chlorophyll in green leaves has a high degree of reflectivity for infra-red rays. According to the degree of its freshness vegetation appears in the pictures in different

intensive reds. If one changes the film emulsion, or uses different filters, one can again produce a large variety of differences in colour quality and in the extent to which the colours are 'false'.

The 'television pictures' made by weather and communication satellites
In the unmanned weather and communication satellites, the photograph is stored in a tube and from there transmitted to earth (when it is required) by an automatic picture transmitter. These photos, similar to television pictures, are made up of dots and lines, therefore their quality cannot be compared with that of the pictures taken during the manned space flights (pictures 5 and 6).

Further technical scope for satellite picture research
The interpretation of air photographs is only one – although at the moment the most important – of the modern aerial research methods, the so-called 'remote-sensing'. The term 'remote sensing' means the measuring of characteristics of the surface of the earth from a distance, both from aircraft and from satellites. To be measured and later to be interpreted are: electro-magnetic radiation of all wave-lengths by cameras, infra-red sensors, radar-systems, radio-wave receivers and spectroscopy. The force fields on the earth, magnetism, gravitation and electricity have also to be registered with appropriate instruments. These research systems receive their information passively through the reflection of radiation from the surface of the earth or from another star. They themselves emit waves and then register the proportion reflected from the earth. Especially valuable is the infra-red radiation. The measuring techniques of this thermal radiation undertaken by unmanned satellites are of the greatest scientific and military importance. In the case of weather satellites a fast rotating mirror searches the earth for infra-red rays. These rays are reflected by mirrors on to apparatus which transforms the energy into electric signals and these are transmitted to earth by means of an automatic picture transmitter. This radiation is so sensitive that a temperature difference of $\frac{1}{2}°$ C on the earth surface can be measured accurately. These measurements are only taken on the 'night' side of the earth or the moon (picture 5). On the moon where there is no mist or cloud these results open up tremendous scientific possibilities (picture 37).

Wave-lengths in the region between 1mm and 30cm can also be measured and interpreted (micro-wave radiometry).

Study of the chemical structure with the help of spectroscopy has been made for a long time and is now carried out by satellite (picture 37).

Where active systems are concerned, the satellite emits certain wave-lengths and receives back those parts that are reflected. The best known of these systems is radar, which uses wave-lengths from 0.536cm to 10m. The received signals are usually stored in the form of photographic images for later use. Radar waves penetrate the soil, irrespective of the moisture content, to a depth of up to a metre, the vegetation cover, snow and the atmosphere. That again opens up new possibilities for aerial and satellite research, eg for establishing the moisture content and details about the chemical structure of the soil or for examining the morphological and geological conditions under a dense vegetation cover or detritus.

Infra-red scanning and radar have been used in satellite research since 1959 especially for military purposes. For instance the launching of a rocket can be discovered by infra-red scanning ten minutes earlier than by a very sensitive radar defence system.

Flying Spies

The scientific importance of satellites

The use of satellite pictures for the exploration of the earth and its neighbouring planets has only just started. This development looks so promising that it is being pushed ahead very rapidly. It will be interesting to see what new results future satellites and above all the space laboratories planned for the next decades, will bring.

The scientist, limited in his movements, has not been able to find out those facts about the world which satellites, equipped with highly sensitive sensors and cameras, now reveal. Natural disasters, vegetation diseases, expansion of the agricultural area, water reserves, moisture content of the soil, undiscovered sources of raw materials or energy, all these can now be monitored.

The satellite can investigate the nature of the space through which it moves, and can examine the radiation in the higher strata of the atmosphere. It opens our view into the universe and can register data, which otherwise has little or no chance of reaching the earth's surface due to the absorbing atmosphere.

Cloud pictures and the recognition of air currents or movements within the atmosphere make the satellite indispensable for weather forecasting.

This silent treasure hunting, often done from a distance of 1,000km, was originally only a byproduct of military satellite reconnaissance. Those 'revealing instruments', originally developed merely for military purposes, turned out to be scientific pioneers in discovering new information about the earth's surface and the crust of the earth.

This development, measured against the results so far, seems to be very expensive. The thousands of millions of dollars that have been invested will, however, pay off in the long run. An American commission of the Third Space Flight Conference, held in June 1968 mentions an amazing ratio between total benefits and total expenses of 20:1! The size of the areas covered and the wide area of usefulness of the results make scientific satellite research financially much more viable than aerial research undertaken from aircraft. For instance in order to photograph the area of the United States from an aircraft one would need $1\frac{1}{2}$ million pictures, requiring a photographing time of ten years. A satellite, however, covers the whole of the USA from a distance of 900km in only 400 pictures, and needs a mere seventeen days to do it. For the satellite pictures the cost would be £300,000 ($750,000), for the photographs taken from aircraft £4,900,000 ($12 million). We are, of course, still at an early stage, and those thousands of millions of dollars which have been spent have not yet paid off, but we can however foresee the time when these investments will be shown to be worth-while.

Economic espionage and satellite pictures

The interpretation and use of space pictures has important economic and commercial aspects. NASA was initially very willing to make their satellite photographs available and various business undertakings were very keen to obtain those pictures. Now, however, not all photographs are revealed to the public, partly for military, partly for economic reasons. False colour photographs for instance show the proportion of cultivated area to fallow or even the different crops in the fields. This information can be used profitably when it comes to buying or selling crops (pictures 28 and 30).

British scientists have recently accused the United States of illegitimately securing an advantage for themselves in the location of ores and oil. After their latest scientific findings from these space pictures they are said to have bought the concessions for enormous areas, before any geologist working in the field could even set foot in them. Through quickly analysing the agricultural production of the world, registering damage caused by the weather and constantly controlling reserves of raw materials – all by means of satellite photography – the United States economic planners can always be a step ahead of their competitors.

Transmission of news by satellite

The ionised layers in the upper atmosphere have long been used as a reflecting surface in the transmission of radio waves at long range. This reflecting function can be taken over by satellites and is then much less prone to interference than the transmission via the natural reflection strata. Today both telephone and television use active relay satellites, which have their own electronic relay equipment and move synchronously with the rotation of the earth, and therefore appear to be stationary above the equator. Photographs 1, 2 and 3 are taken from such a satellite – an Applications Technological Satellite – circling at a height of 35,800km.

Satellites for radiation research

As is well known, most radiation in space is filtered through and absorbed by the atmosphere. Satellites which measure the radiation of the higher atmosphere from different heights give constantly improving results and increasing knowledge about the processes, the structure, the movement and the absorption within the higher strata of this gas-cover around the earth and also about conditions in outer space.

In the service of the weather forecaster

Not only can the satellites measure the natural processes in the atmosphere, they can also establish the changes that take place due to the interference of man. Minor variations in the temperature of our planet due to human influence have already been discovered, these influences being, for instance, a concentration of carbon dioxide, the burning of coal and mineral oil and, in industrial areas, the very obvious darkening of the atmosphere. The clearing of forests and the resulting reduction in the reflection of infra-red radiation can be observed by these weather satellites. The same applies to the pollution of the surface of oceans by oil, for pollution lowers the rate of evaporation. Such knowledge allows us to take counter-measures more quickly than was previously possible.

The weather forecast itself, the uncertainty of which has done great harm to agriculture and to tourism, will improve considerably during future years thanks to satellites. Weather stations on the mainland and at sea can only observe about a tenth of the atmosphere. Two or three meteorological satellites, however, can produce a complete survey of the cloud formations in a few hours. Gale areas, including hurricanes can be recognised in their initial phases and the direction of their movements can be traced. The tremendous importance of satellites for this particular purpose is demonstrated in pictures 2, 3, 4, 5 and 6.

Oceanography from space

Slogans like 'Fishing with satellites', with which we are confronted in the press, are fully justified. The oceans are the real 'blank spaces' on our globe today. We are still far from possessing an adequate knowledge of the ocean currents and the various water bodies in the oceans, which could form the basis for an economic planning of world fishing. The photographic recording of processes taking place on the surface of the ocean, of currents and swarms of fish give us a starting point for oceanographical research.

Besides the ordinary satellite pictures the infra-red sensors are of basic importance for oceanography. The surface temperature of the oceans can be measured very precisely. The distribution and movements of bodies of cold water and above all of ice fields can be observed by infra-red photography.

The oceans which cover roughly seventy per cent of the earth's surface, have been brought into the foreground of research and are now considered to be sources of food for the future world population. About eighty per cent of all animal life exists in the world's oceans. With conventional fishing methods actually finding the fish used to take twenty per cent of the time spent in the fishing area; with the help of infra-red pictures and infra-red sensors this has been considerably reduced.

The difference between areas rich in plankton and therefore rich in nutritive substance and those that are poorer can be discovered easily. By finding these rich areas within the oceans one can detect and trace swarms of fish which have not been previously discovered. Satellites sometimes even carry instruments on board which react to chemical substances discharged by spawning swarms of fish. Recently measuring buoys equipped with transmitters have been used for research into the course and speed of ocean currents. Thus the ATS Satellite III besides its

other purposes also helped in the solution of oceanic problems. Pictures 2, 3, 18, 19, 21, 22 and 23 touch on these problems.

The importance of satellites for geology

In areas such as the detection of mineral resources, the surveying of large-scale tectonic relationships, the measuring of soil movements and the forecasting of volcanic eruptions, satellites are of the greatest importance to geology.

'Photogeology' is now generally recognised as a genuine working procedure in geology; this has been the case ever since, between the two world wars, amazing results were achieved in connection with a large-scale research project using aerial photographs in New Guinea. Besides providing information about tectonic and structural relationships air photographs have proved very helpful in geological projects that are of importance for the world's economy, for instance the location of mineral oil and deposits of ores and other minerals. When space photography was developed it was clear from the very beginning that satellite pictures would be of the greatest help to the geologist.

The main value of satellite pictures which show large areas of the earth's surface lies in the fact that they give a general idea of the relationships and the causes of geological patterns and structures. Only the enormous distance from the object that is to be interpreted makes it possible to recognise large-scale relationships which allow us to do more than just make hypotheses about the movements of the crust of the earth (pictures 7 to 18).

The small-scale geological map of the world (scale: 1:1,000,000) will in future be based largely on satellite photographs, for geological maps made from space are even better than air photographs for examining geological structure and finding mineral resources.

Space photography, however, offers far more to the geologist, especially as it is possible to use infra-red photographs, radar photography, infra-red sensors, magnetic measuring and spectrometric measuring in addition. Infra-red pictures for instance show various geological structures much more clearly than ordinary photography, as they bring out the detailed contrast between the different kinds of rock. Fractures and faults usually come out quite clearly, even when they are covered by detritus. This development has by no means reached its climax, in fact it has only just started. Until recently, we could only deal with the very limited material produced during the Gemini and Apollo flights in each orbit.

Now, however, the entire field is being opened up by NASA's Earth Resources Technology Satellites which carry advanced vidicon cameras and multi-spectral scanners. They are designed to gather information on the earth's resources and environmental problems such as pollution of air and water, flooding, erosion, weather, crop deterioration and mineral deposits. ERTS-1, launched from the Western Test Range on 23 July 1972, achieved an orbit ranging between 903 and 921km inclined at 99.1 degrees to the equator.

As techniques develop it may also be possible to give advance warning of volcanic eruptions. The sudden rise in temperature in the subsoil before the actual eruption can be detected by infra-red sensors in satellites.

All work done in the field of extra-terrestrial geology, the so-called 'astro-geology' depends entirely on satellite observation. For instance with the help of satellite pictures, radiation sensors and the measurement of its radiation, the moon was geologically examined and mapped with regard to its morphological patterns, its light and the degree of decay of its rocks before men ever set foot on it. The same applies to Mars, the geological structure of which has been examined by means of satellite pictures and measurements.

Assisting the soil scientist

In the traditional pedological interpretation of air photographs the soil scientist used to draw conclusions about the different types of soil from landforms, vegetation and the micro-relief features (in the decimetre and metre range). With multi-spectral and infra-red photography it will be possible in the near future to recognise types of soil immediately and above all to find out directly from the satellite picture the moisture content which is so very important for land utilisation. Changes in the soil – eg salinity, which is one of the big problems in subtropical areas with little rain – can also be recognised from the air or from space with specially chosen films or by scanning the earth's surface with different radio frequencies.

17

In the service of hydrography

The mapping of the water bodies of the earth has never been done as completely as it can be done now with the aid of air and satellite pictures. Here again the use of special films aids the detection of hidden water reserves, which on the surface we only notice through a slightly higher moisture content of the soil. Springs and spring lines can be identified without difficulty with infra-red photography. Snow and ice cover, changes of temperature and their dependence on the moisture content can be found with infra-red and radar sensors.

The last 'blank spaces' disappear

Following the successes of the weather satellites TIROS and Nimbus, NASA wants to build a geographical research satellite. Plans for this research project are being co-ordinated by McGill University. It is intended to concentrate above all on the improvement and speeding up of world-wide surveys like the international world map, a land utilisation map of the world, the distribution of population, the traffic conditions and the use of energy. The use of satellite pictures is also most successful in surveying surface temperatures over large areas, the distribution of precipitation, the water vapour content of the atmosphere and the periodic changes in snowfall within the rhythm of the seasons.

Satellites in forestry and agriculture

Aerial photography has been used for quite a long time in forestry and agriculture. Here methods are used which, with only slight inaccuracies, help to ascertain the level of timber reserves. Multispectral and especially infra-red photography open up immense possibilities to the farmer and forester.

Tropical areas, which contain roughly forty-five per cent of the world's forest, and the large sub-polar forest areas of Canada and the Russian Taiga, are to a large extent blanks as far as the proper development of forestry is concerned. There is scope here for the development of forestry and an increase in timber production. Infra-red sensors in unmanned satellites have also detected large forest fires in Canada in time for them to be successfully brought under control.

World land use, plant pests and the state of different crops can be controlled through the interpretation of infra-red pictures. The Food and Agriculture Organisation of the United Nations (FAO) deals in particular with the problem of finding food for the extra millions of people in the future world population. The constantly growing world population makes a rapid extension and intensification of agriculture necessary, and satellite photography offers possibilities in the field which have not yet been appreciated (pictures 28 and 30). The results of the film material of the Apollo IX flight amazed all agriculturalists. It may seem an exaggeration to suggest that in the near future a farmer might be advised to move his cornfield 800m to the right, because the composition of the soil is more suitable for it there, but this might well be the case soon.

Pest control can be intensified on a global scale because the pictures show a clear difference in colour between healthy and diseased plants.

Satellite geodesy of the earth and other planets

The influence which the shape and structure of the earth exercises on the orbit of a satellite can be optically observed and measured precisely. The results are new measurements for the flattening of the earth and the different distribution of the masses of material inside our planet. This knowledge is of great geological importance. In addition the satellite makes new methods of surveying the earth's surface possible.

Two thousand years ago Eratosthenes of Cyrene considered the earth as a sphere and was the first to calculate its circumference. Today we know that the earth is an oblate spheroid, a sphere slightly flattened at the poles. The deviations of the artificial satellites from their theoretically precalculated orbits (called perturbations) are due to irregularities in local gravity caused by uneven distribution of the earth's mass. Thus precise observation of satellite orbits helps us to discover a lot more about the shape and nature of our own planet.

Apart from this earth-satellites serve as key markers in surveying. They make it possible to connect the continental networks of fixed points across the oceans and to cover the whole of the earth with one survey net. The direction from the satellite to the point of observation is fixed by flashes of light, emitted from an active geodetic satellite, and these have to be accurate to a

thousandth of a second! Through this it is possible to bring geodesy nearer to the three-dimensional reality, than was possible with traditional methods. The moon can be used as an additional aid here. The first men who landed on the moon set up a LASER–reflector, which made it possible to measure the distance to the moon to within a few decimetres.

Satellite geodesy and cartography – as does aerial photogrammetry – use pictures that can be interpreted stereoscopically (picture 13). Such pictures are obtained every day by weather satellites.

Satellite cartography is of special importance for the investigation of the moon and our neighbouring planets. So the front and concealed parts of the moon have been fully surveyed and photogrammetrically interpreted with the help of pictures taken stereoscopically during the Lunar-Orbiter flights. These photographs were automatically transmitted to earth. This interpretation was used for the topographical maps of the moon 1:1,000,000, in which contours were drawn at an interval of 300m. The pictures transmitted during the flights of the Venus spacecraft to Venus and of the Mariner spacecraft to Mars are used in a similar way. They serve as the first cartographical material for research on the surface shape and structure of these planets.

Waves of the Measuring System	Photographic Technique	Geology	Hydrography and Pedology
	Simple photography (black and white, colour)	Study of structures, recognition of large-scale geological relationships, large-scale geologic mapping	Mapping of drainage systems, drainage networks
White Blue Green Yellow Red	Multi-Band Camera Multi-Spectral Photography (eg multi-lens camera) exposures with several films, differently sensitised, eg black and white, infra-red, red, and green	Study of structures, recognition of different rocks	Moisture content of soils, characteristics of different soils
Infra-red heat radiation	Infra-red pictures on film; infra-red scanning in distant infra-red, picture on a screen	Mapping of thermal conditions, eg zones of oxidisation of ore deposits, volcanic activity, identification of minerals	Location of soils, which have cooled through evaporation
Radar waves (0.536cm–10m)	Radar pictures (oblique radar)	Pictures of micro-relief (tectonics and sedimentology)	Measurement of moisture content of soil, and of slopes soil erosion
(>10m)	Special radar	Recognition of concealed strata	
Heat radiation (1mm–30cm)	Micro-wave radiometry	Character of concealed strata	Snow and ice cover, temperature differences up to $1/100°$ C
Infra-red ultraviolet	Absorption spectroscopy	Geochemical pictures location of mineral deposits Investigation of active volcanoes	Soil chemistry

invisible rays

visible rays (light)

EARTH SCIENCES, OCEANOGRAPHY AND METEOROLOGY

Geography	Oceanography	Agriculture and Forestry	Meteorology
Land use, mapping of vegetation, land consolidation	Coastal cartography coastal changes, currents, eddies, water bodies	General survey mapping of agriculture and forest land use	Cloud cover, forecasting
Mapping of urban areas Regional planning			
	Colour of sea water as guide to plankton content	Study of land use and of soils, of existing cultivation and plant cover and of disease and pests, forest valuation	Cloud cover, colour photographs via receivers
Land use, coastal currents	Mapping of ocean currents and water	Land use and the occurrence of disease or pests; forest fires; conditions of the crops	Heat radiation over land, sea and ocean currents
Land use, recognition of small relief forms	Coastal currents	Soil formation	Cloud cover, early warning system for storms
Measurement of ice thickness on land and mapping the ice cover	Measurement of ice thickness at sea, and mapping of ice fields		
Location of snow and ice	Mapping of ice distribution and currents	Soil temperature	
	Location of plant cells on the surface		

Glossary

Absorption (Lat): the reduction of light intensity in transmission through the taking up of light by gases and other materials. **Interstellar A**: absorption through finely distributed material in space

Albedo (Lat. From albus = white): the percentage of incoming radiation reflected by a natural surface.

Alluvium (Lat): deposited material, generally water-borne, laid down since the last ice age

Altiplano (Span): high plateau (Peru and Bolivia)

Andesite (Lat): volcanic rock

Anticline (Gr): an arching up of strata = saddle (opposite – syncline)

Apogee (Gr): point in orbit of a satellite that is farthest from earth

APT: **A**utomatic **P**icture **T**ransmission

Arabia felix (Lat): 'happy Arabia' (in contrast to 'Arabia deserta' – deserted Arabia) – roughly the area of Yemen and Hadramaut

ATS: **A**pplications **T**echnological **S**atellite

Bab el-Mandeb (Arab): gateway of tears; strait between Indian Ocean and Red Sea

Badlands: land that is uncultivatable due to soil erosion

Caldera (Span): volcanic depression caused through crater collapse

Cambrian (from Cambria, Celtic name for Wales) oldest period of geological history

Cenozoic (Gr): recent period of geological history – synonomous with neozoic

Cirrus (Lat): small feather-like clouds

Convergence (Lat): zone in which air-streams from north and south come together

Cumulus (Lat): rounded, heaped and often very large clouds

Cyclone (Gr): (*a*) a tropical, violent, whirling storm (*b*) an area of low pressure; a depression

Diluvium (Lat): glacial and fluvio-glacial deposits

Diorite (Lat): a rock originating deep in the earth's crust

Draa (Arab): parallel chains of dunes

Edejen (Arab): fields of sand dunes

Energy, kinetic: the energy of movement, for example of falling water or of wind

Erg (Arab): sand desert with dunes

Erosion (Lat): the wearing away of landforms and the transport of the resulting material

ERTS: **E**arth **R**esources **T**echnology **S**atellite

ESRO: **E**uropean **S**pace **R**esearch **O**rganisation

ESSA: **E**nvironment **S**urvey **S**atellite – weather satellite with polar orbit

Fault: A fracture or fracture zone along which there has been displacement of the two sides relative to one another parallel to the fracture

Fossil (Lat): petrified plant and animal remains preserved by natural processes within the earth's crust; as an adjective – remains of old landforms

Gassi (Arab): depression between two dune ridges

Gelta (Arab): lower parts of dry valleys in the Sahara, which reach to the ground-water

Geodesy: the science of earth measurement

Geosyncline (Gr): a large basin, subsiding through time, in which often thousands of metres of sediment accumulate

Glacial Period: the ice age of North and Central Europe. In the warmer areas (e.g. Sahara) there is a corresponding pluvial period

Gran Chaco (Indian word): large hunting ground; a region in South America

Granodiorite (Lat): a rock formed deep in the earth's crust; chemically between granite and diorite

Guano (originally from Ketshua, adopted by Spanish): accumulation of bird excrement, on the islands off Peru, the Peruvian coast and elsewhere

Guyot (Fr): a table mountain below sea level

Hamada (Arab): stone desert; literal meaning 'not suitable for camels' (also Hammada)

Hor (Arab): marshy area

Hurricane: cyclonic storm. The Mayas called the Great Bear star formation 'hunraken' = one leg. (The shaft points downwards in the southern hemisphere.) As the frightening Antilles storms arrived under this constellation's sign, this one-legged giant was made the weather god. The word reached Spanish and the other European languages via Haiti

Intrusion (Lat): the pushing up of fluid magma into other rocks, without reaching the surface

Jebel (Arab): mountain, mountainous country

LASER: **L**ight **A**mplification by **S**timulated **E**mission of **R**adiation = very powerful and narrow beams of light

Llano (Span): plain (Venezuela)

Lunar-Orbiter (Lat): unmanned satellite used to study the moon from orbit

Magma (Gr): liquid silicate rock inside the earth

Mariner (Lat): unmanned probe for the investigation of other planets

Meander (Gr): river in western Asia Minor with numerous twists and turns in its course; general term for curves in river courses

Mesozoic (Gr): the 'middle ages' of geological history

Metamorphism (Gr): transformation; changes in rock caused by high temperatures or pressure

Monazite (Gr): a mineral; the principal ore of the rare earths and thorium

Morphology (Gr): the study of form; here of the earth's surface (Geomorphology)

Nadir (Arab): opposite of zenith, ie lowest point

NASA: **N**ational **A**eronautics and **S**pace **A**dministration, USA

Nimbus (Lat): cloud formation; name of class of weather satellites

Occlusion (Lat): union of warm and cold fronts

Oolite (Gr): literally 'egg stone'; sedimentary rock made up of consolidated rounded individual rock components

Orography (Gr): study of mountain forms

Palaeozoic (Gr): the oldest period of geological history, since the beginning of life on this planet

Perigee (Gr): the closest point of a satellite orbit to earth; opposite of Apogee, above

Photo-climate (Gr): illumination of the earth

Placer deposits: gravel or sand containing secondary mineral deposits

Plankton (Gr): floating organisms in the sea, rarely capable of movement; main food of many types of fish

Pluvial Period (Lat): rainy period; in the Sahara for instance corresponded to ice age in more northerly areas

Quaternary (Lat): most recent part of the Cenozoic, see above

Ras (Arab): head, chief; figuratively cape or foot-hills

Recent: in geological terms post-glacial, alluvium

Refraction (Lat): deflection of rays from the sun through layers of air of varying thickness

Reservoir: porous or broken strata in which oil or gas can accumulate

Rub el-Khali (Arab): empty quarter; the desert in south-eastern Arabia

Rutile: reddish-brown mineral, titanium oxide

Schatt (Arab): river; but also lakes, salt lakes. Also written Schott, Tschad or Tchad

Sediment (Lat): rock deposit of secondary material eroded and transported from its original situation; eg sand or limestone

Seif (Arab): longitudinal dunes

Selenology (Gr Selene, the moon goddess): study of the moon

Selva (Portug): natural forest

Serir (Arab): gravel desert

Shelf: marginal areas of the continents covered by the sea (up to a depth of 200m)

Sial (Lat): Silica-Alumina. Main constituent of the earth's upper crust, especially on the continents

Silurian (after the Welsh tribe, the Silurier): second oldest period of geological history

Sima (Lat): Silica-Magnesium. Main constituent of the layer below the Sial (see above), the Mantle. Forms of the floor of many of the world's oceans

Stratopause (Gr): boundary layer in the atmosphere, about 60km above the earth

Stratus (Lat): layered clouds

Surveyor: unmanned spacecraft for moon landings

Syncline (Gr): downwarping in stratified rocks; opposite – anticline

Tectonics (Gr): study of the structure and changes in the structure of the earth

Tethys (Gr sea goddess): deep sea basin (geosyncline) in which the recent mountain chains (Alps, Himalayas) were folded

TIROS: **T**elevision and **I**nfra-**R**ed **O**bservation **S**atellite

Titanium: very hard metal with the minerals Anatase and Rutile. Important in the construction of aircraft and spacecraft because of its resistance to heat and corrosion

Tropopause (Gr): boundary layer in the atmosphere at an altitude of 11–12km – boundary of the stratosphere

Typhoon (Chin): tropical storm, common in the Pacific

Uruk (Arab): longitudinal dune

Wadi (Arab): dry valley, in which water is only rarely found after the occasional heavy rain storm

Zenith (Arab): the point of the celestial sphere vertically overhead; the point in the sky vertically above the observer

The explanatory maps are to be regarded as interpretative maps, as they are generally used in photo-interpretation. Only those things which can be directly recognised or assumed from the pictures are shown. Water is generally coloured in blue, land in a pale yellow. Additional symbols, which are explained under the maps, are only included where satellite photography shows distinctly different morphological and geological units as well as geographical, tectonic and agricultural details.

Pictures of the earth; atmosphere -
oceans - continents

The illumination of the earth (five photographs from sunrise to sunset)
Morning, noon, evening – thus time, light and warmth – came to the earth with the rays of the sun. A unique spectacle, when looked at from beyond the earth, from space, which once no human eye had been able to see. The succession of day and night has been recorded here in a number of colour photographs which were taken by a satellite of the type ATS (Applications Technology Satellite), namely the ATS 3 on 18 November 1967. This satellite was launched into an orbit and accelerated in such a way that at a distance of 35,800km above the equator it revolved around the earth in the same direction once a day, which means that, observed from the earth, the satellite appears stationary. Such a position has so far not been achieved by a manned spacecraft. The ATS pictures transmitted to the earth via 'television' were of amazingly good quality.

Recognisable sunlit areas are South America, the edge of the Pacific Ocean, the Atlantic Ocean in a deep blue, north-west Africa, the southern Polar region, the Antarctic (here it is not quite clear whether the ice cover itself is visible or the clouds above it), and cloud formations with cyclones that are clearly outlined and even show changes during the day. Such detailed weather observation was one of the main tasks of ATS 3. In South America, the Andes in Peru and Bolivia are clearly visible as a brown strip, as are the vast green areas of the tropical primeval forest in the Amazon Basin. The pictures of morning and afternoon also show dawn where it gives way to the on-coming day; at the poles bright white-pink clouds at a considerable height, and in the tropical and subtropical zone (off the western coast of South America) the green colour of the highest clouds. This so-called 'green flash', which occurs in the tropical latitudes immediately before sunrise, is a very striking phenomenon; it is caused by the refraction of light rays in the higher strata of the atmosphere and was for a long time considered a mystery which could not be explained. It is known that at a height of 25km above the earth's surface there is still water vapour from which the so-called 'mother of pearl clouds' form. These clouds become visible with the sun's first rays and are still the last ones that can be observed after sunset.

As the reflection of the sun's rays from the earth occurs mostly in the spectral areas of ultra-violet, violet and blue, these colours are dominant in the pictures. The smaller the angle at which the solar rays meet the earth, the more light is reflected. If the rays strike the surface of the ocean at a sharp angle the reflection amounts to only 2 per cent, and thus they appear to be dark. On the antarctic firn plateau and above white clouds it amounts to 89 per cent, thus they appear light.

The salt particles from the foam of the waves on the oceans and Saharan dust at a great height intensify the effect of stray light in the atmosphere of the earth. This indirectly causes a blue colouring.

The earth does not appear spherical, but egg-shaped. The North Pole is flattened as the noon-picture shows; for the northern polar night covers part of the Arctic, which therefore cannot be seen. This is due to the seasonal position of the earth in relation to the sun.

In order to help understand the unique and beautiful succession of the coming and going of the day, as it is demonstrated in these pictures, it is necessary to discuss the 'astronomy' and 'geography' of our daily life.

Our lives are regulated by cosmic phenomena. Day and night, months and years, summer and winter, all have a tremendous influence on us. The energy of the sun, its warmth, which has been radiated on to the earth for millions of years and its light makes life possible on this planet. Even in pre-historic times man recognised his dependence on cosmic events.

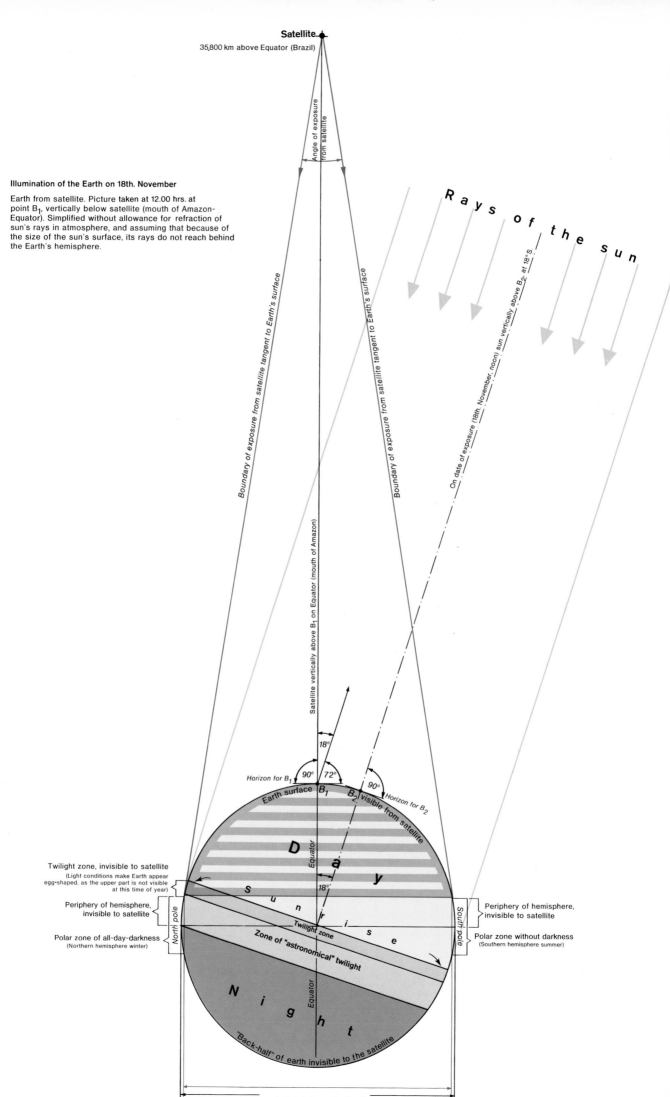

Satellite

35,800 km above Equator (Brazil)

Angle of exposure from satellite

R a y s o f t h e s u n

Illumination of the Earth on 18th. November

Earth from satellite. Picture taken at 12.00 hrs. at
point B₁, vertically below satellite (mouth of Amazon-
Equator). Simplified without allowance for refraction of
sun's rays in atmosphere, and assuming that because of
the size of the sun's surface, its rays do not reach behind
the Earth's hemisphere.

Boundary of exposure from satellite tangent to Earth's surface

Boundary of exposure from satellite tangent to Earth's surface

On date of exposure (18th November, noon) sun vertically above B₂ at 18°S.

Satellite vertically above B₁ on Equator (mouth of Amazon)

18°

Horizon for B₁ 90° 72° 90° Horizon for B₂

Earth surface B₁ B₂ visible from satellite

Equator

D a y

18°

s u n r i s e

18°

Twilight zone, invisible to satellite
(Light conditions make Earth appear
egg-shaped, as the upper part is not visible
at this time of year)

Twilight zone

North pole

South pole

**Periphery of hemisphere,
invisible to satellite**

**Periphery of hemisphere,
invisible to satellite**

Zone of "astronomical" twilight

Polar zone of all-day-darkness
(Northern hemisphere winter)

Polar zone without darkness
(Southern hemisphere summer)

Equator

N i g h t

"Back-half" of earth invisible to the satellite

26

Earth's diameter from pole to pole is greater than it appears from satellite.

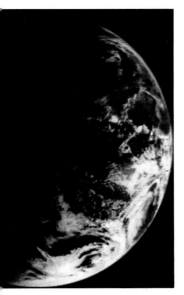
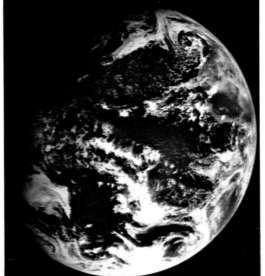
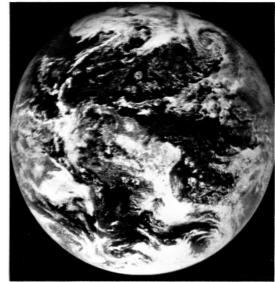

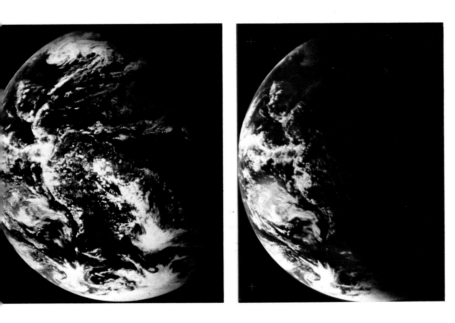

1 The illumination of the earth

NASA-Photo: SCI-1803, ATS-3
Exposure: Unmanned Applications Technological Satellite (ATS)
Date: 18.11.1967
Time: 0730 – 1030 – 1200 – 1530 – 1930 local time at the mouth of the Amazon
Altitude of exposure: 35,800km

The illumination of the earth – the so-called photo-climate or light-climate – is regulated by the daily rotation of the earth around its own axis and its yearly elliptical orbit around the sun, with which the axis of the earth forms an almost constant angle of $66\frac{1}{2}°$. The different positions of the earth in relation to the sun cause the seasonal differences in radiation which are also dependent on the geographical latitude. This difference in radiation led to the division into climatic zones – the Polar Zone, the Temperate Zone and the Tropical Zone. In ancient history the term 'climate' was used in connection with the length of the longest day, the term itself meaning literally 'inclination' or 'angle' and therefore referring to the position of the earth's axis and describing regions according to this position.

The change from day to night or night to day does not occur abruptly. The phenomena of dawn and dusk make the transition gradual. Nor is the change regular; one can observe certain twilight arcs. These are caused by the reflection of the sun's rays, when the sun is below the horizon, on various unstable strata in the atmosphere. The first or bright twilight arc disappears on the horizon or appears when the sun has a position of 8° below the horizon. This moment is the end of 'normal' dusk or the beginning of 'normal' dawn. The stratum which causes this bright twilight arc lies at a height of 11 to 12km and is the boundary of the stratosphere, the so-

called tropopause. When the sun is in a position 17° to 18° below the horizon, the second or main twilight arc disappears below the western horizon. In the morning this twilight arc appears on the eastern horizon. This moment is the end or the beginning of the 'astronomical' dusk or dawn. Between its end and start there is complete darkness so that during this period the stars can be observed with the naked eye. In spite of this the disappearance of another twilight arc can still be observed when the position of the sun is 24° below the horizon. The twilight strata in the atmosphere which cause these phenomena lie at a height of around 60km (stratopause) and at 130km.

As the daily orbit of the sun is very steep in tropical areas, the period of dawn is very short, about 20 to 25 minutes. The difference in the length of the days throughout the year is relatively small; day and night are therefore of almost equal length. Even in Central Europe one can notice the shorter period of dawn in the southern parts compared with the north.

In the tropical latitudes between the Tropic of Cancer and the Tropic of Capricorn ($23\frac{1}{2}$°N and $23\frac{1}{2}$°S) the sun is at its zenith twice a year. As the distance from the equator grows and towards the Tropics (where the sun is vertical once a year) decreases, these two zenithal points move closer and closer together. This fact is of the greatest importance for the distribution of the tropical rainy and dry seasons.

The length of the day at the polar circles in the summer of the respective hemispheres is twenty-four hours, when the sun is at its highest position. Towards the poles this length of day increases to six months of uninterrupted daylight, while the sun apparently rotates around the horizon for three months in a rising spiral and after that in a declining spiral for the same length of time.

In the winter the sun sinks below the horizon for an almost equally long time. Certain slight variations are caused by the refraction of sun rays near the horizon. However, the darkness of the winter is shortened considerably by the dawn especially in areas near the poles where the apparent spiral of the sun (yearly orbit of the sun) shows the smallest angle of inclination.

The distance of the sun from the eastern or western point, the so-called morning or evening distance, is not the same for all places on the same day; it varies with the geographical latitude. The higher the geographical latitude of a place, the wider, or smaller, is the morning or evening distance. Accordingly the length of day and night changes with the geographical latitude.

Length of longest and shortest days

Latitude	Longest Day		Shortest Day		Difference	
0° (Equator) Ecuador Quito Singapore	12^h	0^m	12^h	0^m	0^h	0^m
10° Panama-Saigon	12^h	35^m	11^h	25^m	1^h	10^m
20° Mexico	13^h	13^m	10^h	17^m	2^h	56^m
30° Shanghai New Orleans	13^h	56^m	10^h	4^m	3^h	52^m
40° Philadelphia	14^h	51^m	9^h	9^m	5^h	42^m
50° Frankfurt	16^h	9^m	7^h	51^m	8^h	18^m
60° Leningrad	18^h	30^m	5^h	30^m	13^h	0^m
66° 33' Arctic Circle	24^h	Day	24^h	Night		
70° Tromsö (Norway)	Day =	65 Days	Night =	60 Days		
80° Franz-Joseph-Land	Day =	134 Days	Night =	127 Days		
90° (Pole)	Day =	186 Days	Night =	179 Days		

The figures are for the Northern Hemisphere

Light is reduced in the atmosphere for three reasons:

1 Absorption in the atmospheric gases reduces the light to the visible spectral area (area of radiation). The invisible short wave ultra-violet radiation and the long wave infra-red radiation are mostly absorbed.
2 The dispersion of light on the molecules of the air causes the blue colouring of the sky during the day. It depends to a large extent on the wave-length of the light and is therefore called selective.
3 The dispersion on colloidal particles of the air is caused through the atmospheric haze. The smallest colloidal particles of a diameter between 0.1 and 0.5mm cause a dispersion which depends on the wave-length. Larger particles like dust, soot and drops of water lead to a weakening of the dispersed light which is independent of the wave-length.

Due to the fact that the density of our atmosphere decreases with altitude, a ray of light coming from space is refracted, so that it moves in a concave line in relation to the earth's surface. This refraction of light shows – especially during twilight – a geographically differentiated variation of light colours which also depends on the structure of the atmosphere in the various climatic zones and on weather conditions. Due to this refraction an object, eg a star, does not lie along the straight extension of our line of sight, but lower down. Because of this the object appears as if it was elevated to the observer. The difference between the real situation and the observed situation, due to the refraction, is called astronomical refraction.

The light conditions on the earth are not only influenced by the sun, but also by the moon. The picture was taken during a full moon period. This is the constellation when the moon is situated opposite the sun on the other side of the earth. The earth receives the milky looking sunlight which is reflected from the moon and which we know as bright moon light. The satellite picture does not show the reflection, although it should be visible at the right-hand 'edge of the earth' in the photograph taken at 0730.

With the apparent rotation of the sun around the earth time passes by. For man, it passes in a steady rhythmical change of day and night, which we are accustomed to divide into 24 hours. Thus time passes (in relation to the sun at noon) by an area of 15° per hour, if you divide the earth into 360°. The 'moving forward' of time, its passing, is demonstrated in the series of pictures.

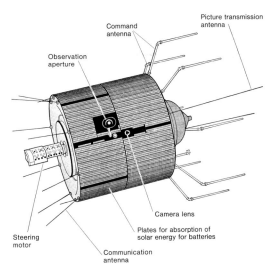

ATS-Satellite
(Applications Technological Satellite)

2 The earth from 35,800km above the Atlantic Ocean

NASA-Photo: SCI-1803, ATS-3
Exposure: Unmanned Applications Techno-
logical Satellite (ATS)
Date: 10.11.1967
Time: 12 noon local time at the
mouth of the Amazon
Altitude of exposure: 35,800km

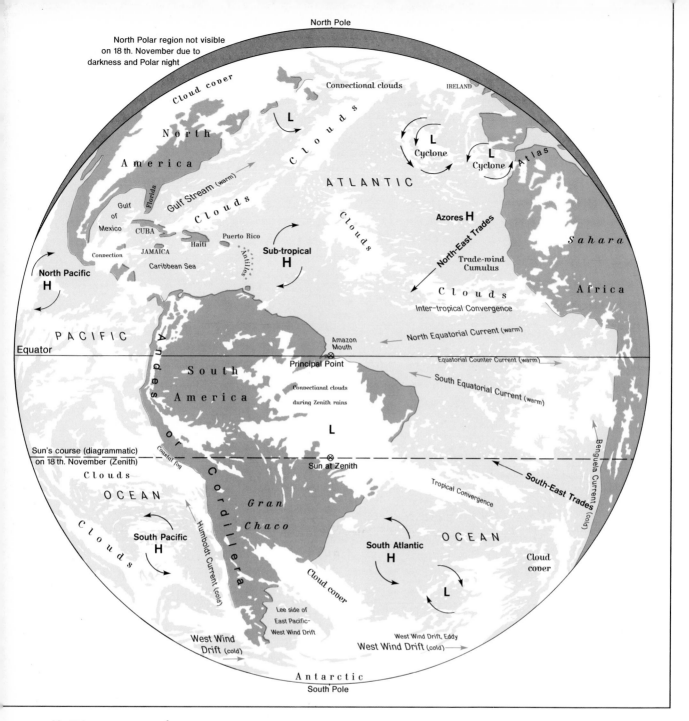

The fully illuminated hemisphere iridesces and reflects in all the various colours of a precious 'blue' opal. The clear contours against space become indistinct in the northern hemisphere in the region of the polar night. The deep blue of the oceans and the greyish green to yellowy brown of the continents dissolve towards the edges into a diffuse light blue. Large areas of the earth are covered by banks of clouds, cloud bands and cloud whirls. The reflection of light produces this colourful picture of our earth according to the differently intensive absorption and reflection on clouds and on land, whether covered by vegetation or not.

Climatic zones and meteorological systems are clearly recognisable in this shot. The functioning and results of the world-wide movements of the air masses in our atmosphere can be seen in the clouds and air streams. Observation of areas like this, with photography over a longer period of time at regular intervals, shows changes in the circulation of our atmosphere on a global level and allows meteorologists to make well-founded statements about the development of our weather.

The colour photograph in question shows an enlarged picture taken by the satellite ATS 3 (picture 1) at 1200 hours on the meridian of the mouth of the Amazon. It is not an original

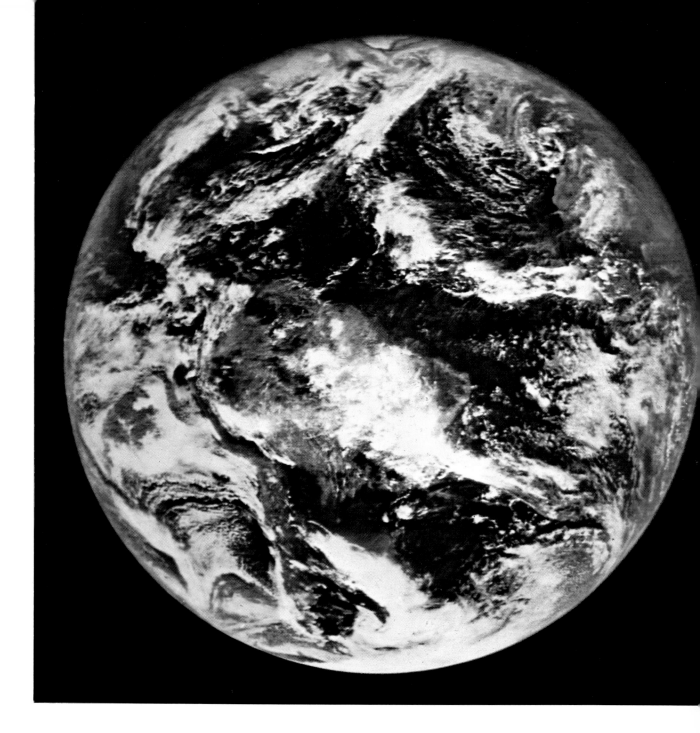

photograph, but one transmitted by television, received by a ground station in North Carolina. As the picture was taken at noon, the hemisphere is completely illuminated by day-light.

In its contours the continent of South America as well as the curved western part of Africa are clearly visible. North America and large parts of Central and South Africa are indistinct. The vast areas of tropical primeval forest on the continental shield of Brazil can only be guessed at from the greyish-green to greenish-blue shades of colour. The Andes with desert areas coloured in a brownish yellow, can be seen along the Pacific Coast. This chain of mountains was crumpled up as the continent moved towards the Pacific after being separated from Africa and drifted west-wards. It left behind the enormous gap which is now the Atlantic Ocean. In Africa it is again the desert areas which stand out through their yellow and brown colour shades.

Cloud formations that tower up very high and thick clouds show up as a bright white. Low cloud formations that are not very thick and dense are whitish-blue and transparent. Along the edge of the hemisphere we get a shining bluish area of diffused light. Here the direction of the 'photo-eye' of the satellite is slanting (compare the description of picture 1). A narrow crescent near the North Pole lies in winter darkness or twilight. The equator is marked very clearly

above the Atlantic Ocean by a narrow strip without any clouds. In the southern hemisphere the central land masses of South America, the Chaco, north-eastern Brazil, the lee side of East Patagonia, the desert area of Northern Chile with the cold water of the Pacific Ocean (Humboldt Current) stand out as cloud-free areas. Also free of clouds are the zone of the cold Benguella current off the coast of Africa and the South Atlantic high pressure area as well as parts of the Western African desert.

The west wind drift in the southern hemisphere shows an accumulation of cloud west of the Patagonian mountains and three large convectional cloud areas above the Atlantic. Off Eastern Patagonia the lee side of the west wind drift can be clearly seen as a ridge of high pressure.

The moist area of the tropical Andes and Central America are marked by cloud. There is a cyclone off the north western coast of Africa, another one to the north-west with a convectional cloud cover. Remarkable and difficult to explain is the large area of cloud which stretches over the Atlantic between the distinct subtropical high pressure areas along to the coast of Guinea. The bands of low trade wind cumulus clouds are well-marked north of the equator.

The low-pressure area of the northern latitude off Labrador and Portugal is marked by several cloud whirls (cyclones, low pressure areas).

Of special importance in these space photographs is the fact that large ocean currents are marked by strips of clouds. Thus around the equator we have a system of three currents; the Southern Equatorial Current, the Northern Equatorial Current (both moving westwards) and between a narrow strip, which can only be understood as a result of the Atlantic Equatorial Counter Current (moving eastwards). This current, which was discovered a hundred years ago by Buchanan was forgotten until it was re-discovered in the fifties of this century by the Soviet research ship *Lomonossov*. Measurements on board the German research ship *Meteor* in 1967 confirm its existence.

This, the third largest current, is one of the most interesting oceanographical phenomena. In all the oceans it moves eastwards along the equator as a narrow band just below the surface. In the Atlantic it is 6,500km long, 300km wide and only 300m deep. At a speed of 1 to 2m/second an enormous amount of kinetic energy is concentrated within it.

The relationship between ocean currents and the temperature conditions and their significance for world weather have hardly been explained as yet. Satellites which make comprehensive pictures of the oceans and the atmosphere can produce the necessary material for an understanding of the origins of world weather.

The distribution of the clouds can be understood from a knowledge of the general circulation of the atmosphere. Over the year in the tropical and sub-tropical areas, incoming short wave radiation, reflected from the earth and the atmosphere as long wave energy (infra-red) is dominant. In higher latitudes, outward radiation is dominant. As for decades hardly any changes in temperature have taken place, heat must generally be transported towards the poles. On a stationary earth this transport would be a meridional circulation. On a rotating sphere, however, this circulation is limited to the areas near the equator (trade wind circulation), while in medium and high latitudes a meandering westerly current in the open atmosphere is the result. The effect of this is a large-scale horizontal mixing in which the cyclones and anti-cyclones of the weather maps are the individual turbulence areas (picture on page 41).

This complicated system, in which the tropical areas are the 'boilers' and the polar areas the 'coolers' in an immense heat-generating machine, gets even more complicated through the irregular distribution of land and sea. The very different heat capacity as well as the different mechanical conditions (friction) have to be taken into account. Not only is the sea, as opposed to the land, an important storage area, it also influences the circulation through its currents. The large ice masses of the polar areas serve as a 'cold reservoir' which ameliorate the changes in the atmospheric circulation due to the seasonally different position of the sun. The structure of this circulation is based on the concept of a horizontal exchange. This led to the definition of pressure and wind belts which can of course overlap in the bordering areas. North and south of the equator are the trade winds with their steady north-east and south-east winds, followed by the sub-tropical high pressure belts of the desert regions. Beyond a wide strip where different currents overlap, there is the sub-polar low-pressure region in both the northern and southern hemispheres. As a west wind drift (roaring forties) it stands out especially in the southern hemisphere, for here the distribution of land and water with the dominance of the latter, has hardly any influence on the movements of the air masses. In the polar regions high pressure is dominant.

With increasing height the atmospheric pressure decreases in warm air more slowly than in cold air. So in the middle latitudes (36° to 65°) high up we find a maximal pressure gradient. In accordance with the greater pressure gradient is a higher wind force. In the higher air strata (above 10km), which are not influenced by the friction of the earth's surface and those turbulence areas near the surface, is a double storm belt ring around the earth, which is fundamental for the determination of atmospheric pressure near the surface and is called the jetstream. The speed of the wind here reaches as much as 400 to 1,000km per hour! (Professor W. Weischet, Geographical Institute of Freiburg University, contributed to this interpretation.)

3 The earth from a distance of 35,800km, America and the Pacific Ocean

NASA-Photo: SCI-1893, ATS-1
Exposure: Unmanned Applications Technological Satellite (ATS)
Date: 25.1.1968
Time: 12 noon local time for the 95th meridian
Altitude of exposure: 35,800km

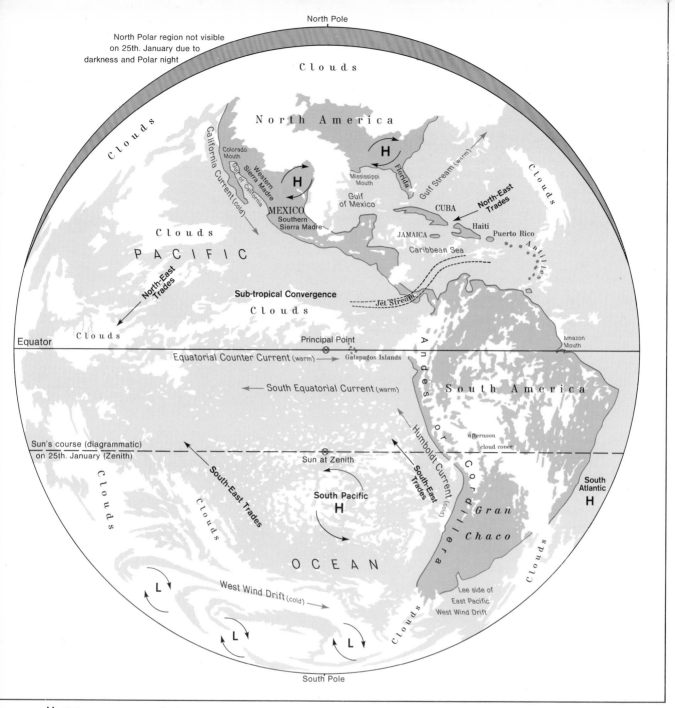

North Pole

North Polar region not visible
on 25th. January due to
darkness and Polar night

Clouds

Clouds

Clouds

North America

Clouds

Clouds

California Current (cold)

Colorado
Mouth

Western
Sierra
Madre

Gulf of California

H

H

MEXICO
Southern
Sierra Madre

Mississippi
Mouth

Gulf
of Mexico

Florida

Gulf Stream (warm)

North-East
Trades

CUBA

Haiti

JAMAICA

Puerto Rico

Clouds

Antilles

PACIFIC

North-East
Trades

Caribbean Sea

Sub-tropical Convergence

Clouds

Jet Stream

Andes

Amazon
Mouth

Clouds

Equator

Clouds

Principal Point

Equatorial Counter Current (warm)

Galapagos Islands

South America

South Equatorial Current (warm)

afternoon
cloud cover

Sun's course (diagrammatic)
on 25th. January (Zenith)

Humboldt Current (cold)
South-East
Trades

Sun at Zenith

South Atlantic
H

Clouds

South-East Trades

Clouds

South Pacific

H

Gran
Chaco

Cordillera

OCEAN

Clouds

Clouds

L

West Wind Drift (cold)

Lee side of
East Pacific
West Wind Drift

L

L

L

South Pole

H =High pressure area **L** =Low pressure area

North and South America, connected by the central American land-bridge, can clearly be seen in their contours on the right-hand half of the hemisphere shown in this photograph. Especially the desert areas are without cloud cover and show striking shades of brown and yellow. In the right-hand half of the picture covered by the sea, the enormous dimensions of the Pacific Ocean, of which only about one-half is shown can be imagined. This picture was taken by a 'Technology Satellite' ATS 1 as were pictures 1 and 2. The principal point of the satellite photograph is now a different point on the earth's surface, namely above the Pacific Ocean, slightly west of the Galapagos Islands. Only three ATS satellites are necessary to cover the whole of the earth's surface at the same time. The picture was transmitted from the satellite and was received on the earth after electronic scanning of the colours red, green and blue (a different film of a multispectral camera for each colour). It shows very clearly a pattern of stripes especially over the Pacific Ocean in the centre of the picture. This is due to the linear scanning by electronic rays. An amazing degree of detail is achieved in those areas of the Pacific coast of Central America, which at this time of year have no clouds. The same is true for parts of Western and Central Mexico. In Mexico and along the Pacific coast it is the dry season (November to April).

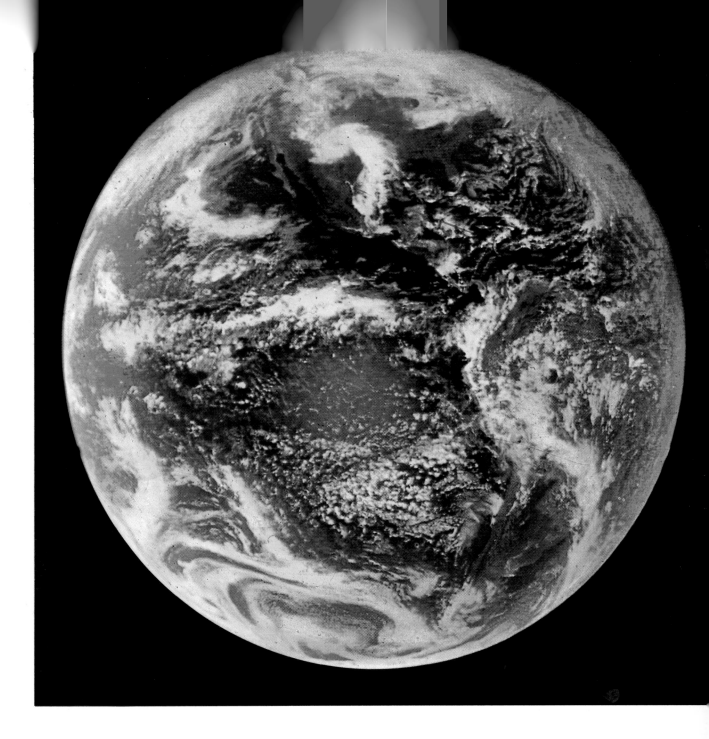

The Western Sierra Madre, the depression of the Rio Balsas and the Southern Sierra Madre can be seen. These two mountain ranges of Mexico stand out in dark colours against the surrounding country.

The peninsula of Lower California, part of a continental block, which was separated from the American continent through a fault line, juts out 1,300km into the Pacific Ocean. In the southern extension of the Gulf of California, which as a narrow long bay separates the peninsula from the mainland, there is an oceanic deep that runs along the Pacific coast of the American continent. North and South America along the entire Pacific coast were pushed up against the Pacific basin and the mountain range of the Andes created. The individual ranges in most of Central and South America are covered by cloud and are therefore not visible. Only in the desert region of Northern Chile and Mexico are the chains of mountains marked by different colours and can thus be distinguished from one another. The line of this movement, along which parts of the continental crust were moved westwards, dips down beneath the continent and is continued deep in the mantle of the earth. Here enormous masses of volcanic material were pushed up out of the mantle. The result is the chain of volcanoes and lava flows known as the 'Circum-Pacific

Vulcanism'. The transport of masses of material in the peripheral mountain regions of the continent was balanced by a reduction of mass in the Pacific which resulted in a deep trench in the sea bed all along the coast. Between the individual continental blocks, counter currents (in an easterly direction) were formed in the earth's mantle material (on which the continents, being part of the earth crust, float). The form of the Antilles system, which juts out far towards the east in the Caribbean Sea between North and South America, as well as the similar system between South America and the Antarctic is the result of these currents (pages 53–6).

The atmospheric circulation of the earth, as described in picture 2, is strongly influenced near the surface by the pattern of mountains and the distribution of land and sea. On the surface these regular movements of air masses are reflected in various climatic zones. Due to the air streams and thus to the differential precipitation we find rainfall regions on the earth, characterised by different vegetation types.

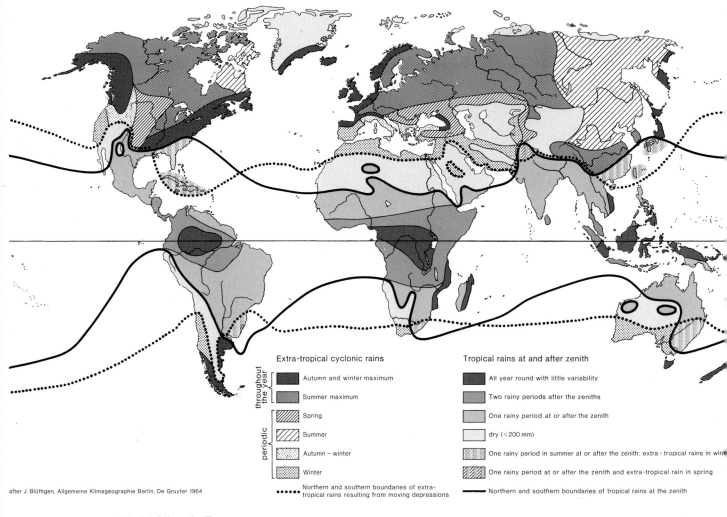

after J. Blüthgen, Allgemeine Klimageographie Berlin, De Gruyter 1964

World Climatic Zones

The equatorial zone with its very high precipitation throughout the year, changes both to the north and the south to zones with either one or two rainy seasons which occur while the sun is at its highest or immediately afterwards. The dry regions of the desert belts, which follow, are largely dependent on the distribution of land and sea and on warm and cold ocean currents. Following this there is a wide strip of irregular temperate and sub-polar zones. The polar regions again form a self-contained climatic complex.

Around the Gulf of Mexico and the Caribbean Sea, these clouds, caused by land and mountains, point to the position of the Great Antilles in the West Indies. The cloud formations are caused by the trade winds blowing from the north-east. Over South America, where on 25 January the sun is at its zenith above the latitude of roughly 18°, we find clouds that at this time of year bring rain, usually in the afternoon. The Amazon with its numerous channels can clearly be recognised. The tropical vegetation near the Amazon mouth and the Chaco appears as an intense blue-green.

The desert landscape of Pacific South America, that is South Peru and North Chile, is free of clouds. It reaches over the Andes eastwards, where the dry region of Argentina, the 'Pampa Seca', lies. This self-contained dry region is due to the cold Humboldt Current, which runs close to the coast. Along the outer edges of the picture the clouds appear very distorted. In the south polar region it is still the period of the midnight sun.

The cloud formations over the Pacific Ocean give an excellent picture of the atmospheric circulation which prevails at this time of the year. Strips of very thin and weak clouds mark the borders of the Southern Equatorial Current and the Equatorial Counter Current. The loose cumulus clouds south of the centre of the picture characterise the area of the South Pacific high pressure area. The south-easterly trade winds are marked by the strip of clouds in the left-hand bottom quarter of the hemisphere. Several cyclones and the strong west wind drift in the southern Pacific stand out clearly. Southern Chile and the area around Cape Horn, which lie within this west wind drift, are hidden under a dense cover of clouds. This cover of clouds opens up very rarely. With strong west winds blowing throughout the year these are the areas where the highest amount of precipitation occurs in the whole world. The double cloud band, in part clearly marked, reaching from the Pacific Ocean over Central America to the Caribbean Sea might possibly be a 'jet-stream' (picture 3, page 34). In the northern hemisphere several curved cloud bands can be recognised. They show the distribution of high pressure areas (free of clouds) and low pressure areas (covered by cloud). At the time the picture was taken there was a high pressure area over Mexico and California which is characteristic of this time of year. Another high pressure area lies over the central part of North America, which leaves large areas of the Mississippi valley, the east coast with Florida up to the North American Lake Plateau, free of cloud.

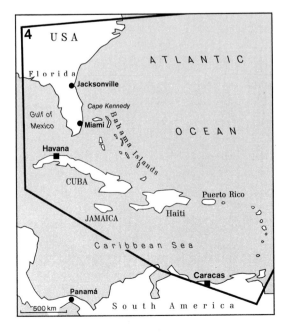

4 A cyclone north of the Caribbean Sea

NASA-Photo: SCI-3031, Apollo VIII
Exposure: F. Borman, J. Lovell, B. Anders
Date: 21.12.1968
Camera: Hasselblad 500 C
Lens: Zeiss Planar 80mm
Film: Kodak SO 217 (Ektachrome MS)
Altitude of exposure: >4,750km
Axis: strongly inclined towards west
Scale: >1:10,000,000 in the area of the Caribbean Sea
Area covered: >15,000,000km²

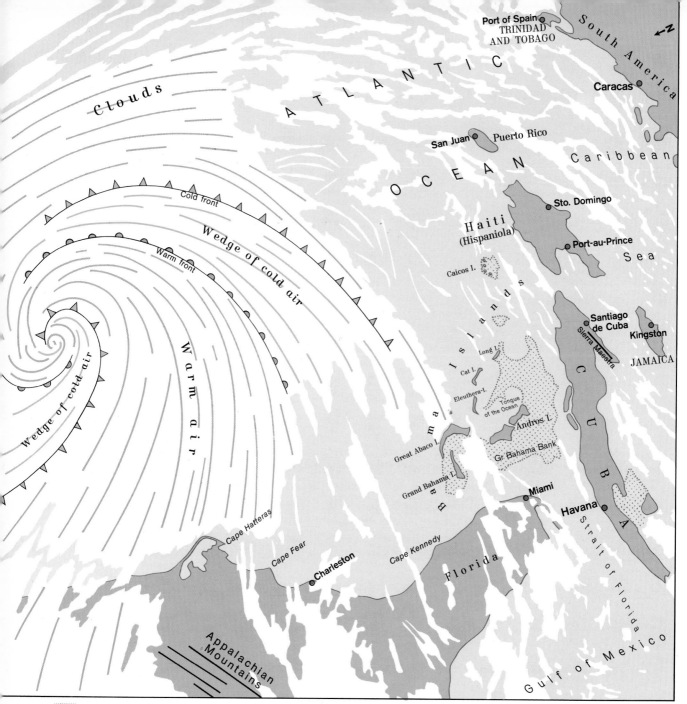

Port of Spain
TRINIDAD
AND TOBAGO

South America

Caracas

ATLANTIC

Clouds

OCEAN

Caribbean

San Juan○ Puerto Rico

Haiti
(Hispaniola)

Sto. Domingo

Port-au-Prince

Sea

Caicos I.

Cold front

Wedge of cold air

Warm front

Santiago
de Cuba

Kingston

JAMAICA

Long I.

Sierra Maestra

Cat I.

Islands

Warm air

Eleuthera-I.

Tongue
of the Ocean

Andros I.

C
U
B
A

Wedge of cold air

Great Abaco I.

Gr. Bahama Bank

Grand Bahama I.

B
a
h
a
m
a
s

Miami

Havana○

Cape Hatteras

Cape Fear

Cape Kennedy

Charleston

Strait of Florida

Florida

Appalachian
Mountains

Gulf of Mexico

░░░ Shallow water

The crew of Apollo VIII were able to take this picture while on their way to the moon, shortly after they left their earth orbit. The cloud whirl of a low pressure area, a cyclone of enormous size off the east coast of the United States, is dominant in the picture. South of it, the Bahamas bank appears as light coloured shallows and the islands of the Caribbean as dark spots – partly covered by cumulus clouds. The east coast of the United States and Florida can be seen in the rising light of the morning. As the earth's surface is curved and disappears eastwards the north coast of South America with the mouth of the Orinoco and Venezuela appear as strongly distorted strips in the right-hand top corner of the picture.

In the area of the Caribbean Sea the islands of Puerto Rico, Haiti, Jamaica, Cuba and the Bahamas are clearly recognisable. The line of the Antilles chain between Puerto Rico and Trinidad is marked by banks of cloud. Over Cuba the shape of the entire island is outlined by an accumulation of fleecy clouds. The mountain chain of the Sierra Maestra in the eastern part of the island is marked by a narrow strip of clouds. Near the Bahamas it is not so much the islands themselves that can be recognised, but the areas of shallow water of the well-known

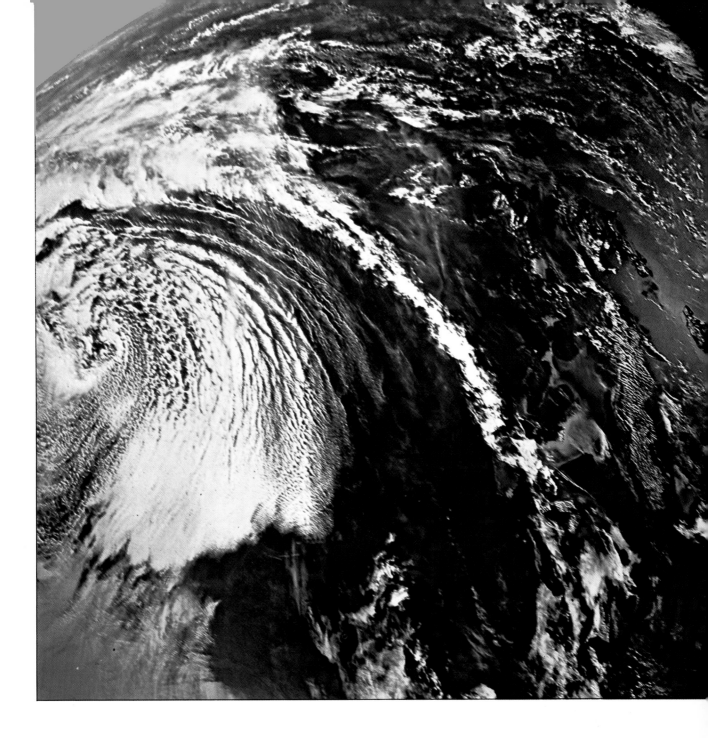

Bahama Bank, which appear in a light-blue and visibly contrast with the deep or blue-black of the Atlantic Ocean. The greatly distorted coastal area of South America near the right-hand edge of the picture shows the Gulf of Venezuela. East of this lies that branch of the South American Cordillera which ends here, on the edge of which Caracas is situated as a cloud-free area. Further east the mouth of the Orinoco with the island of Trinidad lying off-shore can be recognised by the distribution of the clouds and their contours.

The same applies to the island chain of the Antilles, which can be traced from Venezuela via Curacao to Puerto Rico. Florida, the east coast of the United States and the coastline of the Gulf of Mexico are situated in the increasing light of dawn and can be made out only vaguely.

The most striking feature of this picture is the giant cyclone (low pressure area) off the east coast of the United States. Its diameter measures over 1,500km. The centre of this whirl of air masses lies several kilometres north of the Bermudas, which are themselves hidden under the cover of clouds. The individual cloud spirals correspond to different zones of such a cyclone. Those cloud spirals which reflect white and are very dense represent the cold air zone. The dense

cloud in the warm air is caused by the higher moisture content of the air and its tendency to rise more slowly at medium height. This whirling movement of a low pressure area tends to create a stabilisation of the atmosphere with warm air in the upper regions and with cold air lower down. Accordingly in the cold air we find downward movement with a tendency for the clouds to break up.

The whirling of the air masses in a low pressure area (cyclone) takes place as follows. In a low pressure area the air masses stream into a vortex, in the northern hemisphere this happens in an anti-clockwise direction, while they leave a high pressure area (anti-cyclone) in a clockwise direction. As a low pressure area forms at the border between warm and cold air, in its circulation we have a warm and a cold front. These fronts move with the wind system of the cyclone and rotate around the centre of the low pressure area. In this process the cold front eventually catches up the warm front, and through the combination of the warm and cold fronts a new front of the cyclone is formed. Starting near the centre it grows towards the edge of the cyclone with the warm air sector constantly decreasing.

These conditions apply especially to the air strata near the surface, the circulation of which is greatly influenced by the friction of the earth's surface. The warm air along a warm front can only slowly push back the cold air that lies in front of it. As a lighter air mass it glides over the cold air escaping upwards. As opposed to the warm air the cold air and its front moving forward along the surface is accelerated due to its greater weight. Thus an 'occlusion' occurs, a union between a warm and a cold front. After about one rotation the contrasts of the lower strata are evened out to such an extent that a front is hardly recognisable. In the higher strata, between two and five kilometres, where there is no friction, it has not yet been possible to make similar observations to explain the course of the fronts. In this case the satellite pictures provide very valuable help. (Partly taken from: G. Roediger, Seewetteramt, Deutscher Wetterdienst.) The spiral-shaped arrangement of the fronts is intensified by the fact that the air near the centre of the low pressure area whirls round relatively faster than along the periphery. One rotation in the centre corresponds to less than a tenth part of one rotation on the periphery.

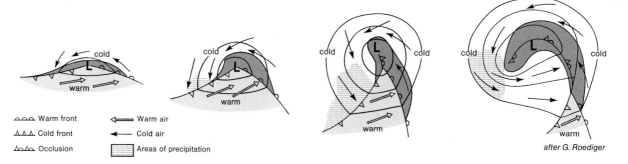

The circulation of air masses in a northern-hemisphere cyclone

The general circulation of the atmosphere (after H. Flohn).

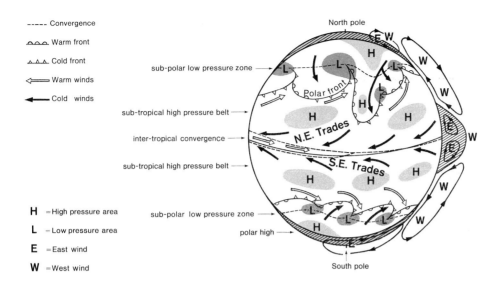

- - - - - Convergence
Warm front
Cold front
Warm winds
Cold winds

North pole

sub-polar low pressure zone
Polar front
sub-tropical high pressure belt
inter-tropical convergence
sub-tropical high pressure belt
sub-polar low pressure zone
polar high

N.E. Trades
S.E. Trades

South pole

H = High pressure area
L = Low pressure area
E = East wind
W = West wind

The distribution of individual cones and wind directions are shown in plan and N-S profile (right). The letters in the meridional profile show the horizontal components of the winds. In the plan, the N-S transfer of masses in the northern sub-polar low pressure area is shown, as well as the E-W transfer in the southern sub-polar low pressure area.

Satellites in meteorological research and weather forecasting

A scientifically based weather forecast depends essentially on a knowledge of the atmospheric conditions that exist at a certain time. Observations made by means of satellites have become a great help during recent years in obtaining knowledge about weather phenomena. The network of weather stations that has been used so far is incomplete and irregularly arranged; it only covers about 20 per cent of the earth's surface. Satellites produce observations for all areas of the earth. They can of course only transmit or measure what they see, they cannot give a weather forecast. Through their pictures they tell us for instance something about the cloud cover, measurements of certain types of radiation on the earth surface, measurements of temperature, snow covering, dust storms and other phenomena. Satellites have proved very useful in forecasting tropical cyclones, notably hurricanes. With the help of satellites the United States has developed an early-warning system, which lessens the danger that occurs annually when these cyclones threaten to cause disaster along America's southern coast (and at a speed of roughly 28,000km per hour). Weather satellites move around the earth at heights of 1,000 and 1,400km. Their cameras cover up to 6,000,000sq km of the earth's surface or the cloud cover, in one picture. As the photographs have to be precise in spite of the high speed of the satellites, the exposure for one photograph is less than a 50th of a second. The pictures are divided up into lines by electrically controlled sensor rays. These strips or lines are later transmitted to the earth by the satellites. Therefore pictures taken from weather satellites do not have the same quality as real photographs, which are taken by astronauts with cameras and brought back to the earth. Direct pictures taken by astronauts are more or less 'snapshots'. On the other hand unmanned satellites produce complete series of pictures over a period of several years. Thus phenomena like changes in cloud formations which happen on a micro-time level as it were, can be registered, as well as seasonal changes, eg the amount of ice on the oceans.

Between 1960 and 1965 ten satellites of the TIROS series were launched (TIROS = Television and Infra-Red Observation Satellite). Except for the pictures by TIROS 8 the photographs of this series could only be received by certain ground stations in the USA, when the satellites were actually flying over these stations.

The so-called TIROS satellites are all equipped with two camera systems of different focal length. With their wide-angle system they can cover areas of 1.27 million sq km of the earth's surface, and with a tele-system can enlarge certain areas at the same time.

Much has been written about the complicated structure of these satellites, the size of which can be measured in a few metres or less and which are packed full of electronics.

The TIROS satellites were launched from Cape Kennedy in a direction such that their elliptical orbits at night formed an angle of between 50° and 60° with the earth's equatorial plane. With such orbits one could observe weather conditions between 65° north and 65° south. The satellites circle around the earth about fourteen times a day. In these TIROS types the axes of the cameras were firmly built into the satellites. In newer weather satellites this disadvantage, which can produce oblique pictures and strong distortions, is avoided. Instead the camera axes are controlled and always automatically set vertical to the earth's surface.

The latest weather satellites of the TIROS 8 type onwards – launched in December 1963 – have an Automatic Picture Transmission (APT) system, on board. This APT system makes it possible for a complete set of information to be received by the ground stations of any interested weather centre. More than 500 receiving stations in more than 50 countries have been able to receive observations and pictures from satellites since the introduction of the APT system, as long as the satellite is within range of their aerials. When the satellite signals are assembled into 500 line pictures the result is similar in quality to domestic television pictures (European television pictures have 625 lines).

Newer satellites are the Nimbus and ESSA series. These have been launched in such a manner that their orbits around the earth go over the poles. They move synchronously with the sun. This means that the orbital angle of these space craft rotates at the same speed from east to

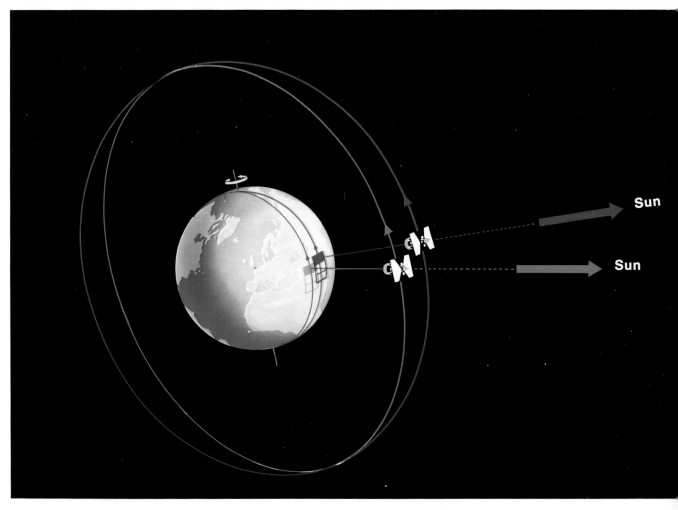

above:
On the day-side of the earth the air-photographs are taken by a television camera. The conditions are at their best when the satellite moves in an orbit synchronous with the sun, that means, when its orbital plane moves at the same speed as the apparent speed of the sun from east to west. (The first orbit is marked in red, the second in blue)

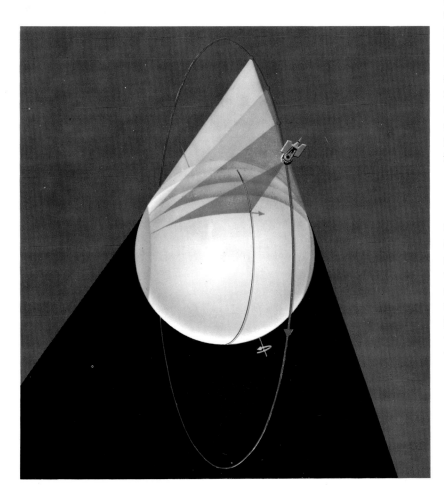

left:
On the night-side the photographic system for infra-red pictures is switched on. A rotating mirror scans the earth and space in lines. Along the edges of the area taken by this method, the pictures are very distorted. Only in parts of the area right and left of the red line on the earth does one get very precise photographs

Taken from *Bild Der Wissenschaft*, (1968) page 757
Reproduction by kind permission of the publishers
After Kaminski

43

west as the sun appears to do. Thus the satellite flies over every succeeding strip of the earth at noon. On the night-side it covers that strip of the earth which is directly opposite the day-side. Thus on the day-side, the satellite always operates under optimum conditions for picture taking.

In the day-area the satellite takes photographs with a plate that is sensitive to visible light. The area covered measures 2,450 by 2,450km. The precision is of such a high degree that places lying at a distance of only three kilometres from each other on the earth can still be recognised.

While these satellites fly over the night-areas of the earth the day-camera is switched off and the infra-red system automatically put into action. In this process the camera does not produce and store a whole picture, then record it line by line and transmit it. In fact, the earth's surface is reflected by a mirror set at an angle of 45° which rotates around an axis that is parallel to the satellite's direction of motion. The infra-red picture is therefore produced in a continuous photographic process. At the centre of these photographs it is possible to distinguish objects or areas lying more than ten kilometres from each other. This infra-red system measures the infra-red radiation coming from clouds, water and land, chains of mountains and regions of vegetation. The result is a picture of different radiation temperatures. By means of efficient gauging and measuring systems the pattern of different radiations is printed into a picture which distinguishes between the contours of continents, different types of rock, ocean currents – cold or warm – as well as clouds. The pictures (6a and 6b) shown here of the European weather situation were received by the APT station of the German Meteorological Office. From the satellite-type ESSA, for instance, the German ground stations can receive 12 pictures a day, which – put together – make up the published weather picture. For special purposes the weather pictures produced by the normal camera and those taken by the infra-red systems are co-ordinated and used together.

By combining the day and night photographs of the weather satellites Nimbus 2 and ESSA 2 the total development of cyclones can be observed. The infra-red night pictures show, as opposed to the daylight pictures, the temperature conditions in the cyclones. Cold and warm air cloud areas as well as the edges of the air masses can be clearly seen. The warming up process near polar cold air over the ocean and vertical movements of clouds can be interpreted. The Soviet Union also uses weather satellites. The first three transmitted photographs and infra-red pictures to the earth from a height of 625km. These were Kosmos 122, 144 and 156, and were launched on 25 June 1966, 28 February 1967 and 27 April 1967. They were followed by a series of operational meteorological satellites in the Meteor Series.

5 Meteorological satellite picture of the northern hemisphere

USIS-Photo: 67–4521, Weather Satellite
ESSA-5
Picture mosaic made up from 12 photo-strips
APT-Photographs
Date: 14.9.1967
Direction of flight: north–south
Average altitude of flight: 1,490km
Interval of exposure: 352 sec
Orbit time: about 2 hours

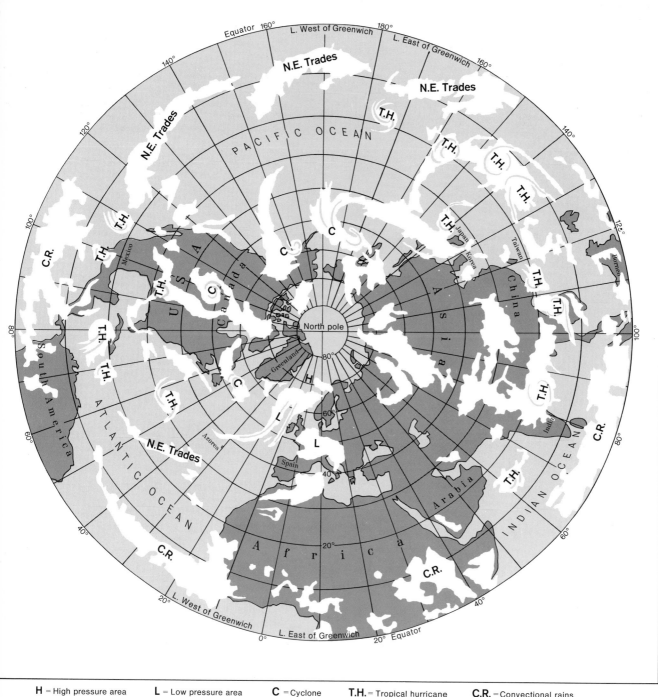

H = High pressure area L = Low pressure area C = Cyclone T.H. = Tropical hurricane C.R. = Convectional rains

Fifteen tropical hurricanes are seen moving around the northern hemisphere of our planet. There is so much energy stored up in them that they could supply the electricity demands of the whole world for six months.

The picture series of the individual rotations of the satellite ESSA 5 on 14 September 1967 – the orbit time was 113.6 minutes, the medium height of its orbit 1,391km above the earth surface – were joined together into a mosaic. The satellite orbit took it over the pole. The pictures were taken (with an orbit time of nearly two hours) over a period of twenty-four hours. The pictures received from the satellite transmitter were compiled by a computer using a polar based projection network. The picture shows the northern hemisphere from the north pole in the centre of the map to the equator along the outer edges. Every ten degrees of longitude and latitude were drawn in. The computer also added to the grid the outlines of the continents.

The weather satellite ESSA 5 was launched on 20 April 1967. Up to 31 March 1968 it had taken 32,200 pictures and transmitted them to earth.

The distribution of clouds shows roughly ten storm centres of tropical hurricanes as white, round patches; they are each about 500km in diameter (marked as 'TH'). Cyclones ('C') of the

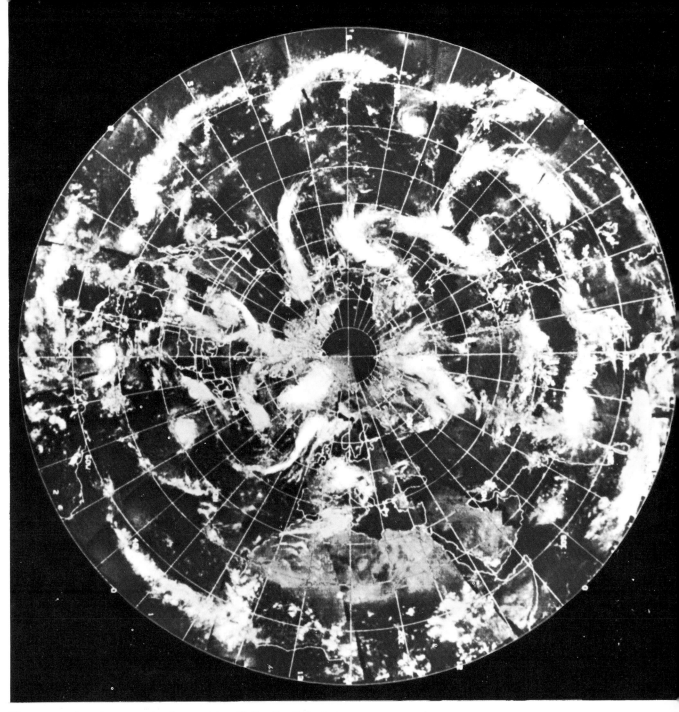

The computer-drawn projection net is elliptically distorted

temperate latitudes as well as low pressure areas ('L') which are already developed can be recognised between the latitudes of 40° and 60° north. In the trade wind area along the southern edge bands of cloud stand out, formed in the north-east trade winds.

Tropical convectional rains, when the sun is at its zenith and the air rises and condenses, are marked by strips of cloud. They occur regionally with a delay of four weeks after the sun is at its highest point.

The continental land areas are partly covered by veils of cloud. The Lesser Antilles (West Indies) and the Azores are hidden under clouds, which shows that the land is far warmer than the surrounding sea.

The white ice cap of Greenland shows up white. In the Northern Arctic Sea ice-fields can be made out. The polar region, which appears partly black in the picture, is not free of cloud and ice. The satellite did not however produce very good pictures of this part.

Of greatest importance in the picture are the tropical hurricanes. Between the latitudes of 10° and 30° a number of circular white patches stand out. These are heavy storm hurricanes, 500 to 600km in diameter. Tropical hurricanes are very conspicuous meteorological phenomena near

the earth's surface and in the atmosphere, occurring usually in late summer and in the autumn over the tropical oceans up to a latitude of about 10°, but not over the equator itself. Here the diversionary power of the earth's rotation is near zero; all differences in pressure that arise are immediately balanced out by winds. Only a few tropical cyclones develop into proper hurricanes. In the case of tropical hurricanes we find a centre of warm air, falling pressure and breaks in the clouds. The 'eye' of the hurricane, which usually has a diameter of 20 to 50km, cannot be recognised in the picture. This area which is almost free of cloud is surrounded by a ring of cloud systems, which reach up to a height of 17km. The central cloud ring has very high wind speeds near the surface (more than 200km per hour). Hurricane-type storms, huge waves and torrential rain cause catastrophic damage and often take thousands of human lives. In the flat and densely populated deltas of the rivers Ganges and Brahmaputra for instance more than 250,000 people died during a tidal wave in 1876, when the water level of the rivers rose by 12 metres.

The spiral-shaped cloud formations have a diameter of up to 300km. Above there is a dense ice cloud layer spread out at a distance of 600–800km from the storm centre. These hurricanes can remain over the tropical oceans for two or three weeks, while they drift westwards at great height and gradually move out towards the Poles; in other words their course is more or less parabola-shaped. In the temperate latitudes cold air masses gradually change the warm cyclone into extra-tropical cyclones with a warm and a cold front.

Research by the hurricane research centre of the US Weather Bureau in Miami (Florida) developed new knowledge about the mechanism of storm development. The hurricanes are named alphabetically according to the chronological order in which they occur, for instance 'Beulah', 'Chloe', 'Doria', etc. Due to the immense speed of 50 to 100 metres per second (that is 180 to 360km per hour) the ocean surface is whipped up by the storm. Hurricane 'Beulah', which was roaring over the Caribbean Sea when the picture was taken, did enormous damage in North Mexico and in Texas. This hurricane, which at times reached speeds of up to 260km per hour, eventually calmed down after two weeks, after causing devastation on both sides of the Rio Grande, over an area some 260km long.

The energy set free through condensation in the clouds is only to a small extent changed into the kinetic energy of the wind, the greater part goes into the potential energy of air pressure distribution. A tropical hurricane with its warm centre changes (unlike most extra-tropical cyclones) its heat into work, like a heat engine. The kinetic energy it produces amounts to roughly one hundred thousand million kilowatt hours per day, which is considerably more than the energy produced by man in the whole of the world. On average about sixty fully developed tropical hurricanes occur every year (75 per cent of them in those zones of the northern hemisphere mentioned above).

6 European weather

Photographs from four earth-orbits of a weather satellite have been joined together. At the time this picture was taken (in the early spring) large parts of northern Europe were free of clouds and so the distribution of land, sea and ice is clearly seen. Scandinavia, the Baltic Sea, and the northern Russian lowland are very well defined. One can see on the west coast the narrow incisions of the Sognefjord and the Hardangerfjord, with their very complex forms. North Cape can also be seen clearly – close to the northern-most European town of Hammerfest – as are the fjords, which are kept free of ice by the warm Gulf Stream. The Kola Peninsula and the White Sea are still almost completely covered with snow and ice.

In the Baltic the northern part of the Gulf of Bothnia, the Gulf of Finland and the Bay of Riga lie under a thick covering of ice. In northern Russia the winter snow cover has largely thawed and only the frozen lakes (Ladoga, Onega, Peipus) stand out as white patches.

The remainder of Europe lies under cloud formations. North Africa and the Red Sea can be identified in the picture, but they are unclear because of transmission disturbances between satellite and earth.

At the time the pictures were taken (on 21 March) in early spring, the sun is just coming over the horizon in the Polar areas (it is vertically above the equator at this time). Thus north of latitude 75° N there is a zone of twilight over the Polar region which appears in the picture as an area of dark shadow.

Picture A

Weather Satellite ESSA-8
APT-Photographs
Picture mosaic made up of 4
strips
Date: 21.3.1969
Direction of flight: north–south
Average altitude of flight:
1,420km
Interval of exposure: 352 sec
Orbit time: about 2 hours
(published by the Institute of
Meteorology and Geophysics of
the FU Berlin, Department for
Meteorological Satellite
Research)
Reproduction by kind permis-
sion of the Institute

The most obvious feature of this weather photograph is the spiral of cloud over the Atlantic. This low-pressure system shows all the elements of a mature cyclone with respect to the cloud formation and distribution. At the centre warm (thick banks of stratus clouds) and cold (bands of cumulus) air is mixing together. A layer of higher cirrus cloud fans out towards the east. The cold front of this depression can be followed as far as the Iberian Peninsula as a thick band of cloud. In the extensive area filled with cold air behind the front some secondary cyclones can be seen east of the Azores. The band of cold air can be seen to turn towards the south-west over Spain, whereas to the south-east a warm front has developed. Chaotic cloud formations lie over Germany and the Balkans, their structure gradually degenerating. Also very noticeable is the strip of cloud running in a southerly direction which, dammed up by the island of Crete, disintegrates into separate cumulus clouds with föhn-like heating on the southern side of the island. Over England the cloud pattern is determined by the pattern of landforms, the land-area being outlined by the thick cloud cover. Northern and eastern Europe are under a high-pressure system and have largely cloudless skies; only over the southern part of the Baltic are there thin layers of cloud.

Picture B

Orbit 3482(2) – 14.07 CET

Orbit 3481(3) – 12.18 CET

Orbit 3480(3) – 10.23 CET

Orbit 3479(3) – 08.29 CET

This photograph shows Europe during high summer and so offers a totally different cloud pattern. The enormous ice block of Greenland with its coast frayed by many fjords can be seen on the left-hand side at the top. Along the coast a strip of up to 300km in width is completely cloud-free. A cloud cover over the ocean begins near the southern point of Greenland. The cloud-free area near the island is due to a föhn; this is the result of a downward gliding movement of air (dry) from the inland ice block of Greenland (3,000m). Northern, Central and Western Europe are covered by low pressure cloud centres and their outliers. At the time the picture was taken at least four vast low pressure areas with their typically whirled cyclones can be recognised as a west wind belt. Again light cloud occurs near the areas of cold air and the dense cloud near the warm air streams of the cyclones. The cyclone over North Russia – near the White Sea – stands out very clearly. The warm front runs from the centre of the low pressure area eastwards and ends as a cold front in the adjoining low pressure area of Northern Siberia. The cold front can be followed southwards as far as a whirl above the northern part of the Black Sea. In Western Europe a warm front causes the dense cloud bank, which marks the Pyrenees, along the North Spanish coast and which stretches across the

Weather Satellite ESSA-6
APT-Photographs
Date: 14.8.1968
Direction of flight: north–south
Average altitude of flight: 1,490km
Interval of exposure: 352 sec
Orbit time: about 2 hours
(published by the Institute of Meteorology and Geophysics of the FU Berlin, Department for Meteorological Satellite Research)
Reproduction by kind permission of the Institute

51

Atlantic into the area of the Azores. The higher mountain parts of the Apennines are under a cloud cover which is caused by local thundery low pressure cells in the Mediterranean.

The rest of the Mediterranean, North Africa, South West Asia and Southern Russia are free of clouds. The Caspian Sea, the Red Sea, the Persian Gulf and the Eastern Mediterranean stand out dark grey against the land areas. North of the Persian Gulf and west of the Red Sea the fertile plain of the rivers Tigris and Euphrates as well as the Nile valley and the delta of the Nile stand out in the picture in a dark shade of grey. In the cloud-free deserts and areas of the Mediterranean different types of rock are marked by different shades of grey. Especially old crystalline and volcanic rocks appear in a dark grey or black, for instance east of the Red Sea, and the basalt volcanic areas in central Libya and south of the Syrte (picture 15). In a faded grey we recognise the mountain chains of the Atlas and the Spanish Sierras in the west, as well as the Persian mountain chains north of the Persian Gulf and the Caucasus between the Caspian Sea and the Black Sea. The pattern of the various grey shades in the Sahara are caused by the distribution of sand and rock as well as their structure. The edges of the basin of Mursuch and the Tassili Mountains appear in a medium grey (picture 15). These differences in the light conditions, which depend on the proportion of the light reflected by the earth surface, were also used for geographical and geological interpretation. But the results from these weather pictures are very incomplete and cannot be compared with the opportunities for interpretation offered by the coloured satellite pictures of the manned space flights.

The movements of the earth's crust

Tectonic structures and processes (on the one hand processes that force parts of the crust together, on the other hand expanding movements and faults, trench-shaped fractures, and the drifting apart of large block-like parts of the crust) cannot be explained more clearly than with the help of the perspective of the satellite pictures.

After the first landing on the moon a laser-reflector was set up, which among other things made it possible to define precisely the situation of the continents in relation to each other. By means of such measurements across the oceans it will for the first time be possible to support the hypothesis of continental drift with definite data.

The combination of observations from space with geophysical research about the inner structure of our planet and the comparison with other planets and stars will eventually lead tectonic geology away from mere hypothesis into the area of proved mechanical procedures. Alfred Wegener (born in 1880 in Berlin, meteorologist and geophysicist, missing in Greenland in 1930) was the first scientist to put forward the theory of continental drift. His idea was based on the assumption that the peculiar shape of the eastern coast of South America, including the shelf, matches the west coast of Africa. From that he drew the conclusion that the two continents must have drifted apart. According to his theory the continental blocks, consisting of light crustal material, which float, like icebergs in the water, on the heavier layers lower down in the earth. At one time the continents formed one coherent mass; only later, in the course of millions of years, were they torn apart and drifted away from one another. India and Australia moved away from Africa, forming the Indian Ocean. Both American continents were separated from Europe and Africa, and the Atlantic Ocean was formed. The two oceans gradually grew larger. The Pacific Ocean however is becoming smaller, because along its borders Asia and its off-lying islands (Japan etc) are moving towards the Pacific. The same applies to the continents of America. Along the front of drifting continental blocks mountains are piled up, eg the Cordilleras against the Pacific Ocean. Another mountain system is that of the younger folded mountains, which stretch along from the Alps across the Balkans, the Near East and the Himalayas as far as East India. Unstable parts of the crust of the earth very slowly disappeared between the old continental blocks and were filled up by thousands of metres of sedimentary rock (geosynclines). When such a trough gets pushed together by the continental blocks moving towards one another, it is folded up into a range of mountains. In terms of the human time scale these movements happen incredibly slowly.

The forming of mountain ranges occurred at different times in the course of the earth's history. During the very oldest phases, shortly after the Sidereal period in the Archaeozoic or Pre-Cambrian ages, parts of the crust were welded together so firmly that during later phases of development they reacted as firm consolidated blocks, continental blocks, which in later movements could only move as a whole. Later these 'old shields' were torn apart by the movements of the crust and then drifted away from one another or were pushed together – creating mountains in the process.

For the causes of these movements of the crust we must look into the interior of the earth. The latest geophysical investigations tell us that the earth is divided into layers, which differ from one another in density, plasticity and chemical structure. Starting at the outside, the thin layer of the crust, which is to a large extent missing in the oceanic areas and reaches a thickness of up to 35km on the continents, is followed by the skin of the upper mantle, which is up to 1,000m thick. It consists mainly of basic rock, which comes up to the surface and is deposited as basalt volcanic rock wherever the crust is opened up by faults, structural depressions or fractures. This layer is followed by the lower mantle down to a depth of 2,900km. The upper and lower mantles together are known as the Sima, as opposed to the Sial (crust). It is the lower mantle which is mainly responsible for the reshaping and movement of the crust. The material of the mantle is liable to deformation, and contains thermal currents that balance out the difference in temperature. The warm material rises in the area of the mid-oceanic ridges and moves outwards

underneath the continents, as in the example given towards the Pacific Ocean. There it cools and sinks again. Thus currents called convection cushions are formed, which cause the movements of the crust. The parts of the crust, which compared to the earth's radius form a very thin skin indeed – similar to the skin that forms on milk after boiling – are transported and torn away.

Those layers that follow further inwards, namely the outer and inner earth core, have no influence on the movement and deformation of the crust.

It is not only the shape and the geological structure of the continents and the assumption that their contours and structures formerly belonged together that leads to the idea of continental drift, but also the surface shape and structure of the sea bottom. As mentioned before, on parts of the continents the crust reaches a thickness of more than 30km, whereas on the bottom of the

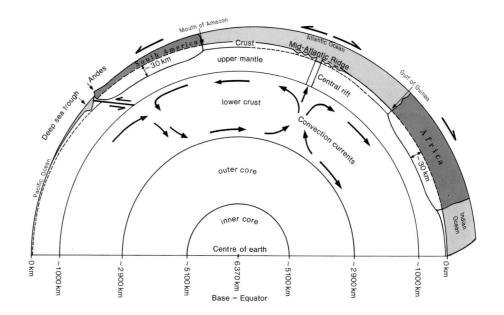

Section through the earth showing the crust (grey) exaggerated in scale

sea it is often completely missing or only a few kilometres thick. In the mid-oceanic ridges we find the youngest activity in this drifting movement which is still active. Here, where the crust is almost completely missing, we are near one of the central dividing trenches. Mantle material is constantly brought upwards which 'heals up' the opening. Thus starting with the inner core and following the layers upwards we recognise a difference in the age of the respective rock, from which conclusions about the extent of the drifting of the continents can be drawn.

In the crust we find signs of old movement that is no longer active as well as younger processes which still have an effect. These trenches of the oceanic ridges or fault-block depressions between parts of the crust as well as the piling up of mountains along the edges of the continents or the folding between continents are young active zones of the earth. They are marked by oceanic deeps, earthquakes and volcanic concentrations.

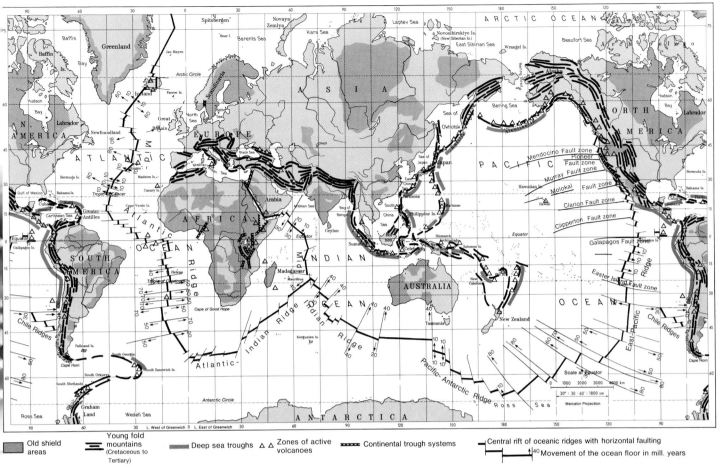

	Old shield areas	$\underset{\equiv}{\equiv}$	Young fold mountains (Cretaceous to Tertiary)		Deep sea troughs	△ △	Zones of active volcanoes	▰▰▰▰	Continental trough systems		Central rift of oceanic ridges with horizontal faulting

↑40 Movement of the ocean floor in mill. years

Tectonic survey map of the earth

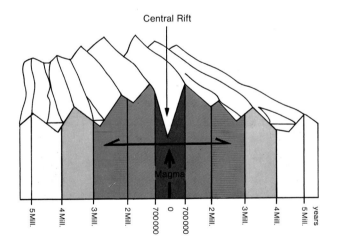

Section through a mid-ocean ridge

The age and amount of movement in a mid-oceanic ridge can be determined through the symmetry of magnetic anomalies in the basalt on either side of a central rift.

55

CHRONOLOGICAL TABLE OF GEOLOGICAL EVENTS AND PERIODS

Era	Age according to Holmes symposium 1964 in mill. years	Period	Mass movements and Continental Drift	Epochs of folding orogenous phases
Caenozoic		Quaternary	Opening of Gulf of California	e.g. Po basin
	0,6	Tertiary	Origin of Iceland Opening of Gulf of Aden and of Red Sea Division of Australia from Antarctica Division of Greenland from Norway	Alpine folding
Mesozoic	65	Cretaceous	Division of New Zealand from Antarctica Division of Africa from India, Australia, New Zealand, South America, and Antarctica	
	135	Jurassic		
	190	Triassic	Origin of South Atlantic	
	225	Permian		Variscian folding
Palaeozoic	280	Carboniferous	Origin of North Atlantic	
	345	Devonian		
	395	Silurian		Caledonian folding
	435	Ordovician		
	500	Cambrian		
	580			
Archeozoic (Pre-Cambrian)		Algonkian		Algomian folding
	1100	Archean		Laurentian folding
	5000		Origin of earth's crust ?	
Stellar time				

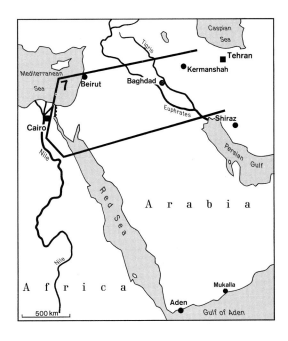

7 Egypt – the Sinai Peninsula – the Near East

NASA-Photo: 66-HC-1701, Gemini XI
Exposure: C. P. Conrad and R. Gordon
Date: 12.9 to 15.9.1966
Camera: Hasselblad SWA
Lens: Zeiss Biogon 38mm
Film: Kodak SO 368 (Ektachrome MS)
Altitude of exposure: about 250km
Axis: strongly inclined towards north-east
Scale: in the centre of the picture roughly
1:2,500,000
Area covered: >500,000km²

Map labels:

Shatt el-Arab
Euphrates
Beirut
Haifa
Lake Tiberias
Jordan
Tel Aviv
Dead Sea
Mediterranean Sea
Wadi Sirhan
Hejaz railway?
Ma'an
Nafud Desert
Ismailia
Suez Canal
Gt. Bitter Lake
Suez
Elat
Aqaba
Gulf of Aqaba
Wadi Araba
Gulf of Suez
Red Sea
Ras Mohammed
Wadi Kena

Legend:

≡ Fault lines
⊥ Strata with direction of dip
⬛ Basement complex
--- Dry valley (Wadi)
▦ Palaeozoic strata
▣ Coral reefs
▢ Desert plateau (Mesozoic-Tertiary)
✕ Volcanic rocks
▒ Salt Lake

The Red Sea – a giant joint in the earth's crust – separates Africa from Asia. At the northern end two long narrow inlets – rather like the feelers of a snail – stretch towards the Mediterranean. Wedged between the two is the Sinai Peninsula. One of the inlets, the Gulf of Suez, is a continuation of the axis of the Red Sea in a north-north-west direction and is 300km long. The north end of the Gulf is separated from the Mediterranean Sea by little more than 100km; since 1869 the two have been connected by the Suez Canal. The other inlet, the Gulf of Aqaba, lies at an angle in a north-north-easterly direction. This gulf, which is 150km long, is part of a fault zone cut in the earth's surface, which stretches further along the Wadi Araba, the Dead Sea and the Jordan valley as far as the valley area between the mountains of the Lebanon and the Anti-Lebanon.

The blue colouring of the south-eastern part of the Mediterranean Sea, the north end of the Red Sea with the two gulfs and the Dead Sea stand out very conspicuously against the grey or light yellow shades of the endless desert areas of the Near East and Egypt. Due to the strong inclination of the camera towards the north-east the area shown is very distorted. The convex shape of the earth's surface makes this effect even worse, so that the contours along the upper edge of the picture are rather indistinct. The Euphrates is just recognisable as a thin dark ribbon and in the right hand upper corner of the picture a darkish strip shows the mouth of the rivers Euphrates and Tigris, the Schatt el-Arab with its vast swamp areas. In the foreground

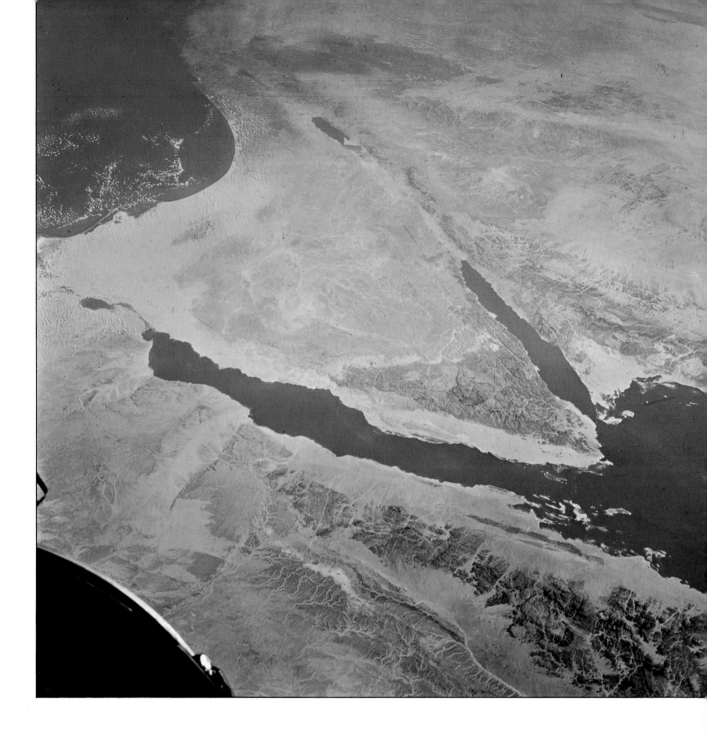

however (the lower half of the picture) distinct contours of the earth's surface can be seen very clearly and allow the observer to study in considerable detail the geological history of these dry desert areas, where no vegetation hides the rock. The different colours and the various shapes of the relief make it possible to differentiate clearly between different types of rock – apart from the large areas covered with sand. Thus along either side of the Red Sea, half way up the Gulf of Aqaba and the Gulf of Suez we find rugged mountain ridges – they appear dark in the picture – some of which reach heights of more than 3,000m. The mountains on the southern part of the Sinai Peninsula have the same shape and colour. All these consist of rock of the rigid Precambrian crust, which forms the bedrock of the vast north African and Arabian landmass. This rock is covered by sedimentary rock which is only deformed to a very small extent, is of great thickness and forms large plateaus with characteristic scarps down to the sand-covered lowlands and valleys.

The Graben of the Red Sea with its two diverging branches, and those of the Jordan and of Suez dominate the picture. Here we have a unique demonstration of expansion processes in the earth's crust and their effects on the shape of the earth's surface. Such expansion leads to a ripping of the crust along its lines of weakness.

Faults are opened up and between them the surface sinks like a wedge; in this way systems of

59

trenches develop. They cover the earth's surface in an extensive network and continue through the crust down to the earth's mantle. The picture shows a classic section of such a Graben system, which in its origin goes back as far as the early Tertiary.

One branch of the trench of the Red Sea can be traced as a straight morphological depression in the continuation of the Gulf of Aqaba through the Red Sea and the Jordan trench as far as the depression which separates the mountains of the Lebanon from the Anti-Lebanon. The course of this trench is marked in the picture not only by the Gulf of Aqaba and the Dead Sea (which lies 392m below sea level) but also by light-coloured sands in the trench area north of the Gulf.

If a Graben develops further, the edges break off in the shape of steps towards the interior. These steps with blocks of material tipped up towards the outside can be seen along the Gulf of Suez as distinct parallel lines both in rock formations as well as in the situation of the islands. If a trench opens up further still, the 'wound' in the earth's crust cannot be closed by parts of the crust that sink in from higher up, but the gaping crack is filled from underneath out of the earth's mantle with volcanic material, as in the basin of the Red Sea.

Along the edge of the Red Sea trench the rock has been lifted. Thus along both sides there are chains of mountains, rising to over 2,000m, dipping away from the Graben formed in the Precambrian crystalline base rock.

Towards the Mediterranean Sea the crystalline material disappears under the younger sedimentary rock. In connection with this arrangement we can explain the lateral wave-like forms of the covering sedimentary plateau, for instance the structure of the Wadi Araba.

The structure of this whole area is dominated by the subsidence of the Red Sea. Apart from the vein-shaped filigree of the dry valleys in the drainage area of the Wadi Kena, in the lower part of the picture, linear elements show distinct symmetrical connections with the Red Sea. Bundles of lines run parallel and cut other lines forming angles with them which appear to be always the same. These lines are given by the course of the coast, the position of the islands and their elongated shape as well as the countless valleys and gorges, which cut into parts of the old base mountains.

In a similar way the main directions of the trench system can, in large areas of the covering sedimentary plateau, be traced as thin lines. On the Arabian Peninsula the Wadi Sirhan is marked as a light-coloured sand strip parallel to the Red Sea. Its origin lies in a fault zone parallel to the Red Sea. In these faults volcanic rock emerged, which as basalt layers – in the upper half of the picture we see them as dark patches – cover extensive areas east of the Jordan.

Due to the enormous distance at which the pictures were taken, towns and settlement areas are not recognisable. The Nile valley, which runs roughly parallel to the Wadi Kena, lies just off the bottom edge of the picture. The course of the Suez Canal (picture 25) can be pinpointed as a bluish-green line and by the Bitter Lake. East of the Gulf of Aqaba a thin light-coloured line probably shows the track of the abandoned Hejaz railway. Shining through in a light blue on the southern point of the Sinai Peninsula and off the Egyptian mainland, one can see coral reefs which partly connect the islands and partly surround them as narrow bands.

The steps of the fault on both sides of the Gulf of Suez have large resources of mineral oil. Egypt is the oldest petroleum country of Africa; while its production is not very extensive, it is consistent. As early as 1886 mineral oil was delivered from the tertiary oil reservoirs in the fault scarps near the southern end of the Gulf of Suez. Oil fields are located on both sides of the whole length of the Gulf. Some resources are found in the shallow sea off the coast. The output amounts to less than 10 million tons a year and is therefore considerably less than that of the other Arabian states.

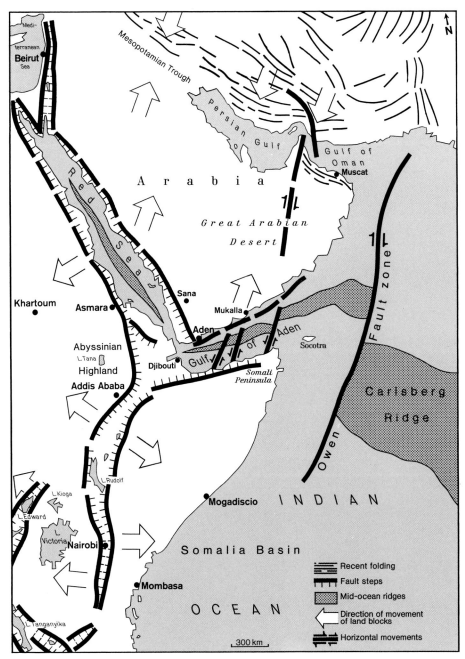

Outline of structure - East Africa and Arabia

Legend on map:
- Recent folding
- Fault steps
- Mid-ocean ridges
- Direction of movement of land blocks
- Horizontal movements

300 km

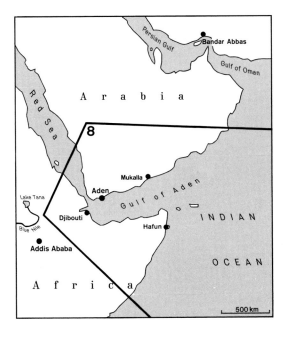

8 The Gulf of Aden

NASA-Photo: SCI-1458, Gemini XI
Exposure: C. P. Conrad and R. Gordon
Date: 12 to 15.9.1966
Camera: Hasselblad SWA
Lens: Zeiss Biogon 38mm
Film: Kodak SO 368 (Ektachrome MS)
Altitude of exposure: about 850km
Axis: inclined towards east, therefore the upper edge of the picture distorted
Scale: in the area of the Gulf of Aden roughly 1:3,500,000
Area covered: 2,000,000km²

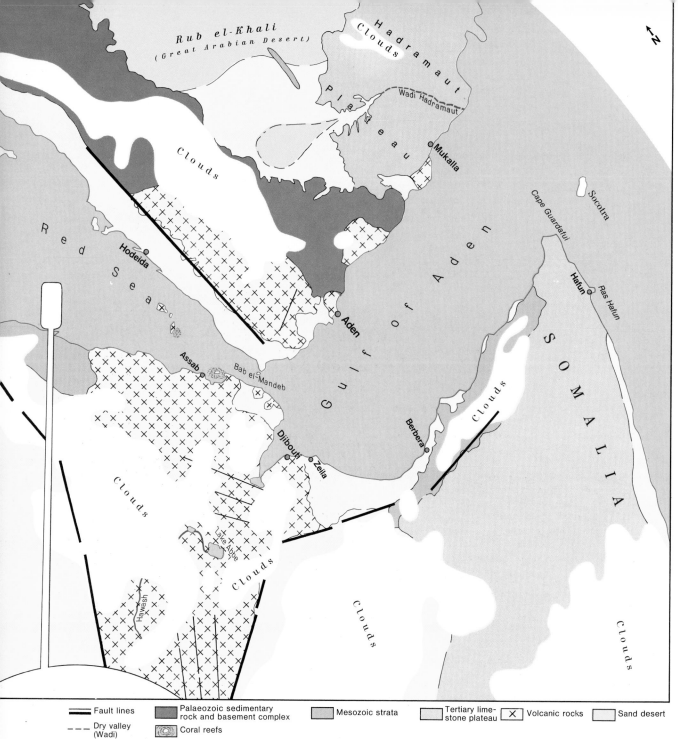

Rub el-Khali
(Great Arabian Desert)

Hadramaut

Clouds

Clouds

Wadi Hadramaut

Plateau

Mukalla

Clouds

Cape Guardafui

Socotra

Red Sea

Hodeida

Gulf of Aden

Hafun
Ras Hafun

Aden

SOMALIA

Assab

Bab el-Mandeb

Clouds

Berbera

Clouds

Djibouti
Zella

Clouds

Lake Abbe

Clouds

Hawash

Clouds

Clouds

▬ Fault lines	▨ Palaeozoic sedimentary rock and basement complex	▨ Mesozoic strata	▨ Tertiary lime-stone plateau	☒ Volcanic rocks	▨ Sand desert
--- Dry valley (Wadi)	◎ Coral reefs				

Roughly 200 million years ago Africa and Arabia were one single continental block. About the beginning of the Mesozoic the parts were separated. This process reached its climax in the tertiary, but it is still active now. The trench, which became wider and wider all the time, was filled with water; thus the Red Sea and the Gulf of Aden were formed.

Satellite pictures like this one, taken from a height of 850km, demonstrate much better than a topographical map Wegener's theory of 'continental drift'. In the north one can recognise the Arabian peninsula, separated from Africa (Abyssinia and Somalia) by the Red Sea, in the centre-left the Straits of Bab el-Mandeb (Gate of Tears), and on the right-hand side the Gulf of Aden, which opens (in the top right-hand corner) towards the Indian Ocean. The sudden change of colour, with space appearing completely black in the picture, demonstrates spectacularly the convex shape of the earth's surface. In Africa, the most easterly point, Cape Guardafui, stands out clearly. A short distance from the cape we see the peninsula of Ras Hafun, which is connected to the continent by a sand bar.

Parts of Somalia as well as the Abyssinian plateau are largely covered by clouds. On the Arabian side the highland of the Yemen, which reaches heights of up to 3,000m, is also hidden under a cover of clouds. Towards the inner parts of Arabia the clouds are dispersed; the southern end of the 'empty quarter' of Rub el-Khali can be recognised as can the plateau of Hadramaut

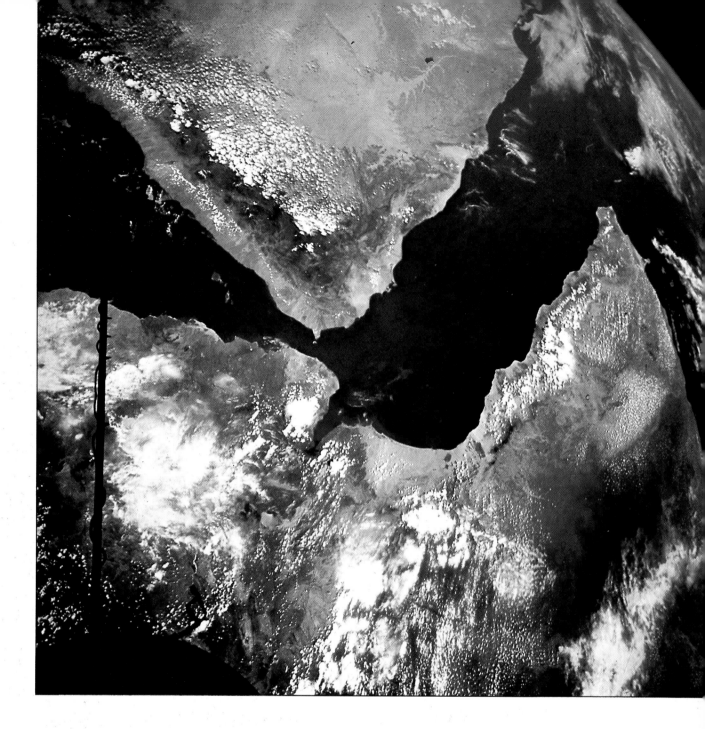

with the valley of Hadramaut (picture 9), which opens as a funnel towards the central Arabian desert. On the coast the harbour town of Aden stands out (east of Bab el-Mandeb) through the two spits that jut out into the sea and enclose the natural harbour. The islands in the Red Sea, surrounded by coral reefs, can be seen in great detail. The islands situated off Cape Guardafui with Socotra are hidden under a cumulus cloud, shaped like the islands themselves. The red and yellow coloured deserts of central Arabia and the like-coloured quasi-deserts of Somalia strike the observer as special phenomena of this landscape. The chains of mountains, which stretch along the Red Sea and the Gulf of Aden with their summits of 3,000m, show different colours due to their differentiated rock structure. The areas of strong precipitation and therefore dense vegetation in the highlands of the Yemen and of Abyssinia on either side of the Red Sea are only partly recognisable in the picture, as they are to a large extent under a cloud-cover.

Geologically this picture shows the drifting apart of the continental blocks. Through shattering and tearing of the earth's crust the trench of the Red Sea was formed, which separates Africa from the Arabian Peninsula. The part of this structure shown here is called the Afro-Asian 'Graben Star'; it is recognisable from its pointed shape, formed by the Red Sea and the Gulf of Aden. One branch of this star-shape cuts into the African continent and can be traced from the Rift Valley of Abyssinia (cloud cover) via Kenya and Tanzania as far as Rhodesia.

The other branch, the Gulf of Aden, can be traced as far as the submarine Owen ridge in the Indian Ocean. The contours of the African and Arabian coastlines along the Gulf of Aden show how Africa and Asia once belonged together.

The movements take place over incredibly long periods of time. The material of the earth's mantle, on which the crust floats, is to a certain extent pliable, and through the exchange of heat, currents occur, which with their movement tear the crust open in certain fault areas and pull parts of the crust down. To start with trenches are formed (picture 7). If the openings develop and become wider and deeper, material from the earth's mantle moves up. In the central zone trenches are formed again and again, and these are afterwards filled up. In the case of the trench of the Red Sea for instance, there are old parallel faults along the edges, whereas in the centre the trench has only recently been opened up and in fact is still active – this is the case in the narrow oceanic deep in the central area of the Red Sea which is over 2,000m in depth.

Along the fault-lines volcanic material emerges. Witness to this process on the earth's surface are the numerous volcanoes (3,000m high) in the highlands of Abyssinia and the Yemen (in the picture they appear black). At the bottom of the sea geophysical measurements in the different types of rock show that the age of the rock increases the nearer it is to the surface; through this the age of the drift can be reconstructed.

Arabia moved away from Africa in a north-easterly direction. In this process a horizontal shifting of different blocks against each other took place along the edge of the mantle.

These lateral movements can still be morphologically recognised in the relief of the Gulf of Aden, where they appear as oceanic deeps of up to 5,000m. One might even assume that they are continued under the consolidated block of Arabia in the form of the recently folded chains of the Zagros Mountains and the Upland of Oman on either side of the Persian Gulf. Along the faulted depressions, the continental blocks are pressed upwards and then dip away towards the interior of the continent. Thus the old crystalline rock forms those mountains, which run along either side of the faulted depressions. On the Arabian Peninsula they can be recognised as a dark grey zone. Towards the interior of the country the geological formations become younger and younger. The rock disappears under the endless dunes (yellow-red) of the Rub el-Khali in Arabia (upper edge of the picture) and under the young sediments in Somalia, which are covered by brownish-red steppe vegetation.

The settled areas all lie in the highlands of Abyssinia and the Yemen, the relief and geological structure of which stand out clearly against the deserts and semi-deserts. They are areas of heavy precipitation (rainy season in the summer) and therefore rich vegetation. In these regions civilisation was able to develop in ancient times.

The largest part of the African area is taken up by Ethiopia, whose civilisation is over 2,000 years old. The dense settlement is concentrated on the volcanic highland of central Abyssinia. The vegetation can be recognised from the black and green colours, some rivers can be made out despite the dense cloud cover.

A large part of Somalia, which is the wide coastal zone along the Gulf of Aden and the Indian Ocean, is shown in this picture. The south is to a large extent a dry savanna with patches of dense forest, where nomads graze their sheep and camels. Along the north coast the area is a semi-desert, which further southwards in the mountains gradually changes into xerophytic forest. The barren semi-desert of the Peninsula of Somalia shows as a brownish-red burnt colour in the satellite picture. The main settlements lie along the coast and some towns like Zeila, Berbera and Hafun can be recognised in the picture.

The state of Somalia was formed in 1960, a union between the two colonies of British Somalia and Italian Somalia. Towards the north along the bay, which cuts deep into Africa and is recognisable in the picture, there is French Somalia (today the French territory of the Afars and Issas).

Our picture covers two areas of political unrest on the Arabian Peninsula, namely the Yemen and the Peoples' Republic of South Yemen. Here, too, the volcanic region of the Yemen is the main settled area. The Yemen, which together with Hadramaut was called 'Arabia felix' ('happy Arabia'), has an intensive oasis agriculture. On the slopes near the Red Sea coffee, and also cotton, maize and tropical fruit are grown. The rest of the country is either complete desert and uninhabited like the Rub el-Khali or desolate mountain desert and coastal area.

9 The Plateau of Hadramaut in Southern Arabia

NASA-Photo: Gemini IV
Exposure: J. McDivitt and E. H. White
Date: 3.6 to 7.6.1965
Camera: Hasselblad 500 C
Lens: Zeiss Planar 80mm
Film: Kodak SO 217 (Ektachrome MS)
Altitude of exposure: about 200km
Axis: is strongly inclined towards south-east,
therefore the background of the picture is
very distorted
Area covered in the Hadramaut Plateau:
about 60,000km²

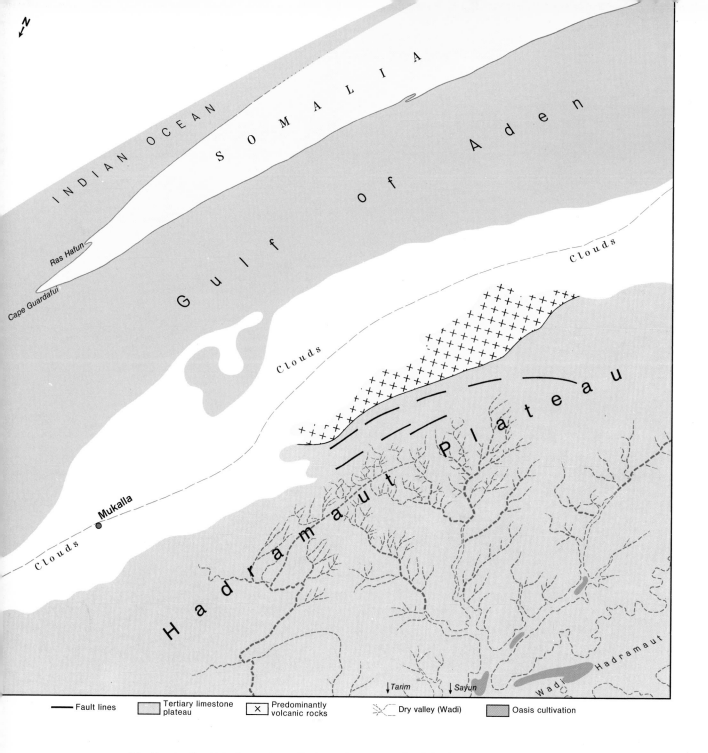

INDIAN OCEAN

SOMALIA

Ras Hafun

Cape Guardafui

Gulf of Aden

Clouds

Clouds

Clouds

Clouds

Mukalla

Hadramaut Plateau

↓Tarim ↓Sayun

Wadi

Hadramaut

Hadramaut

—— Fault lines Tertiary limestone plateau ☒ Predominantly volcanic rocks Dry valley (Wadi) Oasis cultivation

Similar to the thin branches of a tree the network of the Wadis cuts deep into the thousands of square kilometres of the enormous limestone plateau of southern Arabia. The blue and grey limestone rocks stand out in clear contrast against the yellow valley floors filled with sand.

The view of this strongly inclined picture is directed towards the south-east. The foreground shows the Hadramaut Plateau (lower half) along the southern edge of the Arabian Peninsula. The coastline is very cloudy. Only towards the open sea in the Gulf of Aden does the cloud cover disperse. In the haze on the other side of the Gulf (due to the convex shape of the earth's surface it is distorted to a narrow strip) Somalia; the triangle jutting out from Africa, and Cape Guardafui are recognisable. The horizon becomes indistinct over the vast expanse of the Indian Ocean. As a narrow blue strip against the blackness of space the thin layer of our atmosphere stands out.

The Hadramaut Plateau is an almost horizontal, very thick tertiary limestone plateau which is flattened out towards the north-east and dips underneath the endless sand-dunes of the Rub el-Khali (empty quarter) in the centre of South Arabia. Near the coast this limestone plateau falls away in bundles of parallel faults. Steplike going down to the sea these fault scarps are part of the great fault zone along the edges of the extensive triangular Graben of Aden. Along this fault line the Hadramaut Plateau is elevated (picture 8). The limestone plateau which on aver-

age has a height of 1,200m, here reaches summits of over 2,500m. Along these faults on the

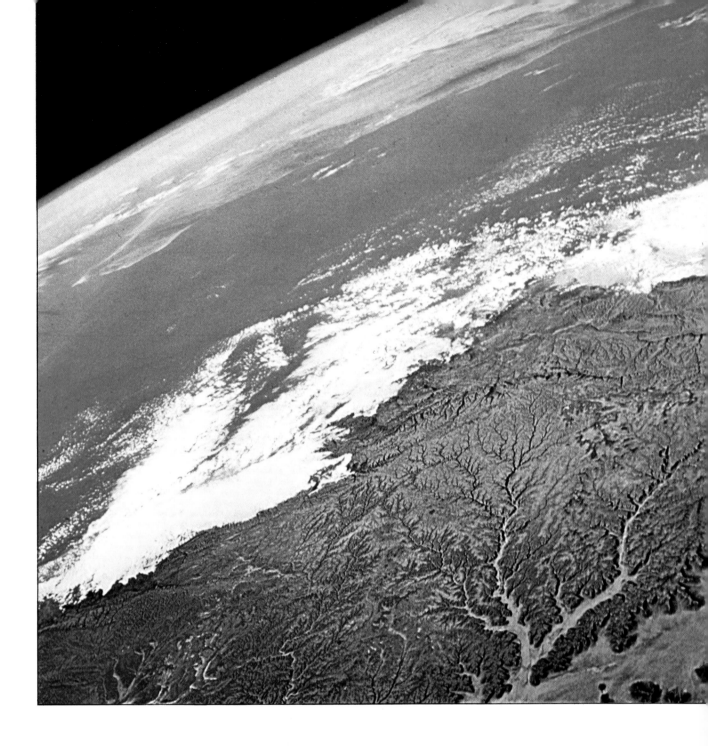

coast volcanic rock was poured out, which in its darker colour stands out as a contrast against the rock of the Hadramaut Plateau.

The uplift of the rocks along the coast as well as the parallel fault-lines are shown in the mountain ridges running parallel to the coast and the structure of the irrigation network.

This recent uplift and the rainy seasons in prehistoric times (in our latitudes during the ice ages) created the valleys that are shaped like canyons and that cut up to 300m deep into the sedimentary plateau. The structure of this raised network of valleys partially follows the weak areas of rock with their cracks and faults.

The network of valleys of the individual rivers merge with one another. The headwaters of rivers with a very steep gradient often drain the water from rivers belonging to other systems; this is shown very clearly in the centre of the picture. Here a very deep and steep dry valley cuts through the complete upper part of another drainage system.

The wide valley of the Wadi Hadramaut (bottom left) is marked by a fault area, which runs parallel to the Gulf of Aden. This vast dry valley stretches out over a length of 400km. In a wide sand funnel it opens into the 'empty quarter' in the interior of the country. Towards the ocean it breaks out through a very narrow gap east of Mukalla.

Today the Hadramaut area, formerly part of 'Arabia felix' is very thinly populated. The

settlements are all situated in the Wadi Hadramaut and some of the wider tributary valleys as well as along the coast. The region was at one time divided into a large number of Sultanates, and these are now united into the independent Federation of South Arabia.

In the sand of the dry valleys, which are up to 300m deep, it was possible to reach the ground water by wells; water also appears on the slopes of the valleys. Thus an oasis civilisation developed here in very early times (in the picture it is only vaguely recognisable). Coffee, incense, myrrh, sesame, cotton, maize and dates are grown here. This horticulture was carried out more intensively in earlier centuries, namely on terraces on the slopes of the Hadramaut valley and its side-valleys, areas which today are, to a large extent, desolate. This satellite picture, too, gives us an impression of the decline of the cultivated areas. Only a few of them in the actual Hadramaut valley as well as in the wide side-valleys can be recognised.

10 Oman – the eastern point of Arabia

NASA-Photo: S-65-34661, Gemini IV
Exposure: J. McDivitt and E. H. White
Date: 4.6.1965
Camera: Hasselblad 500 C
Lens: Zeiss Planar 80mm
Film: Kodak SO 217 (Ektachrome MS)
Altitude of exposure: about 180m
Axis: approximately vertical
Scale: about 1:750,000
Area covered: roughly 22,500km²

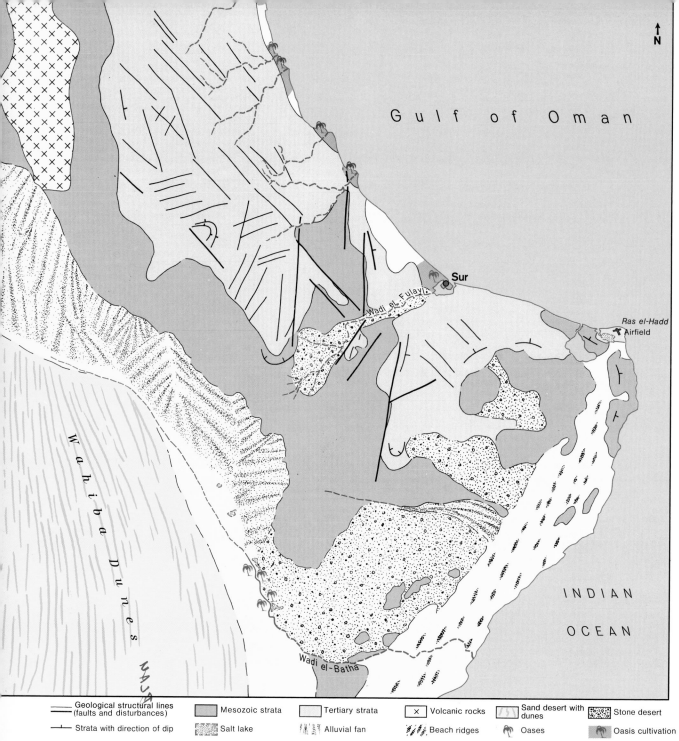

Geological structural lines
(faults and disturbances)

Strata with direction of dip

Dry valley (Wadi)

Mesozoic strata

Salt lake

Tertiary strata

Alluvial fan

× Volcanic rocks

Beach ridges

Sand desert with
dunes

Oases

Stone desert

Oasis cultivation

This picture shows the outliers of the endless sea of dunes of central Arabia in red and yellow colours, in contrast to the mountain chain of Oman, and the cape on the eastern point of Arabia that juts out into the deep-blue Indian Ocean. This is one of the least known areas of the Near East; it is very thinly populated indeed and almost untouched by modern developments.

The long strips of dunes, which run from north to south in the left of the picture, are the Wahiba sand dunes; they are eastern spurs of the Rub el-Khali, one of the largest sand areas within the desert belt of the earth. It covers the central basin of South Arabia, with a length of 1,500km and a width of 600km. These dunes, the individual ridges of which are recognisable in the picture and are up to 50km long, were formed as longitudinal dunes parallel to the pre-vailing direction of the wind. They are typical of the entire 'empty quarter' and can be compared to the 'sword' dunes (Seif) in North Africa; in Arabia they are called 'Uruk'.

Out of this monotonous endless sand sea the wildly rugged mountain chain of Oman along the eastern coast of the Arabian Peninsula, with summits up to 3,000m, rises abruptly. Towards the interior of the country, meaning in this picture towards the area of the dunes, vast alluvial fans are marked by shades of dark grey-blue changing into brown-grey. They run along the whole of this chain of mountains. This strip of alluvial material is on average 20km wide. The bold relief, the lack of vegetation and the great changes in temperature during the day cause very strong

70

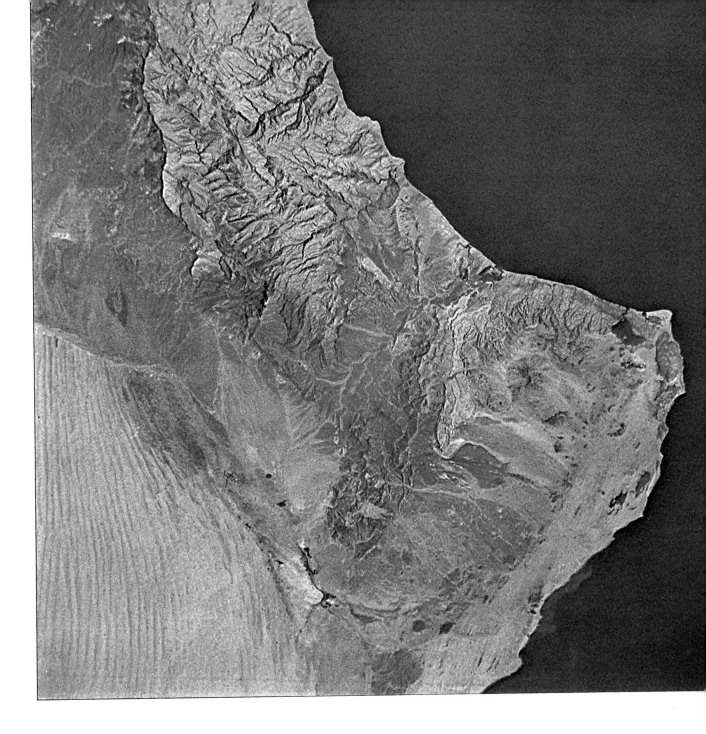

weathering. The very rare, but catastrophic rainfalls in this extremely dry area are not suffi-
cient to process the alluvium or to carry it away; the torrential rains (occurring at intervals of
several years) only manage to redistribute it. Thus in the dry valleys enormous alluvial fans
have been built up towards the interior of the country. Also along the coast some very con-
spicuous alluvial fans have been moved out into the sea (upper part of the picture) or have filled
up bays (centre of the picture near Sur). Some salt lakes that have been cut off from the open
sea and bogs along the coast near Ras el-Hadd are connected with the sea by twisting tidal
channels (tidal range c 2m). The ocean current off the south-east coast, the 'Monsoon drift',
changes its direction every half year with the monsoon.The mountain-chain itself is built up
mainly out of mesozoic schists and volcanic lava (dark colours) which are covered by lighter
yellow and brown tertiary limestone and marls. Tectonically the mountains of Oman consist of
young folded mountains, which were crumpled against the edge of the rigid Arabian continental
block in a geosyncline filled up with young malleable rock. This folding process took place
during the movements of the large continental blocks. The structural lines of the folding run
parallel to the coast. Between the schists and the limestone, as well as within the limestone,
folding can easily be recognised. The valleys which cut deep into the limestone and marls which
are less resistant to the weathering, form a fault pattern with lines that run parallel to as well as

71

across, the main direction of the folding. The protruding of the schists towards the coast in the centre of the picture is due to young faults, that run through the picture from north-east to south-west. The main structure axis of the folds, parallel to the main ridge (north-west to south-east), changes its direction near the Cape of Ras el-Hadd in the lower half of the picture and runs from north-east to south-west.

A quaternary and therefore very young uplift along the southern edge of Arabia (see text under picture 9) displaced the sea by about 15 to 20km. In the picture this is indicated by the beach ridges which run parallel to the coast from Ras el-Hadd down to the lower edge of the picture. The elevated continental plateau is on average less than 100m high. The beach ridges could be mistakenly interpreted as ribs of rock, but careful study shows clearly the contrast between their soft and washed-out contours and the adjoining rock ridges.

The Sultanate of Oman covers an area of 212,000sq km, but has only 750,000 inhabitants. Most of the settlements are on the coast. The capital of Muskat (population 6,000) and its neighbouring town Matrah (population 14,000) lie off the northern edge of this picture. Traces of the very rare settlements in the coastal plain and main valleys of the interior of the Sultanate can only be recognised in a few places although the scale of the picture is very large. On Ras el-Hadd one can make out the runways of an airport that overlap at an acute angle. A narrow band of oases can be recognised along the edge of the dunes. In the small basin between the sea of dunes and the mountains of Oman there are a number of salt lakes. On the southern edge of the picture the dry valley of the Wadi el-Batha leads into the Indian Ocean. A small section of the Wadi shows dark blue-green colours, an indication that there is water near the surface. Here we find the vegetation of the oases which lie in this valley. On the vast alluvial area near the Wadi el-Fulaysch, north-west of Ras el-Hadd, the harbour town of Sur (population 10,000) is recognisable on the sand bar which cuts the lagoon off from the open sea. The cultivated area of the oases is only vaguely visible, but it can be interpreted from the surface structure.

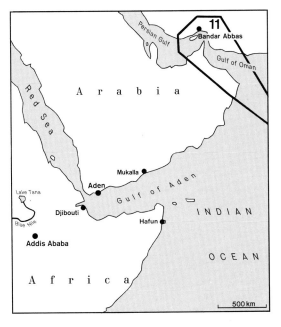

11 The Strait of Hormus, the gate to the Persian Gulf

NASA-Photo: S-66-63082, Gemini XII
Exposure: J. Lovell and E. Aldrin
Date: 11.11.1966
Camera: Hasselblad SWA
Lens: Zeiss Biogon 38mm
Film: Kodak SO 368 (Ektachrome MS)
Altitude of exposure: about 250km
Axis: strongly inclined towards east, therefore right-hand side edge strongly distorted
Scale: in the centre of the picture about 1:2,500,000
Area covered: about 400,000km^2

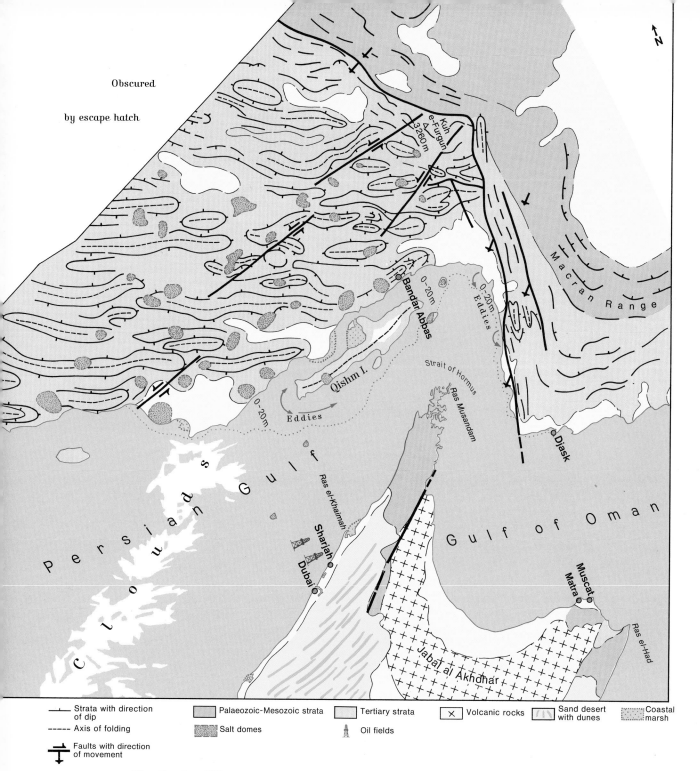

Obscured
by escape hatch

The Strait of Hormus separates the shallow 'tributary' sea of the Indian Ocean, the Persian Gulf (on the right), from the funnel-shaped Gulf of Oman. The rich blue of the deep sea stands out clearly against the turquoise of the shallower water, in which we find a large number of current eddies.

On the Persian mainland in the left-hand part of the picture fold mountains are recognisable. They are worm-like, rising and then sloping off, and their colour is the yellow-red of the desert. The ridges are on average 1,000m high. Some individual peaks reach 3,000m. As a contrast to this the coast of Macran (in the right-hand part of the picture) shows dark blue and green chains of mountains, with simple structures, reaching heights of 2,000m which are overthrust along the line of the Zagros Mountains (the difference in colour stands out). Separated by the Strait of Hormus, which is only 55km wide, the Arabian peninsula with the mainly volcanic mountain chain of Oman (over 3,000m) juts out far to the north in Cape Musandam, which due to the inclination of the camera is very much distorted.

Folds, thrust-fronts and the coastal forms follow the horn of Arabia which juts out to the north like the waves of a river breaking on the piles of a bridge. This explains the clearly marked change of direction in the course of the thrust front of the coastline of Iran (which with

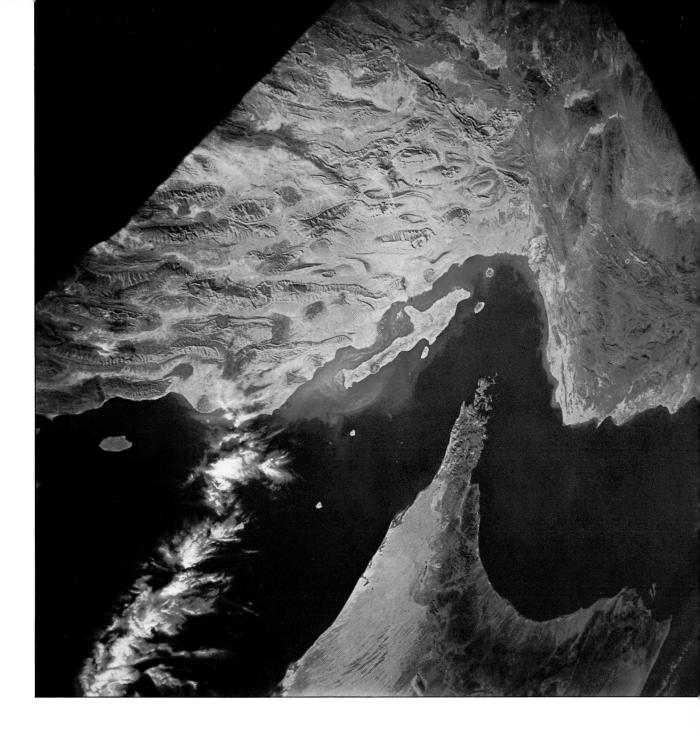

the chain of Macran swings out far to the south) and of the horizontal thrust faults within the Zagros Mountains.

This picture gives us an excellent impression of what the geologist can learn from satellite pictures about the movements of the earth's crust and the relationships between major structures. Unlike the preceding pictures (pictures 7, 8 and 9), faulting, other major distortions and fault-block depressions in rigid continental blocks are not the main geological phenomena.

In the weak zones of the earth's crust between old and no longer pliable blocks, crust material sank and extended troughs (geosynclines) were filled up. Afterwards, when the crust started to move and the continental blocks came nearer to one another, these folded up into mountains between the blocks. Thus the southern part of the Zagros Mountains is one link in a whole chain of young folded mountains, which were created out of the trough of 'Tethys' and can be traced from the Pyrenees via the Alps, the Balkans, the Near East and the Himalayas as far as the East Indies.

Three very different geological patterns can be distinguished. First the secondary mountain ranges of the Arabian continent plateau with the parallel chains of dunes of the 'empty quarter' (in the picture they are only vague and distorted); secondly the intensive folding of the Zagros

Mountains; and thirdly the chains of Macran and Oman, which stand out through their simple structure and their dark colour.

In the Zagros Mountains, a large number of elongated (up to 100km) saddle-shaped folds can be recognised. They emerge suddenly out of the young cover and disappear again, looking like the backs of whales strung together. The very fine parallel stripes in their structure indicate different rock hardnesses. A further striking morphological factor are the many circular dark blue-grey patches and hollows. These are the so-called salt-domes. The salt, which reacts like a plastic material, emerges to the surface and is the cause of the irregular structure of the Zagros Mountains. The limestone and marl shown in the picture mostly belong to the younger tertiary and 'float' on very thick palaeozoic salt sediments. When the sedimentary trough became narrower, the particular form of the folded structure was created by the mobile salt. It moved into the individually recognisable saddle-structures, opened up their ridges, arched up and penetrated through to the surface. At the bottom of the Persian Gulf the same folding is continued towards the Arabian continental plateau, as is indicated by the small islands visible in the satellite picture.

The generally older types of rock in the chain of Macran are less pliable and more fractured. When the very intensive squeezing process took place, these rocks were thrust up to 100km over the Zagros folds. Along this thrust front, called the Oman line, the folding of the younger series, which resembles a bow wash, is very intensive and complex. It is assumed that in this process of thrusting the salt acted as a lubricant; it is also believed that underneath the cover of the chain of Macran the Zagros folding continues far towards the east.

The chain of Oman, the line of which exactly matches the chains of Macran, is the southern, largely volcanic, continuation of this mountain range. The separation between the two units by the Gulf of Oman is probably due to the drifting apart of the two parts.

The southern end of the Persian Gulf and the southern part of the Red Sea belong to the driest and hottest areas of the earth. Quite often temperatures in the summer months reach over 50° C. The intense dryness means that in some cases the salt domes which reach the surface are not completely leached out and infilled. Even in the Persian Gulf there are islands which, apart from a narrow edge of rock, consist entirely of salt. The rare rains have only managed to leach out the salt-domes into flat hollow shapes. The moist salt paste has in some areas become pliable. This is indicated by a number of 'salt glaciers' that come down from the mountain ridges.

The areas of shallow water along the Persian coast up to 25m in depth stand out clearly. Their light turquoise blue is in contrast to the dark blue of the deeper sea. As the water becomes deeper a very conspicuous colour gradation takes place. The Strait of Hormus, only 55km wide, is a very narrow passage with a strong horizontal current of varying direction. This current and the meeting of different water bodies are the reasons for considerable mixing processes, which result in the water whirls visible along the coast.

Due to the decreased transparency of the water the shallow Persian Gulf appears in the same dark blue as the Gulf of Oman (over 3,000m), although the average depth of the Persian Gulf is only 31m – the deepest areas lie along the Persian coast and reach 75m. The very high salt content in the Persian Gulf, especially the nitrates and phosphates collecting near the surface cause a very rich growth of plankton, which makes the water less transparent. In 1965 the conditions of the currents and the darkening of the water in the Persian Gulf and the Strait of Hormus were examined by the German research ship *Meteor*. It was found among other things that the higher salt content of the Persian Gulf is carried by the current through the Gulf of Oman into the Indian Ocean. Between the island of Qishm and the mainland we can see a large area of salt bog in the picture.

All the settlements lie in the coastal areas. The main settled area of the Sultanate of Oman lies in the fertile alluvial plain with its two most important towns of Muskat and Matra, which is situated in the shape of a crescent between the darker chain of Oman and the Indian Ocean. In the agricultural areas we find the typical oasis cultivation where they work the land in terraces: date palms, shrubs and vegetables. This also applies to the coast of Macran with the little harbour town of Jask, which is situated on the cape that juts out into the sea like a needle. On the Strait of Hormus there is only one major settlement, Bender Abbas (population 14,200), founded in 1623 and formerly the place of exile of the Persian empire. It has a certain importance as it is the only harbour town of South Iran as well as the centre for the fishing industry with one

tinning factory. Due to the extreme temperatures in the summer, the number of inhabitants falls below 10,000 during the summer months. Our picture does not show the oases north of the town because the scale is too small.

The most important place within the area of the Trucial States on the Arabian peninsula is Dubai with 60,000 inhabitants. Of economic importance here are the resources of crude oil, some of which have been developed while others are still in the process of being prospected. Successful boring for mineral oil is being carried out in the relatively shallow Persian Gulf as well as along the Arabian coast. The enormous reserves of salt, which could be obtained from the vast salt domes, spread all over this country, have not been exploited up to now.

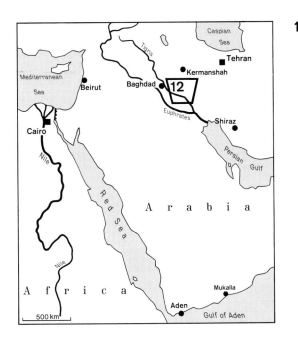

12 The Tigris Plain in Mesopotamia and the Zagros Mountains in Iran

NASA-Photo: S-65-45617, Gemini V
Exposure: G. Cooper and C. P. Conrad
Date: 21 to 29.8.1967
Camera: Hasselblad 500 C
Lens: Zeiss Planar 80mm
Film: Kodak SO 217 (Ektachrome MS)
Altitude of exposure: roughly 300km
Axis: inclined towards north
Scale: 1:1,000,000 to 1:1,500,000
Area covered: about 75,000km²

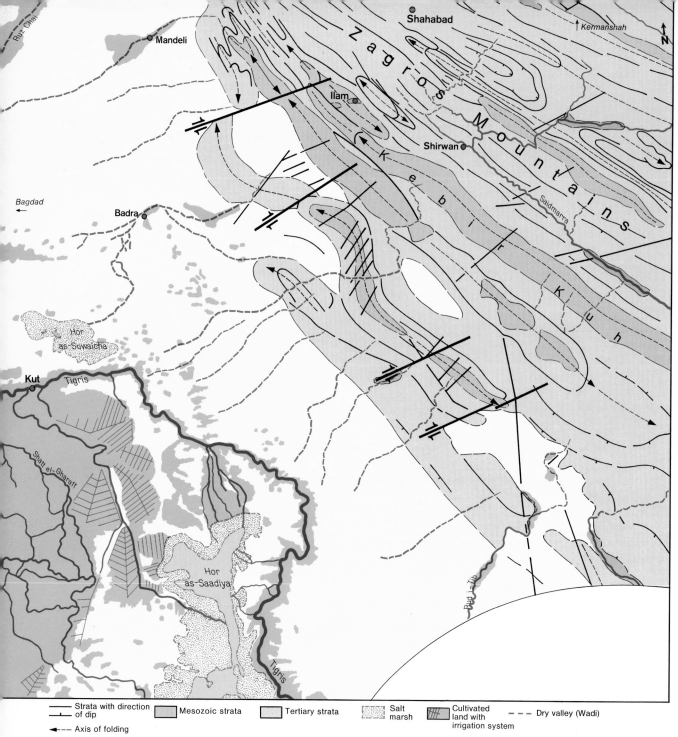

Strata with direction
of dip

Axis of folding

Faults with direction
of movement

Mesozoic strata

Tertiary strata

Salt
marsh

Cultivated
land with
irrigation system

Dry valley (Wadi)

Taken from a height of 300km over the nose of the spacecraft, the observer can see the plain of the rivers Euphrates and Tigris. This region has been the cultural centre of mankind since the ancient Babylonian states were founded more than 5,000 years ago. Along the edges, the wildly rugged chains of the northern Zagros Mountains reach heights of up to 3,000km. Along the foot of the mountains runs the border between Iraq and Iran.

In the western part of the picture one can easily recognise the winding course of the river Tigris. The areas in the southern part of the region between the two rivers, which get periodically flooded and are partly salt covered and partly water covered are also visible as is the division of the fields in the irrigated country between the Tigris and Euphrates.

Towards the east as far as the foot of the mountains follows a strip of semi-desert – over 100km wide – which is salt infested to a large extent and floods only occasionally.

The north-easterly third of the picture covers the ridges of the limestone chains of Iran, which run parallel to each other in a north-west–south-east direction. Their folded structure is very clear and regular. Towards the plain of Mesopotamia the chains of Zagros are accompanied by a badlands, made up of soft tertiary marls, furrowed with braided and deep channels. The structures disappear under the young alluvial plain. In the colouring of the semi-desert the recently superimposed folds are still visible.

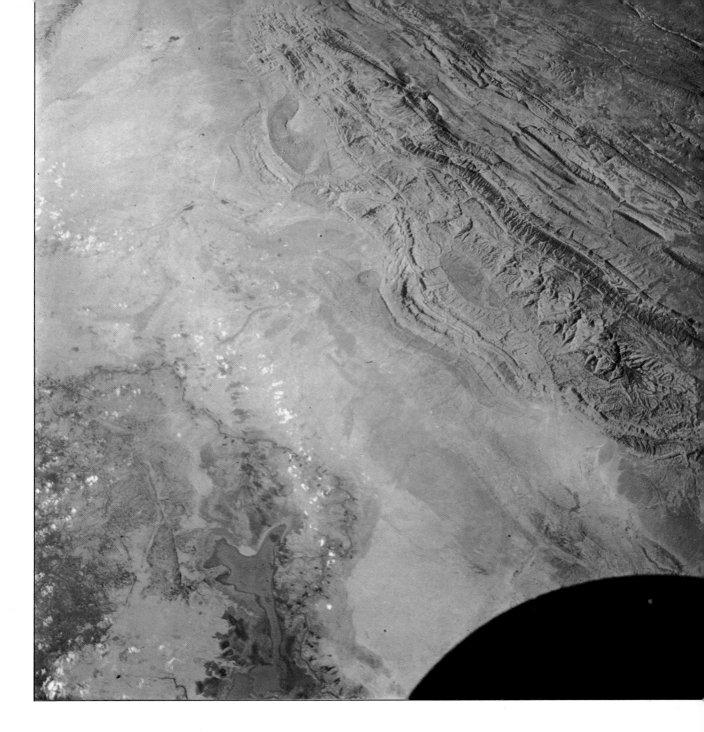

By far the largest part of the picture is taken up by the Mesopotamian trough, which stretches along in the northern continuation of the Persian Gulf from south-east to north-west, and through which the rivers Euphrates and Tigris flow. This extensive tectonic and morphological downfold (geosyncline) is situated between the plateau of the basement complex of the Arabian block in the south-west, which is covered by sediments and highly consolidated, and the young folded chains of the Zagros Mountains in the north-east. The latter originate from the Tethys (the world-wide sedimentary trough, out of which the young folded mountains from the Alps to the Himalayas were folded). The Mesopotamian trough, the south-easterly part of which is shown in the picture, is believed to be still sinking in the lower course of the rivers and is continually filled up with material by the Euphrates and Tigris in the alluvial plain.

Towards the north-east a zone of foothills follows, most of which are not more than 300m high. They are quite young (quarternary) anticlines of tertiary rock, mainly marls and lime-stone. Underneath the alluvial plain the shallow wave-structure is continued towards the main axis of the Mesopotamian trough, which runs parallel with the River Tigris, and then gradually peters out in this direction. In the satellite picture they can be recognised as strips running parallel with the chains in the entirely flat alluvial plain. This particular observation can only be made by means of satellite or air pictures. The axes of these anticlines in the foothills run partly

in a snake-like manner and match the limestone chains, which follow towards the north-east. Again and again the structures disappear under the recent sediments. These simply structured saddles are the main sources of mineral oil along the border between Iran and Iraq. The oil collected to a large extent in the upper part of the flat ridges in tertiary limestone, which serves as a great reservoir. Fields, where oil is being drilled today are, apart from Napht-i-Schah on the border, mostly to the north and south of this picture. Beyond the foothills the main range of the folded Zagros Mountains appears. It consists of saddles and troughs, which are simple in structure and hardly disturbed and can in the picture be traced over a distance of 100km. Clearly structured are the anticlinal ridges like the Kebir Kuh. This mountain range is covered along its edges by tertiary sediments. In the central part of the range, standing out clearly, the older mesozoic rocks are exposed. With other saddle structures, eg the one that follows towards the south-west, the younger tertiary cover has not been removed completely, so that the older rocks along the top of the saddle are only exposed in a few places, in the so-called 'windows'. Towards the north-west the structures disappear under the younger sedimentary cover of the Mesopotamian trough, where in the picture the rock formations have the shape of a hyperbola. Towards the interior of the country the folding becomes more intensive. The individual saddles and depressions are closer together or even pushed on to one another. In the right-hand top corner of the picture the folding of the Zagros range gradually changes over into the overthrust and broken series of Central Iran (picture 14). (Because of the indistinct blue shade this is not easily recognisable in the picture.)

The only perennial river is the Tigris (the Euphrates lies 200 to 250km west of this picture). The course of the Tigris with its large number of meanders can be seen very clearly in the left-hand bottom part of the picture. This river which is 1,850km long and rises in the Taurus Mountains in Turkey, carries on average 2,900cbm/sec after the spring precipitation and the thaw in the Taurus and Zagros Mountains. The water level is lowest between August and November when the average is 350cbm/sec. The tributary streams which carry their water from the Zagros Mountains to the Mesopotamian lowland plain, hold water only in the spring. The courses of these rivers cannot be traced in the picture all the way up to the Tigris as they disappear temporarily in the flooded bog area between the river and the foothills. Their course however becomes clear through dark patches which mark oases and irrigated fields, especially where they leave the mountains. Both the Tigris and Euphrates – the life-giving veins of this area – are dammed by several coffer-dams, which make the irrigation of the fertile soil possible. The widely varying amount of water that is carried by the rivers and the partial flooding of large areas due to this fact create an amphibious landscape in the lower course of the rivers. These periodically flooded bog and reed areas are called Hor. In the picture the Hor as-Saadiya is clearly visible, resembling an amoeba. Around this area, covered in water, lie a number of bogs and salt-bogs with a large network of very small distributaries, which connect the central part of the flooded bog basin with the Tigris. Other bog lakes, like the Hor as-Suwaicha, have dried out, but are marked by the lighter shades of the salt areas.

By means of dams, for instance the one near Kut on the western edge of the picture, the cultivation of the constantly changing natural bog landscape and the improvement of the soil is attempted. In connection with the dam of Kut, a side-stream to the Tigris, the Schatt el-Gharraf, has become a perennial stream again. An ancient irrigation canal dating from classical antiquity, called the Dujaila, was cleared in 1945. By means of this canal the old agricultural land can once more be irrigated. The division into lots of roughly 25 hectares each, on either side of the canal, is clearly recognisable in the picture. Following a very successful start the cultivated land suffered from the increasing salt content of the soil as drainage was insufficient. Only the installation of drainage facilities will be able to overcome this problem. The oversalting and the fact that part of the fields are no longer used is easily seen in the picture, where the division into lots can only be vaguely made out.

The settlements of the area covered here are concentrated in the irrigated alluvial plain of the River Tigris and its tributary stream, the Schatt el-Gharraf. This country has been inhabited for more than 4,000 years. The first sedentary civilisations in the Mesopotamian area developed in the hilly country north of Bagdad 6,000 years ago. Two thousand years later the swampy lowland of the lower plain of the Euphrates and Tigris (area of the state of Ur) was colonised.

The largest town in the picture is Kut with 35,000 inhabitants. It has grown tremendously through the setting up of modern industries, especially the cotton industry. Kut and Bagdad,

216km to the north-west, are connected by railway and road. The railway line was continued along the Schatt el-Gharraf as far as Basra, the harbour-town of Iraq 350km further south. The plain between the Tigris and the hilly zone which lies in front of the Zagros Mountains is only settled where the rivers break through into the foreland. The palm-tree and oasis cultivation, which is not very large, can be seen in various places in the picture on the alluvial fans. The Persian part of the Zagros Mountains is to a large extent desolate, and only the main river valleys are thinly populated.

The main economic factor, besides agriculture in the plain of the Tigris, are the mineral oil fields along the Zagros Mountains. The Napht-i-Schah field on the northern edge of the picture was opened in the twenties and is exploited by both Iran and Iraq. The largest Iranian mineral oil fields lie just off the picture towards the south-east on the right-hand side of the space-craft. The main fields of Iraq are near Kirkuk in the north.

13 Folded area of the Persian Gulf

Aerial photograph: black and white
Camera: Wild RC SWA (Super Wide Angle)
Lens: 88.5mm
Altitude of exposure: 6,100m
Axis: vertical
Scale: 1:75,000
Area covered: 400km²
Advertising material by Wild, Herbrugg, Switzerland
Exposure: Hunting Ltd, London

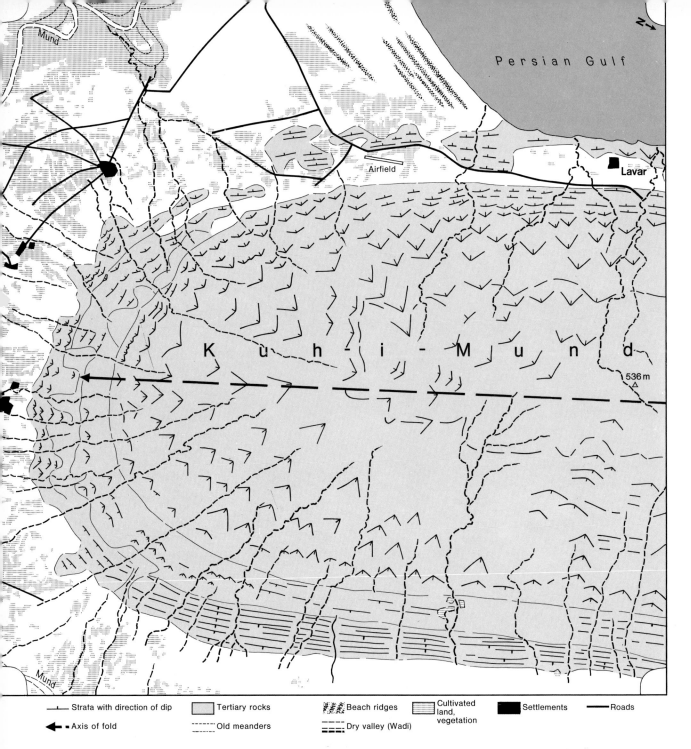

—⊢— Strata with direction of dip	▨ Tertiary rocks	⧚⧚⧚ Beach ridges	▦ Cultivated land, vegetation	◼ Settlements
◀—■ Axis of fold	┄┄ Old meanders	═══ Dry valley (Wadi)		— Roads

This black and white photograph, taken by an aircraft from a height of only 6.5km, shows a small, and therefore correspondingly large scale section of a dipping ridge along the coast of the Persian Gulf. On average 600m high, the crest of the mountain stretches from the well-known Iranian port of Bushir 80km to the south and shows at its dipping end in the smallest detail the typical structures and the characteristic morphological development of the folded ranges of the vegetationless Zagros ranges.

Such aerial photographs taken from different altitudes have been widely used for topographical surveys since World War I. Experience, with aerial photographs was utilised in the development of satellite photography. Indeed, satellite photography and its evaluation have developed out of aerial photography with photogrammetry. Aerial photographs are, to a large extent, black and white since until recently when using colour films, the quality of the colour became worse as the altitude increased. New knowledge about the production of the emulsion, the use of certain filters and improved methods of developing make it possible to obtain true-colour photographs from higher altitudes, like the excellent photographs from the satellites. Evaluation of aerial photographs is not normally done by means of single photographs, but by using pairs of pictures taken from a strip of photographs. During the flight the strip is taken in such a way that the areas covered on the photographs overlap from picture to picture up to

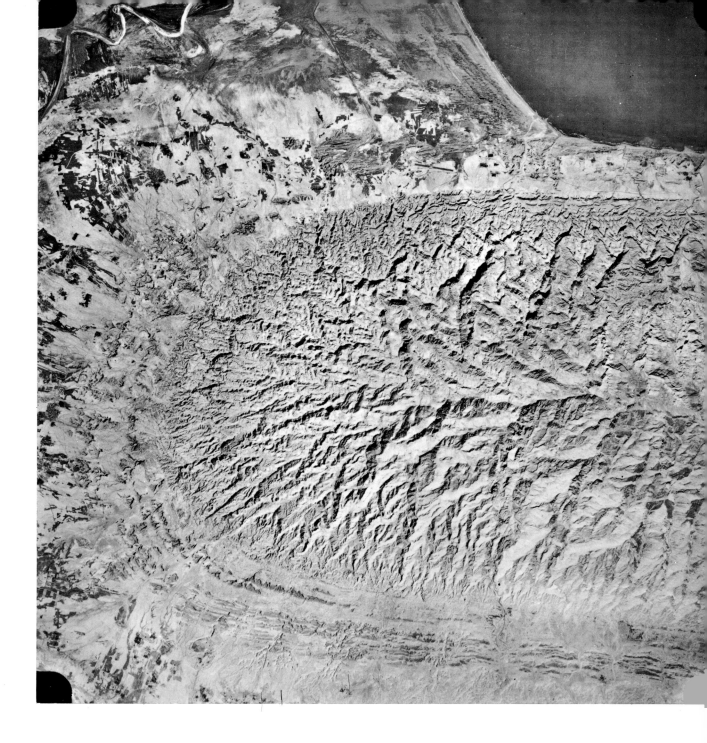

60–80 per cent. Every photograph is (starting radially from its centre and depending on its relief) perspectively distorted. To put it more simply this means that objects which are nearer to the camera (eg mountains) appear larger than those which are further away. This distortion is, of course, different on two successive photographs, because the centres of each of the pictures are over a different spot of terrain. This enables the observer, when he looks at the two photographs at the same time, to see the overlapping parts stereoscopically as one picture. Today topographic maps all over the world are produced largely from such stereoscopic pairs. This method is considerably cheaper and faster than the production of maps through the survey of the terrain on the ground. The aerial photographs themselves and the maps made from them offer important working material for geography, geology, regional planning, pedology (soil science) and forestry.

Photographs which can be stereoscopically evaluated have also been taken by satellites. Here, in this case however, due to the large distance from the surface of the earth, one cannot see the relief so clearly and in as much detail as on aerial photographs, where differences in elevations of only a few metres are distinguishable. A further condition for the stereoscopic evaluation of photographs is that the axes of exposure are parallel to each other, usually vertical to the surface of the earth, which applies only to a very few space photographs.

The aerial photograph represented here shows the south end of the Kuh-i-Mund ridge which is deeply furrowed by radiating valleys. On the wide alluvial fans, which stretch far into the foreland, villages and oases follow the slopes of the foot of the ridge. The river Mund, which only occasionally carries water, flows around the Kuh-i-Mund. Its winding bed can be seen just before it enters the Persian Gulf (top left). The coast of the Persian Gulf in front of the alluvial plain of the river mouth is shown in the top right corner. Striking differences in resistance within the tertiary rocks pictured in the photograph become clear through the hyperbola-shaped parallel strips of light and dark grey shades. Harder rocks are carved out as ribs, softer components are filled in or eroded into hollows. The valleys which run from the mountain crest radially towards the lowland divide these parallel strips. The ribs are separated into a large number of acute-angled hooks which are open towards the foreland. These hooks show to the geologist interpreting the photograph that the rock strata dip outwards from the crest of the mountain. Thus a saddle can be constructed, the long axis of which runs across the picture and dips down under younger alluvial fans towards the south. This dip means that the parallel rock ribs which form a border on the sides of the crest run round the dipping end of the ridge. So one can trace each separate rib, shaped like a hyperbola, round the whole mountain ridge.

Different rock series can be distinguished from the flanks into the core of this saddle by its morphological structure. On the outside there is a strip about 2cm thick of alternating soft and hard strata. Then a strip of the same thickness of predominantly soft rocks, in which only two or three resistant bands can be traced, follows towards the foot of the slope. The rise of the slope is affected by banked resistant limestones. Towards the central part of the mountain crest the strata becomes more and more indistinct. This shows that the central part consists largely of homogeneous material (marl).

This aerial photograph shows in great detail all those structures which can be picked out in the satellite photographs of the Zagros Mountains, such as the structures along the Strait of Hormus (picture 11) rising and plunging like the back of a whale, or the tortoise-shell-like domes north of Lake Niris (picture 14).

On the alluvial fans at the foot of the ridge one can clearly see the field patterns on the cultivated land and, contrasted through the dark grey colour, the tilled (green) fields. The areas used for agriculture open out in the shape of a funnel in front of each larger wadi emerging from the mountainous country. The valleys only rarely carry water; the inhabitants depend in the main on ground water and the springs of the alluvial fans. The water is obtained from wells, which are particularly numerous where the alluvial fans issue forth from the mountains into the foreland.

In the region of the mouth of the Mund, old river loops and meanders can be clearly recognised as a different shade of grey adjacent to the present course of the river. Parallel to the coast old shore lines have formed in the young alluvial plain in front of the mouth of the river. In the sea along the coast the surf is visible as a thin white line.

Several villages can be identified in the picture as dotted heaps of lighter and darker houses. Roads and tracks run through the flat regions as thin lines.

Compared with the pictures taken by satellite, this aerial photograph shows that much more detail can be achieved. The overview of the large scale regional relationships, which the study of a picture by satellite renders possible, is, however, missing. In order to cover the same area photographed by satellite with aerial photographs hundreds of them would have to be put together like a mosaic.

14 Lake Niris in South Iran

NASA-Photo: S-65-45720, SCI 1190, Gemini V
Exposure: G. Cooper and C. P. Conrad
Date: 21 to 29.8.1965
Camera: Hasselblad 500 C
Lens: Zeiss Planar 80mm
Film: Kodak SO 217 (Ektachrome MS)
Altitude of exposure: about 200km
Axis: approximately vertical
Scale: about 1:750,000
Area covered: about 22,500km^2

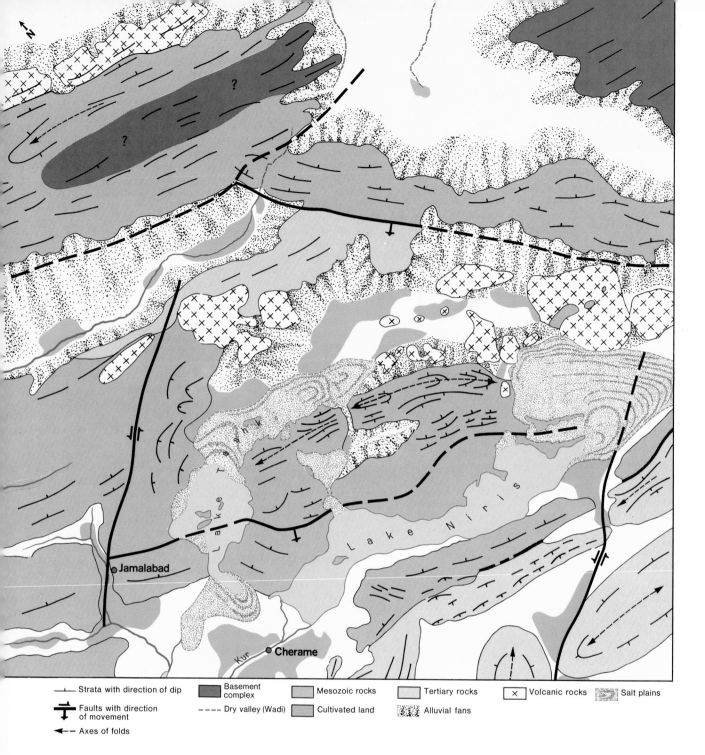

—⊥— Strata with direction of dip	▓ Basement complex	░ Mesozoic rocks	░ Tertiary rocks	⊠ Volcanic rocks	▒ Salt plains
⊤ Faults with direction of movement	- - - - Dry valley (Wadi)	░ Cultivated land	░ Alluvial fans		
◄- - Axes of folds					

The dry white salt plains of Lake Niris and Lake Tashk, which at the time when the photograph was taken were flooded by water, lie imbedded in the jagged and steeply folded ranges of the central Zagros Mountains.

This photograph which covers a section of 150 by 150km with a telescopic lens is uniquely informative from a geological point of view. It shows complicated structures which are more difficult to interpret than the photos of the Zagros Mountains (pictures 11, 12 and 13) which have appeared so far.

At the bottom edge of the photo we can distinguish the course of the River Kur which carries a great deal of water at times and which is accompanied by the geometrical mosaic of the cultivated valley areas. The Kur, called Cyrus (Kyros) in antiquity, has its source, like its tributary the Pulvar, in the summit regions of the Zagros Mountains, which rise to more than 4,000m and are covered by snow in winter. After 480km it flows into the two lakes, Tashk and Niris, which have no outlet and are more like salt swamps than lakes. In the course of thousands of years more and more salt was added to the lakes. The rivers pour highly concentrated salt water into the lakes where salt marsh forms at an increasing distance from the river mouth. Only after rare rainy periods or after the thaw in the high mountains are the otherwise dry, flat salt bottoms of the lakes covered by water. The salt crusts at the top are loosened or merely moistened. Around

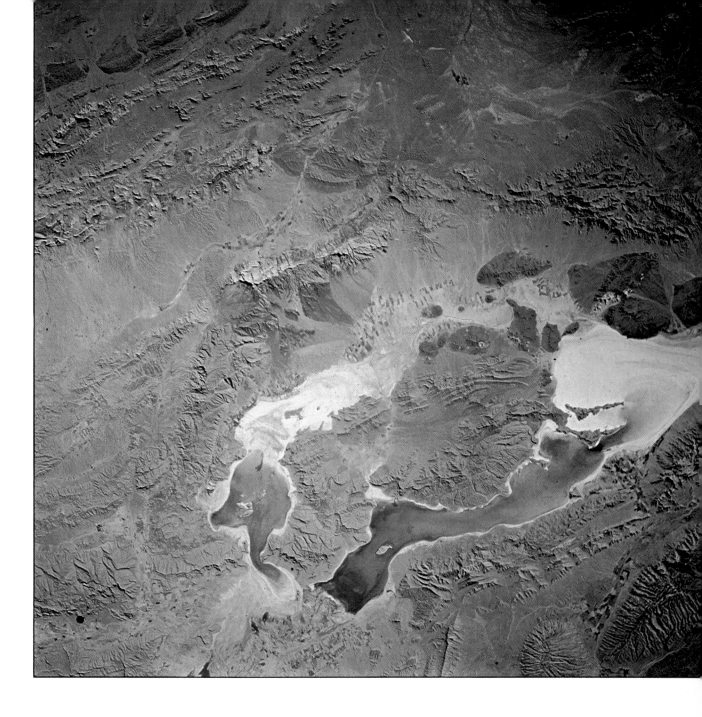

Lake Niris and Lake Tashk, one can clearly see several concentric shore lines in the white salt as a sign of flooding of the lake bottom to a varying extent. When a photograph was taken from an unmanned satellite eleven months earlier, these lakes were almost completely dry.

The lakes lie 1,500m up in a central mountain basin which has no outlet. The surrounding mountain ranges tower on average about 1,000m above this region which widens towards Shiraz and covers an area 100 by 50km. Individual summits reach a height of 3,200m above sea level.

From the geological point of view this picture reveals a confusing amount of detail. Due to intensive decomposition and degradation in a desert, differences and distortion of rocks are completely weathered away. One can clearly recognise calcareous and siliceous stratified rocks of mesozoic times by their striking parallel structure. The disintegration into individual ribs is caused by selective erosion of hard resistent and soft strata. The tortoise-shell-like and deeply furrowed domes in the lower half of the picture are soft tertiary sandstone and marl deposits. A noticeable contrast is formed in the picture by dark volcanic rocks which, north of Lake Niris, are the remains of extinct volcanoes and are recognisable as stratified lava flows at the top edge of the photo.

The wide valleys and the erosion surfaces are filled with detritus. The furrowed mountain

ridges are drowning in their own masses of detritus, which is clearly indicated by the large alluvial fans.

While the Zagros ranges at the edge of the Arabian plateau and along the Persian Gulf are gently folded, as is shown in pictures 11, 12 and 13, here, near the northern edge, the mountains were more strongly compressed. The individual rigid blocks of the Central Iranian plateau served as abutments against the folded mountains. Under very great pressure, the rocks broke off and, detached from their bedrock, were pushed over each other. Such striking overthrusting, characterised through the structural lines of the rocks north of Lake Tashk, can be traced all across the picture. Altogether the noticeable change of structural directions allows a subdivision into larger individual tectonic blocks. The direction of movement of the thrusts and the folding runs towards the south-west. Along the striking thrust lines older series were pushed over younger rocks. Within the individual tectonic blocks an intensive folding can be recognised, especially in the central part of the picture in the clearly discernible chert ribs of the massif between Lake Tashk and Lake Niris. The blocks disintegrated into individual segments which again were moved at a different speed. Some of these great blocks moved more quickly in relation to their surroundings whereby horizontal movements of the individual blocks relative to each other occurred with a marginal drag. These striking lateral faults can be clearly seen in the picture diagonally and vertically to the principal line of movement. On the thrust lines, which reach deep down into the crust of the earth, basaltic material was able to force its way up. The cones of volcanoes and dark lava extrusions can be recognised in the picture.

In the bottom right corner of the picture the transition into the gentle, less disturbed folds can be seen. This simple fold formation continues south and south-west to the Persian Gulf (picture 13).

The area surrounding the salt lakes is one of the oldest cultivated regions in the world. Just beyond the area covered by the picture are two important cities of the ancient Persian empire, Persepolis and Pasargadai, whose ruins provide evidence of former civilisation. The importance of this region in antiquity is shown by the large cultivated districts which are partly abandoned today. The blurred pattern of untilled fields – on the northern shore of Lake Tashk, for instance – clearly contrasts with the areas still cultivated in the bottom half of the picture, as can be seen on the alluvial fan which juts into Lake Niris at its narrowest point, and in its southern narrow drainage area.

Only the eastern part of the large basin is shown in the photograph. The spurs of the vast cultivated areas are visible where the River Kur flows into Lake Niris. The Kur and its tributaries flow through this alluvial plain which continues for more than 100km to the east. The whole area is artificially irrigated and intensively cultivated. Rice, cotton and vegetables are grown and until restrictions on the production of opium were imposed in 1955, this district of Iran was an important area for growing poppies.

Compared to the otherwise uninhabited mountain regions of the Zagros Mountains, these central basin areas are relatively densely populated. Shiraz, the capital of the province of Fars, is the most important town and is a significant centre of industry and commerce. The carpet industry, which is scattered in small concerns all over the Kur basin, is world-famous.

A metalled road linking Shiraz with Bushir on the Persian Gulf and Isfahan and Tehran inland has reduced the isolation of the region.

Landscape types on earth: desert - mountains - coasts - islands

15 The desert landscape of the Fezzan in Libya

NASA-Photo: 66-HC 1757 (S 66-54525),
Gemini XI
Exposure: C. P. Conrad and R. Gordon
Date: 14.9.1966
Camera: Hasselblad SWA
Lens: Zeiss Biogon 38mm
Film: Kodak SO 368 (Extrachrome MS)
Altitude of exposure: 324km
Axis: strongly inclined towards north-east
Scale: about 1:6,000,000 in the centre of the picture
Area covered: >1,000,000km²

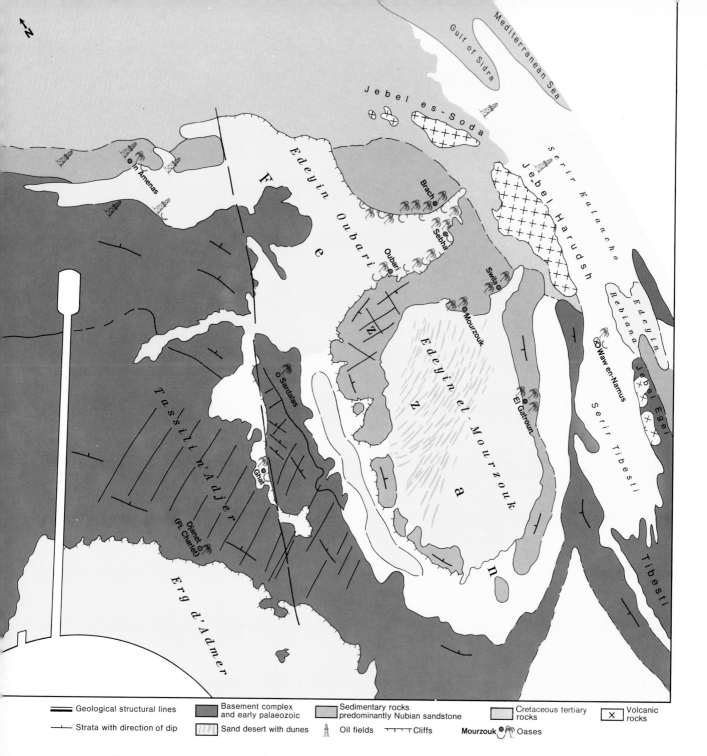

▬▬ Geological structural lines	**Basement complex and early palaeozoic** (dark)
—┼— Strata with direction of dip	Sand desert with dunes

Geological structural lines · Basement complex and early palaeozoic · Sedimentary rocks predominantly Nubian sandstone · Cretaceous tertiary rocks · Volcanic rocks

Strata with direction of dip · Sand desert with dunes · Oil fields · Cliffs · Mourzouk ● Oases

The cuestas of torn and frayed desert plateaus rise like cliffs out of the vast areas of yellow-red sand-dunes of Southern Libya. Ribbons of oases, which have been followed by important tracks of early tribes and caravan-routes since prehistoric times, nestle along the foot of the escarpments. Sunk into insignificance at the beginning of this century, these remote areas of the Sahara experienced a new economic stimulus through the considerable oil resources discovered here in recent decades.

Satellite pictures like this give us an invaluable picture of natural and geographical relationships which can be used for industrial planning and the opening up of the little known Fezzan to traffic and agriculture.

The border between Algeria and Libya runs across the photograph in a north–south direction, following the depression in which the Ghat oasis lies. In the bottom right corner of the picture the northern parts of the central African states Chad and Niger are covered. The district of the Fezzan with the provinces Sebha and Oubari in south-west Libya can be seen in detail. Towards the north-east stony deserts, dune fields and mountainous country, contorted to narrow strips by the curvature of the earth and the inclination of the camera, can be distinguished as can the basalt mountains Jebel es-Soda and Jebel Harudsh, which are clearly set off as dark patches.

The Serir (gravel desert) Kalancho and Serir Tibesti, the sand lake of the Edeyin Rebiana and

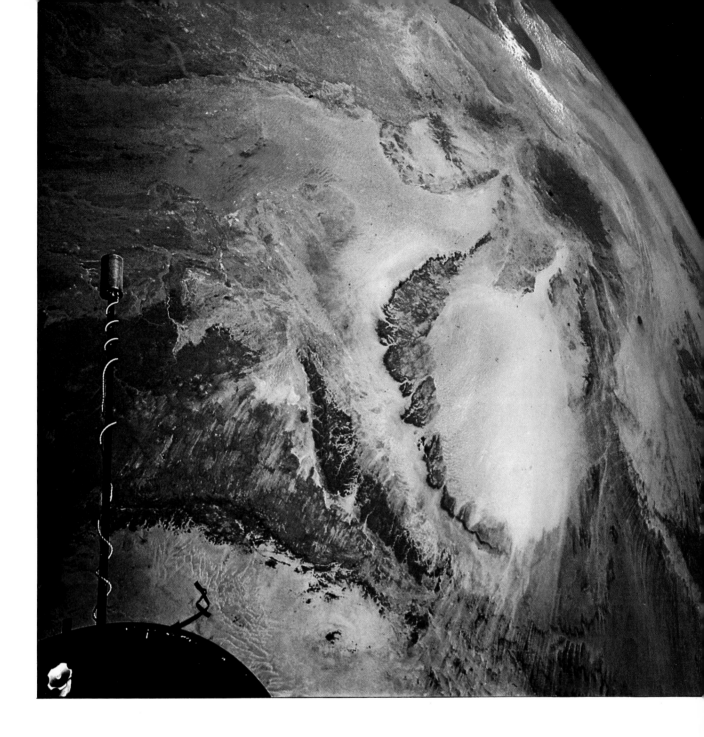

rock and mountain strips of Eastern Libya can be recognised. The Gulf of Sidra and the coastal mountainous region of Cyrenaica which juts out far to the north near Bengasi appear to be strongly contorted.

The distinct cuestas 400–600m in height clearly divide the Fezzan into different districts. Sediments up to 5,000m thick and of cambrian to tertiary age were deposited in huge basins over the folded precambrian basement complex which comes to light in the rock massif of the Tassili n'Adjer, as a spur of the Hoggar Mountains and in the foreland of the Tibesti Mountains. The rocks lie horizontally or dip gently towards the centre of these slowly subsiding basins. The central part is formed by the immense, sand-filled basin, the Mourzouk Basin with the oval sea of dunes of the Edeyin el-Mourzouk. The frayed edge of the basin is formed by enormous sand-stones, which with an escarpment of 400m dip towards the Edeyin Oubari. The soft rock series of carboniferous age appear light-grey and flat. Before the depression of Ghat, the Jebel Akakus at a height of 1,400m appears as the next cuesta of geologically older formations. West of the depression of Ghat, the large crescent of the Tassili n'Adjer rises to a height of more than 2,000m, in its scarp, facing the Erg d'Adamer, the precambrian rocks of the basement complex outcrop. The Tassili Mountains with their great scenic beauty and their bizarre shapes are

91

interlaced with innumerable gorges which, incised vertically following the jointing, carry in parts ample water.

North of the Fezzan cuestas, vast desert plateaus, formed of upper cretaceous tertiary chalks, cover the older bedrock as far as the coast. They are evidence of a geologically young marginal flooding of the African continent. During the late tertiary and the quaternary period volcanic rocks (Jebel es-Soda and Jebel Harudsh) were forced to the surface along the weakness zones of the crust which run from north-west to south-east. The extensive torrents of lava disintegrated into endless boulder fields, called Hamada which, as the Arabian name 'cannot be traversed by a camel' implies, are impassable.

Ground water and springs at the foot of the escarpments and along the flat small depressions around the edge of the sand lakes make vegetation growth possible and give rise to the ribbons of oases. The oases in the Fezzan were of great significance even in antiquity and particularly at the time of the camel caravans. One of the most important military and caravan routes crossing the Sahara connected the Roman settlements at the Gulf of Sidra on the Mediterranean Sea with the River Niger. This route follows the oases situated at the edge of the Erg Oubari, touches Ghat, crosses the gorges of the jagged Tassili, by-passes the Hoggar Mountains and reaches the Niger at Gao and Timbuktu. Further caravan routes connected Mourzouk via Waw al-Kebir and Waw en-Namus with the Kufra oases in the east. Kufra, a junction in eastern Libya, was connected with Egypt by caravan routes across the Libyan desert and with the Sudan by caravan routes across the South Libyan desert.

In the early quaternary period the climate of the Sahara was wetter than it is today, as is proved by remainders of old woods with isolated gnarled tamarisks in the Tassili Mountains. The Tassili Mountains are known for their stone-age cave drawings which French archaeologists such as Henry Lhote have thoroughly investigated. Stone-age men lived here in natural caves at the edge of the deeply cut gorges, which still have an abundance of wells and water. The later cave drawings from around the birth of Christ, showing Roman baggage waggons in their pictures, prove that the Romans, too, used the old Trans-Saharan route for trade.

Mourzouk, the former capital and most important trading centre of the Fezzan, has largely lost its significance today. The present capital Sebha has palm gardens with terraced cultivation and larger irrigated areas. It represents a growing desert town with modern residential and administrative quarters.

The vast oil fields of the Sidra basin, north of the Jebel Harudsh, are of great economic importance in Libya. In 1959, following laborious reconnaissance work very rich resources were discovered, stored in thick tertiary chalks. By 1960 the first pipe-line to the Mediterranean had been completed. Further important resources are found near the Libyan–Algerian border on Algerian territory, near the village of In-Amanes. This extensive area of the so-called Polignac Basin was connected by a net of pipelines with the other Algerian petroleum fields and with the Algerian Mediterranean coast. In the region of the Libyan Fezzan extensive exploration for oil fields was conducted, but so far no commercial deposits have been found on this side of the Algerian border.

16 Dune landscape of the Tifernin basin in South Algeria

NASA-Photo: S 65-63829, Gemini VII
Exposure: F. Borman and J. Lovell
Date: 4 to 18.12.1965
Camera: Hasselblad 500 C
Lens: Zeiss Sonnar 250mm
Film: Kodak SO 217 (Ektachrome MS)
Altitude of exposure: about 250km
Axis: approximately vertical
Scale: about 1:300,000
Area covered: about 5,000km²

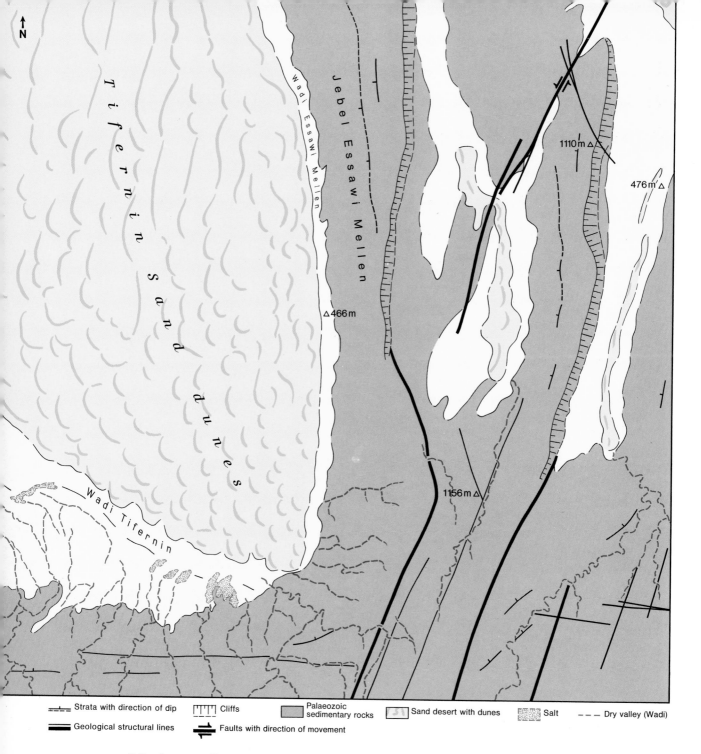

| Strata with direction of dip | Cliffs | Palaeozoic sedimentary rocks | Sand desert with dunes | Salt | — — — Dry valley (Wadi) |

Geological structural lines Faults with direction of movement

Like frozen yellow waves of a lake, the barchan dunes of the Tifernin Basin, framed by bluish-black rock plateaus, lie in the light of late afternoon. The oblique incidence of the sun sets off the relief with deep shadows and increases the difference between the light dune fields and the dark rocks of the cuestas.

The photograph shows an area of 90 sq km north of the mountainous region of the Tassili n'Adjer. It is completely uninhabited and is only touched and crossed by a few secondary caravan routes.

Outside the picture towards the south, ie towards the Hoggar Massif, the precambrian crystalline rocks in the jagged massif of the Tassili n'Adjer (picture 15) 2,000m high stand out. On their northern escarpment they are covered by palaeozoic sandstone, which disappear in the north under the dune fields of the Erg Issawan and the detritus plains of the Hamada of Tingert. The palaeozoic rocks which generally dip towards the north or north-east are divided through disturbances (which run in the same direction) into individual blocks, which have partly subsided and partly risen. The raised blocks project as mountain ridges, like fingers of a hand far into the dune fields in the north. The depression between the raised faulted blocks are covered by separate smaller dune fields. On the left the southern end of the Erg Tifernin is visible, and on the right smaller strips of dunes lie between the individual mountain ridges.

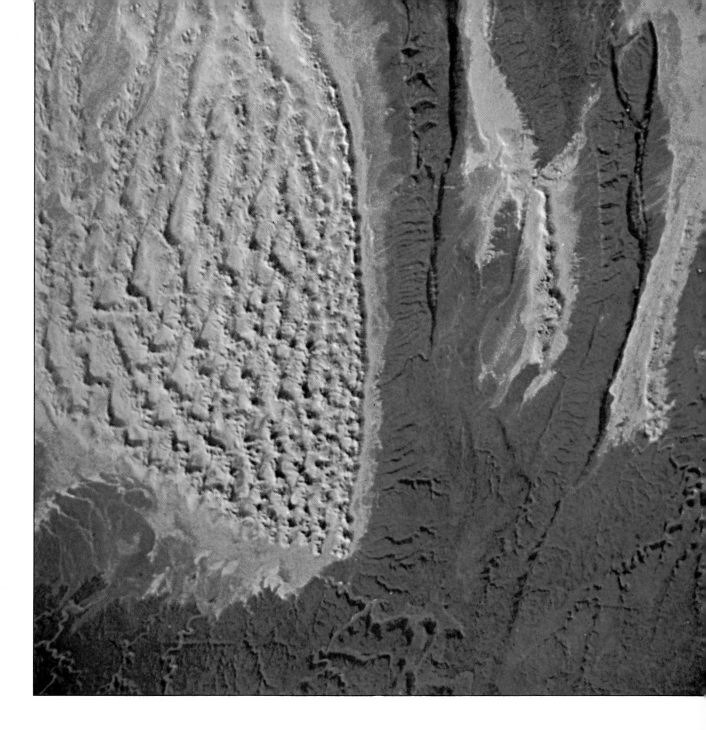

The mountain ridges, which tower above their surroundings to a height of 500–600m, fall gently towards the west in accordance with the dip of the sandstone strata and have, along the lines of disturbance, escarpments up to 500m high in the east. The fault lines can be easily traced. The rocks of the individual fault blocks are tilted towards the west. The same light horizon in the rock series repeats itself as a narrow white ribbon in the Jebel Essawi Mellen and in ridges which follow in the east. This points clearly to the repetition of the same geological strata sequence in the individual fault blocks. Thus the rocks are divided through parallel faults into individual blocks which are tilted towards the west, and towards the east are set off against each other in steps with vertical distances of 100m between the steps.

The crest of the eastern ridges, which was shifted to the north-east, along one of these faults, shows that horizontal movements also took place.

Only the large overview provided by such a satellite photograph makes it possible to clarify so distinctly the geological and structural relationships of a larger area – an example of the many possibilities of using satellite photography for geological research.

This satellite picture is particularly instructive for studying the shape and formation of dunes. In the western Tifernin dune basin (two-thirds of which is shown in the photograph) barchan dunes can be recognised. The individual barchans grow together into rows or chains of dunes

which, after being linked, have the shape of waves. Since with barchans the curvature of the crest of the dune is always formed against the direction of the prevailing winds, one can assume that the prevailing winds in this region come from south-west to west. Individual star dunes at the southern end of the Erg Tifernin show that winds here blow from different directions. The dunes are up to 150m high. Between the individual barchans and the crests of the dunes one can see rocks or detritus of the underlying bedrock, recognisable by its dark colour.

The plateaus are cut into by canyon-like, winding wadis. Strikingly wide wadis run along the edge of the Tifernin dune field; eg the Wadi Tifernin and the Wadi Essawi Mellen between the last wall of the dune area and the rising crests of the mountains. The rare rainstorms coming at intervals of several years bring water which seeps away or evaporates leaving behind salt pans and salt crusts, which can be seen as white areas in the tributary valleys of the Erg Tifernin.

The area is extremely dry. Only at the foot of the escarpments of the mountain ridges can water be found in wells 2 to 5m below the surface of the earth. Thus there are no signs of vegetation anywhere. The area shown is one of the loneliest landscapes of the Sahara and has no settlement at all, and only a few nomads roam through the wadis and ergs (sand desert).

17 Atlantic coast in South Morocco

NASA-Photo: Usis-111-GT-5, Gemini V
Exposure: G. Cooper and C. P. Conrad
Date: 21 to 29.8.1965
Camera: Hasselblad 500 C
Lens: Zeiss Planar 80mm
Film: Kodak SO 217 (Ektachrome MS)
Altitude of exposure: about 280km
Axis: approximately vertical
Scale: about 1:800,000
Area covered: about 25,000km²

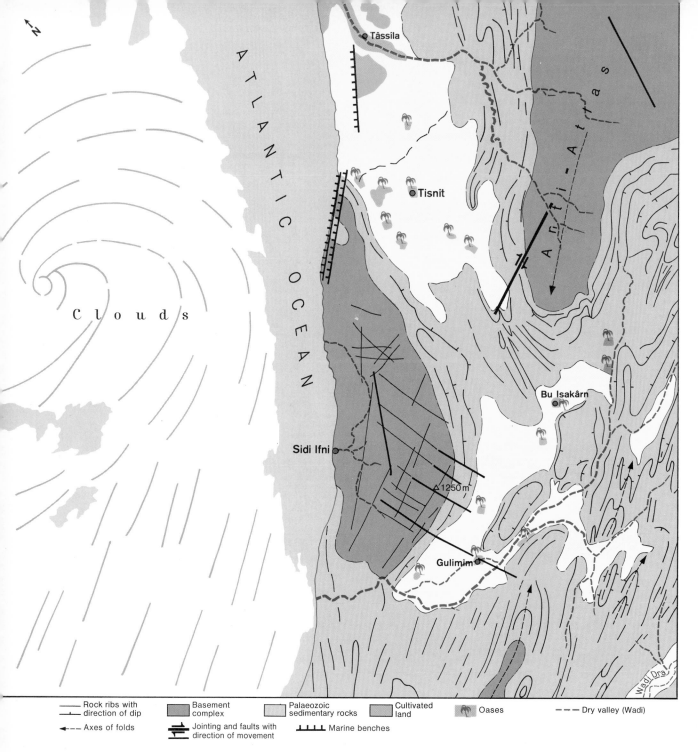

—— Rock ribs with direction of dip	▨ Basement complex	▨ Palaeozoic sedimentary rocks	▨ Cultivated land	🌴 Oases	– – – Dry valley (Wadi)
◄– – Axes of folds	Jointing and faults with direction of movement	⊥⊥⊥⊥ Marine benches			

The white clouds of a cyclone in the atmosphere over the dark-blue Atlantic enliven the picture of the rigid, 'frozen' whirl of folded rocks at the southern end of the Anti-Atlas Mountains.

The section of the coast of South West Morocco stretches 40 to 200km south of Agadir, which was almost completely destroyed by an earthquake in 1960. In the central part of the coast lies Ifni, which was a 2,000sq km Spanish enclave from 1878 until 1969. when it was given back to Morocco.

The dominating elements on land are the mountain ridges, with the zig-zag folds of the Anti-Atlas which ends here. It runs parallel to the High Atlas, which is separated from it by the earthquake-prone basin of Agadir, and extends in front of the High Atlas towards the Sahara in the south and south-west. The mountains are, in general, of moderate height, only individual peaks reach a height of more than 2,000m, eg in the north-east corner of the picture. Compared to the High Atlas, the Anti-Atlas has little vegetation, while over large areas there is no vegetation at all. The rock series involved in the folding of the mountains have been carved out through erosion of the variable hard and soft strata.

In the core area metamorphic rocks (which have undergone transformation by high temperature and high pressure) of the precambrian basement complex are upwarped and outcrop on the

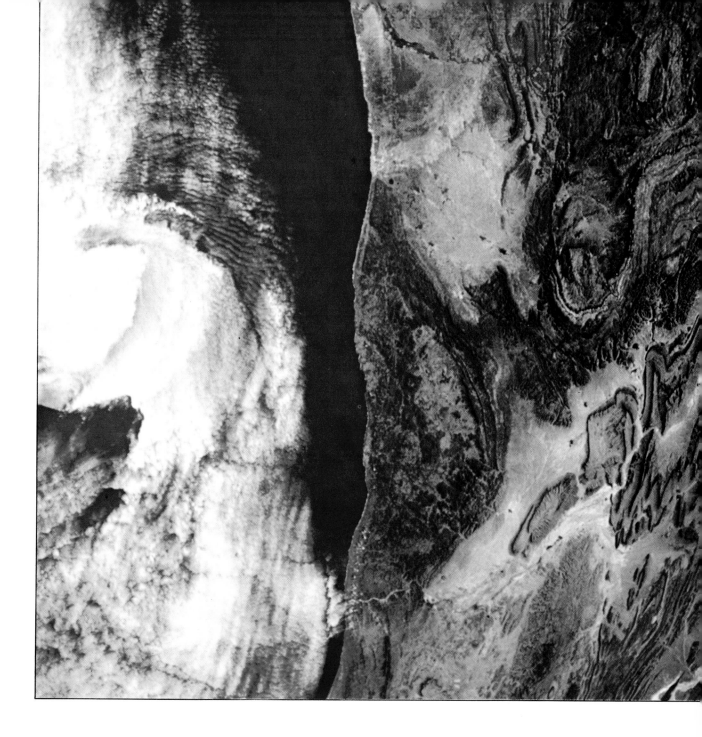

surface. They reappear, interrupted by a cross depression for a short distance, at the Atlantic coast in the area around Ifni. The covering palaeozoic stratified rocks follow the arched core in their structure. They clearly contrast with the basement complex through reddish-brown colouring. The brown strip passes over into alternating thick hard quartzites and soft argillites. The quartzites are carved out through erosion into mountain ribs (some hundred metres high) and copy the formation of the folds in the course of their crests, only interrupted by deeply cut wadis filled with light sand.

Over the cloud-free Atlantic coast-line, surf marked by light dots can be seen in places. About 50km off the coast over the open sea there is a cloud-cover. North-easterly off-shore winds blowing parallel to the High Atlas and the Anti-Atlas cause a clearly discernible whirl where cold and warm air currents meet. The direction of rotation of these cyclones, with thick white clouds in the centre and cumulus and cirrus clouds at the periphery, is anti-clockwise.

On the mainland it becomes obvious how the vegetation and settlement depend on the sand-filled wadis and the alluvial plains, which either closely follow the mountain chains or cut through them. The mountain chains themselves are free of vegetation, apart from the higher regions of the Anti-Atlas which are covered by a thin forest. The southern spurs of the fertile alluvial plain of Agadir are visible in the coastal plain at the top edge of the picture. The irri-

gated land along the Wadi Massa and the vegetation along the coast appear as dark, blue-green spots. Corn and citrus fruits are grown. The rocky areas further south are far less fertile, in the area around Ifni some maize is grown on a small scale.

South of the Anti-Atlas a mainly dry region stretches towards the Sahara. The desert is traversed by innumerable wadis which carry water for a short period immediately after the rare downpours in the Anti-Atlas. Morocco's famous date-palm oases lie in these wadis along the edge of the Sahara. The most significant wadi is the Wadi Draa, part of whose dry bed is shown in the bottom right corner of the picture. It has its source in the High Atlas, cuts through the Anti-Atlas in a southerly direction and follows its peripheral ranges parallel to the central Sahara over a length of 1,300km to the west. In its upper valley it carries water all the time, in the central part it carries surface water periodically, but always a great deal of ground water. Seldom are the rains so profuse that the Wadi Draa carries surface water in its lower course, as well. It flows into the Atlantic just south of the edge of the picture.

The oasis settlements, called 'Kasbah', are an important part of the South Moroccan landscape, and form a popular tourist attraction. Some of the oases can be recognised as dark, geometrically defined spots in the vast sand plains in the southern part of the picture as well as in the tributary valleys of the Wadi Draa. Ifni is the most important town of this area, the second largest settlement is Tisnit with about 7,000 inhabitants at the southern end of the fertile coastal strip of Agadir.

The most important road which crosses this area, is the most westerly of the Trans-Saharan routes, the Piste de Mauritanie. Coming from Agadir it touches Tisnit, runs through the Anti-Atlas to the Wadi Draa and from here onwards, though incomplete, forms the only overland link with Dakar, the capital of Senegal.

100

18 Namib desert in South West Africa

NASA-Photo: 65-2652, SCI-1195, Gemini V
Exposure: G. Cooper and C. P. Conrad
Date: 27.8.1965
Camera: Hasselblad 500 C
Lens: Zeiss Planar 80mm
Film: Kodak SO 217 (Ektachrome MS)
Altitude of exposure: about 330km
Axis: approximately vertical
Scale: approximately 1:1,000,000
Area covered: about 40,000km²

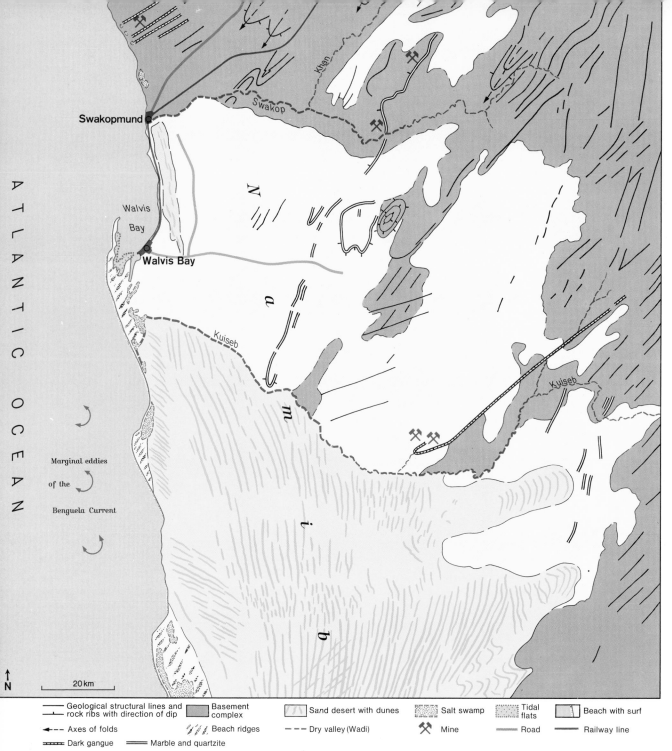

Marginal eddies

of the

Benguela Current

Swakopmund

Walvis
Bay

Walvis Bay

N

a

m

i

b

Khan

Swakop

Kuiseb

Kuiseb

N

20 km

——— Geological structural lines and rock ribs with direction of dip	Basement complex	Sand desert with dunes	Salt swamp	Tidal flats	Beach with surf
◄--- Axes of folds	Beach ridges	– – – Dry valley (Wadi)	⚒ Mine	══ Road	Railway line
▭▭▭ Dark gangue	══ Marble and quartzite				

This geologically and geographically unique satellite photograph is characterised by sand bars jutting out from the Atlantic coast, the reddish-yellow, seemingly frozen dunes of the Namib, and by the distorted and folded base of eroded sand-covered mountains. The clarity, which enables us to distinguish every detail, and the brilliance of the colour reproduction make it possible for the geologist to collect new and valuable information about a desert area which usually appears as a white patch on the geological map.

In the north of the picture the River Swakop with its tributary the Khan can be clearly seen. The town of Swakopmund is situated at its mouth. The River Kuiseb meanders south along the vast dune field of the Namib. A sand-bar in the middle part of the coast, jutting out 20km to the north, forms Walvis Bay. Along its shore the town of the same name can be recognised by its grey-blue colour.

We can see the folds and structures of the old precambrian mountain ranges in considerable detail. Individual infaces are carved out into ribs and show narrow, intensely distorted folds. The rocks are gneiss and granites into which are inserted ribbons of marble. These white bands of marble stand out particularly clearly in the picture, and, by following their serpentine lines, even small folds can be seen. The folded mountain ranges of South West Africa, running from north-east–south-west, meet the Atlantic coast at an acute angle and disappear where the

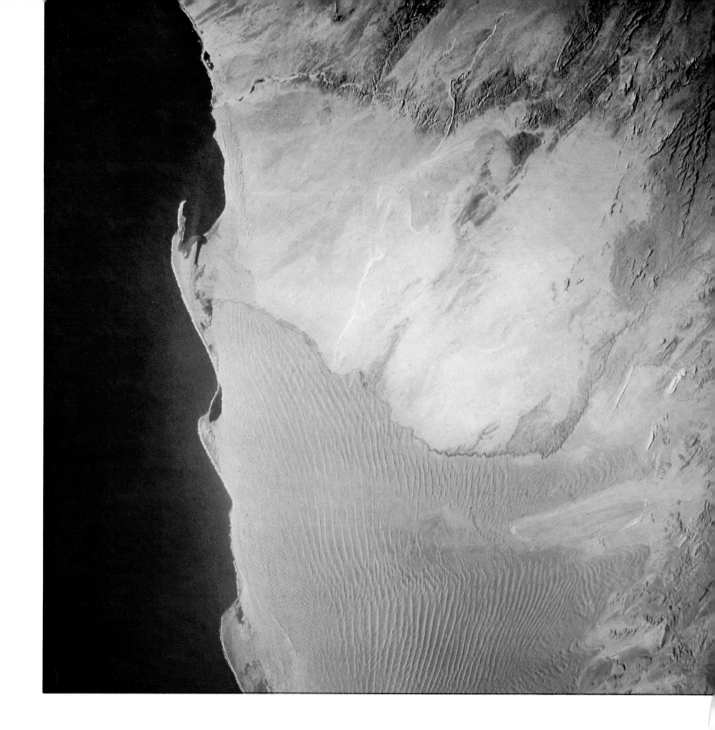

continental shelf breaks off, 80km off the coast. These structures are additional evidence of the tearing apart of the continents, as they can be found again and followed with the same form and direction on the South American continent on the other side of the Atlantic.

The structures gradually dip towards the south-west, which is clear from the hyperbola-shaped ribs. The old precambrian mountains are now well worn and a reduced relief only exists because rivers have subsequently cut down into the mountains and because of the varying hardness of the rocks. The average surface altitude in the central part of the picture reaches 700m. The land slopes gradually towards the sea. The rock ribs, described above, tower as elongated mountain ridges 100 to 400m above their surroundings.

Apart from the white marble ribs in the centre-right of the picture, a fine, straight, black sill of basic rock can be seen. This lies north of the Kuiseb and turns back on itself in the form of a hook towards the north-east. The sill which can be followed for 80km, is rich in mineral deposits as is the white marble.

Copper, lead and tin deposits, the existence of which has been known for more than 60 years, lie here like pearls on a string. Thus the knowledge of geological relationships is useful for large scale prospecting. Furthermore South West Africa is rich in pegmatite deposits, which do not

stand out from the gneiss-granite series in the picture.[1] They serve mainly as raw material supplies for the light metal industry. In the region east of Walvis Bay, the cover of sand is like a thin veil, which makes the underlying structures visible. Only south of the Kuiseb do the old mountains disappear completely under the enormous sand-dunes of the Namib. The sand desert stretches south as far as the River Orange. Much of the desert is a prohibited area since diamonds, which are systematically exploited by the large South African diamond trusts, are found here.

Off-shore winds blow on to the beach and towards the sea. The large dune field with crests directed towards north-south or south-east–north-west was formed by continuous winds blowing in the direction of the sea. Near the coast are smaller dunes which indicate the region where the daily changing land and sea winds are effective.

In the picture three larger spurs (sand hooks or sand bars) pointing from south to north are conspicuous. It is often incorrectly stated that they owe their existence to the Benguela Current, which flows in a south–north direction in the Atlantic. The area covered by this photograph lies between latitudes 22°S and 25°S. About 3,000km further south, around 50°S lies the storm region of the southern hemisphere, the 'Roaring Forties'. In this region strong gales occur regularly throughout the year, but particularly during the southern hemisphere's winter (ie June and July). These gales cause waves which move as a strong swell towards the east and north-east. The wave front crosses the southern Atlantic Ocean to the south-west coast of Africa in about three days. In the shallow water off the coast the swell builds up and reaches the coast as strong surf. This surf produces a current which flows predominantly in a northerly direction, transporting sand-masses through the surf to the north. Through the mechanism of the transport long narrow beach ridges, sand hooks and sand bars of various sizes are formed. The direction of transport can be clearly seen in the picture. In spite of the great altitude the strong surf along the coast can be seen on this satellite photograph in the shape of small white dots. The sand bars, which extend towards the north, form bays, which are gradually filled in. Here a sparse vegetation and salt lakes develop in the shelter of the beach ridges and sand bars. On the photograph they are visible in the greenish-blue colour of the lower half of the picture.

The desert region is only thinly populated. A few smaller villages and settlements follow the course of the River Kuiseb. There are also a few settlements along the Swakop although this river carries water only every five to ten years. The largest settlement is Walvis Bay, situated on the bay of the same name. In the picture one can also see, in the shape of a thin white line running in an east–west direction, the road from Walvis Bay to Windhoek, which lies east of the picture. The large salt-pans north of Swakopmund, important as salt suppliers for the Republic of South Africa, lie side by side as grey-blue, clearly defined patches along the coast.

[1] Pegmatites (coarse grained igneous rock) are formed during the cooling-off process of magmatic rocks, which either penetrated into the crust or came into existence through the melting of crust material during the metamorphosis (change of rocks through higher pressure and higher temperature).

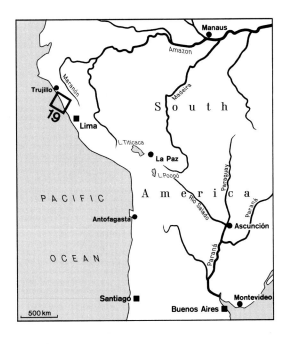

19 Pacific coast of Peru

NASA-Photo: SCI-1193, Gemini V
Exposure: G. Cooper and C. P. Conrad
Date: 21 to 28.8.1965
Camera: Hasselblad SWA
Lens: Zeiss Biogon 38mm
Film: Kodak SO 368 (Ektachrome MS)
Altitude of exposure: about 200km
Axis: approximately vertical
Scale: about 1:1,250,000
Area covered: about 57,000km²

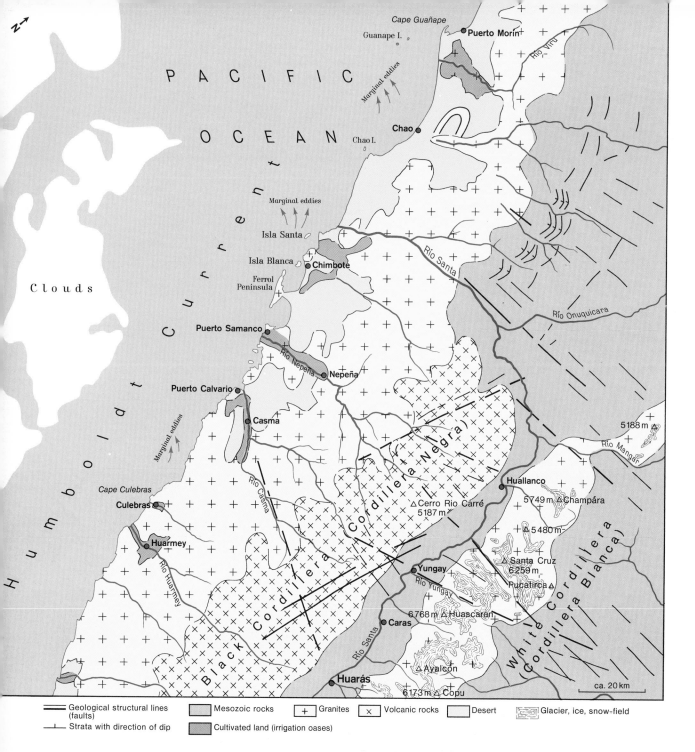

▬▬ Geological structural lines (faults)	▨ Mesozoic rocks	+ Granites
┴ Strata with direction of dip	▨ Cultivated land (irrigation oases)	× Volcanic rocks

× Volcanic rocks	☐ Desert	▨ Glacier, ice, snow-field

In the hinterland of the desert-like coast of Peru, the Andes, with deeply incised gorges, rise abruptly to a height of 6,000m. Only 80km separate the ice-covered summits of the Cordillera Blanca from the arid coastal plains.

Between 9°S and 10°S the Cordillera Occidental is divided into two ranges, the Cordillera Negra and the Cordillera Blanca, by the longitudinal valley of the Rio Santa, which has a length of more than 200km. In the west a narrow flat strip of coast extends in front of the mountain ranges, which, because of the influence of the cold Humboldt Current, is of desert-like character from Central Chile to North Peru.

The satellite photograph covers a section of the desert and mountain region about 300km north of Lima, 200 by 200km in area. At the time when the photo was taken the sun was in the north-west. The considerable relief of the mountain ranges becomes clearly visible through the shadows on the slopes.

On the left of the picture lies the Pacific Ocean with the cloudless area over the Humboldt Current, running parallel to the coast. The coast of Peru appears south of Chimbote (in the middle of the picture) as strongly indented and rocky and north of this town as low with a smooth form and extensive strips of sand. The high, deeply dissected mountains of the Cordillera Negra and the Cordillera Blanca fill the greater part of the right half of the picture. The broken white

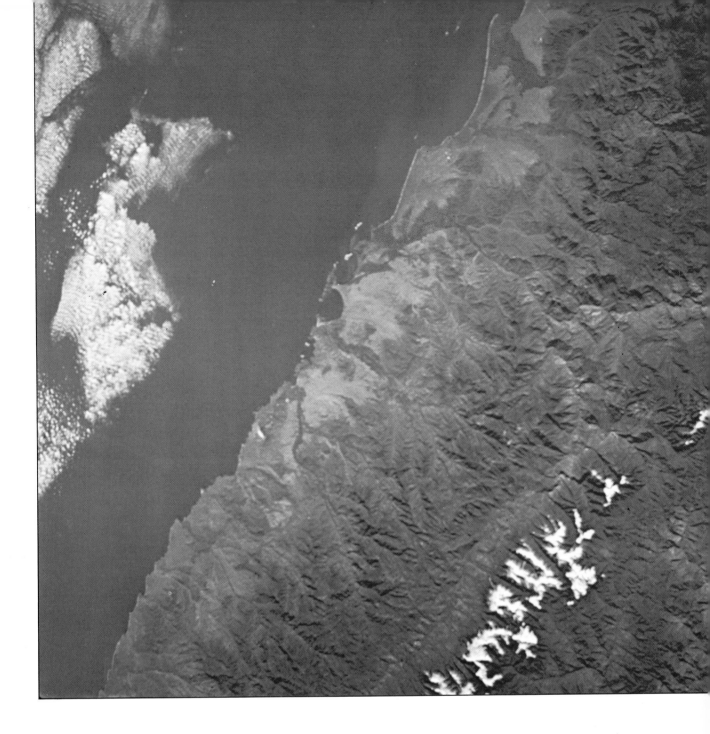

patches, the extensive glaciated areas of the Cordillera Blanca, are very conspicuous. The Cordillera Blanca, the 'White Cordillera', owes its name to these summit regions covered by permanent snow and glaciers. It is the backbone of the Peruvian West Cordillera rising abruptly from the coast in the west and towering over the upland in the east. It is perhaps the most impressive mountain region of the whole of the tropical Andes. For over 170km one ice-covered peak follows another, built up out of strongly folded mesozoic strata and post-cretaceous granodiorite intrusions (subterranean penetration of magma between other rocks). The folds of the Andes strike parallel to the mountain ranges. In the top half of the picture rock series of a length of 40km can be traced through different colour tones, which show the main trend of the structures.

The coastal strip is mainly built up out of granites and granodiorites, which, in the picture, stand out indistinctly against the high regions through their slightly lighter colours. The mountain landscape of the West Cordillera itself is built up of intensely folded, mesozoic sedimentary rocks. Plutonic and volcanic rocks which penetrated into the folded series caused the splitting into two crests. The Cordillera Blanca owes its morphological uplift to a series of granite stocks which penetrated mushroom-like into the ridge of a saddle. The Cordillera Negra which runs parallel in the west is formed, as its name suggests, out of black volcanic rocks which cover

the mesozoic sediment base. The longitudinal valley of the Rio Santa striking parallel to the folds follows soft mesozoic rocks which were excavated between the granite domes of the Cordillera Blanca and the volcanic rocks of the Cordillera Negra as less resistant material. The water gap of the Santa valley to the sea depends on a transverse depression in the crest of the West Cordillera.

The present height of the mountain crests was reached through uplift after the main folding. In the upper Santa valley diluvial uplifts of several hundred metres have been established.

Most of the valleys which drain the mountain ranges at the margin follow fractures or clefts, which can be clearly seen in the picture by the parallel formation of the valleys. Some further diagonal faults can be recognised particularly in the region of the Cordillera Negra. In this picture it is possible to differentiate the various rocks not because of the colour but because of the different morphological shaping of the individual mountain ridges.

In the region of the coast one can see rocky peninsulas, small islands and beaches of white sand. Particularly in the middle and upper part, the coastal strip is less mountainous and is covered by yellow-brown desert areas with no vegetation. The only interruption is the broad dark courses of the rivers. The coastal zone is one of the most arid areas on earth, a characteristic which, in spite of the position in the tropics, can be explained through the influence of the Humboldt Current. The temperature of the water off the coast is only 14 to 17 degrees centigrade (only $10°$ from the equator). The cold Humboldt Current influences the temperature of the air above it. The narrow ribbon of higher air pressure above the cold water along the coast at this time of the year is marked by the cloudless strip parallel to the coast. The Humboldt Current, which flows north at a speed of 1.5 knots, does not rank among the strong ocean currents; it does, however, cause marginal eddies along the coast and sand bars to the north.

The Cordillera Negra has no glaciers though it is more than 5,000m high. Tarns and moraines of an earlier glaciation cannot be identified on the satellite picture because of the small scale. The Cordillera Blanca is glaciated in its entire summit region. Thanks to an expedition of the German and Austrian Alpine Club in the Cordillera Blanca in 1939, one of the best maps of the entire Andes region is at our disposal today. On the satellite photograph only the northern half of the Cordillera Blanca is recognisable. The highest peak is the Huascarán with a height of 6,768m. When comparing the 1939 map with the satellite picture one can see, as far as is possible with the small scale of the picture, that the glaciers have approximately the same extent as they did thirty years ago. The snow line lies at a height of between 4,700 and 5,200m. The Cordillera Blanca forms the watershed between the Pacific Ocean, into which it drains via the Rio Santa, and the Amazon Basin.

The rivers which drain the cordillera have cut deeply into the terrain. Thus the Rio Santa falls 5,300m over a length of only 332km.

The vegetation is ordered in parallel strips from the coast up to the peak region of the Cordillera Negra. According to altitude, one can distinguish between various zones, beginning with desert, cacti forest, bushes, sparse woodland and ending up with thick woodland in the higher mountain areas.

Settlement is concentrated on the coastal plain, in the regions where the numerous rivers carrying water flow into the sea and in the longitudinal valley of the Rio Santa in the Cordillera. In some places jagged ledges along the coast permit the building of harbours, as for instance Chimbote. The areas of settlement in the desert region were turned into river oases (Valles) through irrigation and used for mono-cultures according to position and soil. The irrigated regions clearly contrast through their bluish-green colour with the yellow-brown of the desert.

The large scale irrigation plans of the Peruvian Government concerned themselves with those rivers which have the greatest fall and only a third of their water is used. It is also intended to build power stations and reservoirs for energy production. In the coastal oases cotton, sugar and vegetables are grown.

Because of its profusion of plankton, the cold sea water of the Humboldt Current abounds with fish, on which enormous flocks of cormorants and pelicans live. On their breeding grounds, for instance on the two small islands off the coast, Isla Santa and Isla Blanca which can be seen in the picture, the bird droppings collect into guano deposits which are processed into fertilizer.

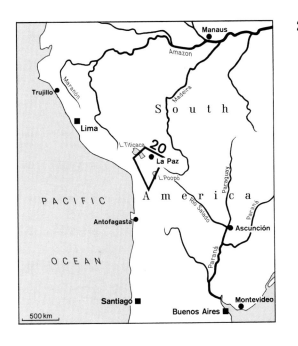

20 Lake Titicaca in the highlands of the Andes

NASA-Photo: SCI-1193, Gemini V
Exposure: G. Cooper and C. P. Conrad
Date: 21 to 28.8.1965
Camera: Hasselblad 500 C
Lens: Zeiss Planar 80mm
Film: Kodak SO 217 (Ektachrome MS)
Altitude of exposure: about 200km
Axis: inclined, therefore lower part of the picture strongly distorted
Scale: about 1:1,000,000 to about 1:2,000,000
Area covered: about 125,000km²

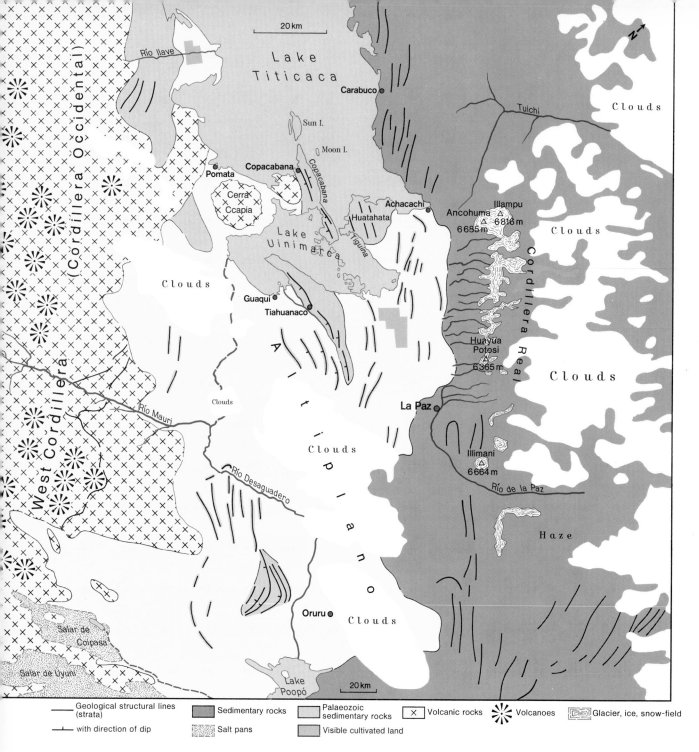

——— Geological structural lines (strata)	▓ Sedimentary rocks	░ Palaeozoic sedimentary rocks	⊠ Volcanic rocks	✳ Volcanoes	▨ Glacier, ice, snow-field
——⊢ with direction of dip	░ Salt pans	▒ Visible cultivated land			

Snow and ice-covered mountain giants of the Cordillera Real and the volcanic ranges of the Western Cordillera surround the Altiplano of Bolivia, a plateau of economic importance even at the time of the Incas, lying 3,500m above sea level. Imbedded in it is Lake Titicaca, whose shoreline is broken up by young volcanoes and folded rock ribs. As the shadows of the clouds and mountains show, the sun was very low at the time when the photograph was taken. The result is an intensification of the stray light in the atmosphere and a blueness in the photograph.

The picture can be divided into three morphological units. In the east (right) one can recognise the main range of the Eastern Cordillera with the peaks of the Cordillera Real, covered by snow and glaciers – peaks which are all between 6,000 and 7,000m high. The Cordillera Real is furrowed by deeply cut valleys. The east slope of the mountains, which is in the drainage basin of the Amazon (Rio Beni), is covered with dense tropical vegetation (jungas = jungle), which is clear in the satellite picture through the haze and clouds, which largely conceal the slope of the mountains. The great differences of altitude towards the Amazon region cause the valleys to cut gorge-like into the mountains. In the middle of the picture one can see the plateau of Bolivia, the Altiplano, a fault depression in the central part of the Andes, with an area of 50,000sq km. At the north end of this highland basin lies Lake Titicaca, whose southern half can be seen in the top left of the picture. The Cordillera Occidental, the Western Cordillera, follows

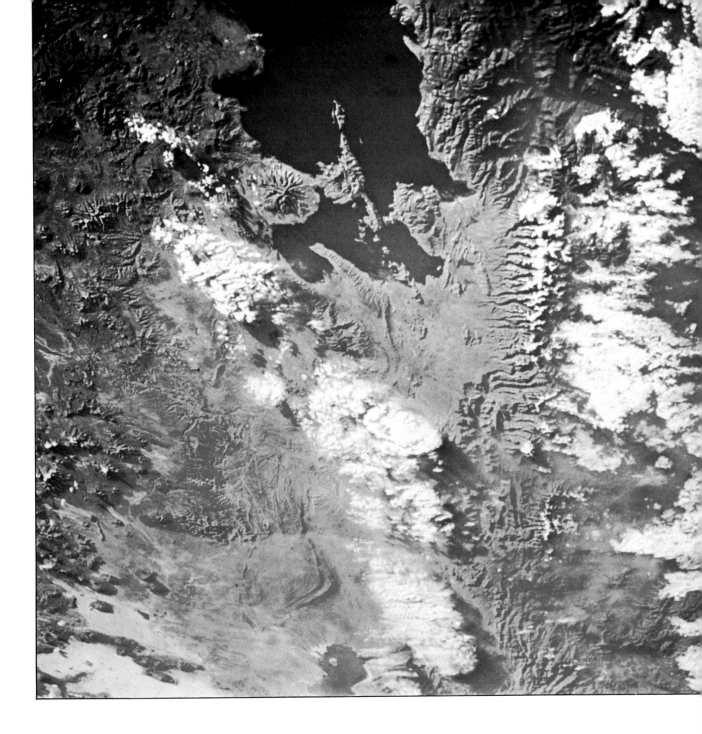

towards the west, a volcanic mountain range with extensive extrusions of lava, from which many individual volcanic cones, recognisable on the satellite picture by their pointed shape, project.

The morphology of the Altiplano, the Western and Eastern Cordillera is strongly stamped by the tectonic structure of the Andes.

In the Eastern Cordillera, there are intensively folded palaeozoic rock series striking north-west–south-east, whose trend clearly stands out on the satellite photograph through the parallel arrangement of smaller ridges. In the central part of these folded mountains dome-shaped magmatic rocks were pressed to the surface. These granite domes, which originated during the tertiary period, have been largely laid bare by glacial erosion and form the crest of the Cordillera Real, which runs in a straight line in the picture and is covered by ice and snow. The Cordillera Real is bordered in the north by the two peaks Illampu and Ancohuma which are about 6,500m height and in the south by the conspicuous pyramid peak of the Illimani.

The Altiplano is to be interpreted as a Graben-like depression created after folding. It is filled with recent detritus and gravel deposits, which are sporadically pierced by the folded ridges of older rocks.

The Western Cordillera is built up out of a base of mesozoic folded sediments, which is not

visible in the picture. Along young faults running parallel to the ranges of the high mountains, basaltic rocks were forced up in very recent times and covered the entire Western Cordillera with enormous lava flows. The famous volcanoes of the South American Andes are situated on the watershed, located exactly on the fault lines. On the left one can recognise a great number of these volcanic cones which reach a height of up to 6,000m, some of which are still active today. Their shape becomes particularly clear through the pointed shadows which they cast into the foreland.

Lake Titicaca lies 3,812m above sea level and covers an area of 8,100sq km. It has a length of 190km and a width of 50km. In the main lake, which is situated in the north, depths of 272m have been measured. The southern part of the lake is connected with the main lake by the narrow Tiquina straits running between the peninsulas of Copacabana and Huata. Lake Titicaca at one time covered a much larger area. Its level was more than 100m higher, as can be seen by the presence of terraces 80 to 100m above the present shore-line. The lake drains through the River Desaguadero, into the salty Lake Poopó, which lies 300km further away at a height of 3,698m. Poopó is 100km long but only 3m deep; from here water flows into the salt basins of South Bolivia which have no outlet (Salar de Coipasa and Salar de Uyuni at the bottom of the picture).

The annual fluctuations of the water level of Lake Titicaca amount to 2 metres (high-water mark in June, low-water mark in October). Most of the rain falls during the evening. About 40 per cent of the water which flows into the lake comes from the drainage area of the lake, and the other 60 per cent from rainfall directly over its surface. As a result of the strong evaporation of the water over the lake the air on the shores is more moist than in the surrounding highland. That is why there is a particularly high amount of stray light, which explains the dark blue colouring of the water and the surroundings in the picture.

The mass of water of Lake Titicaca has a moderating effect on the climate of the surrounding area. March to November (summer in the southern hemisphere) are free of frost. This was certainly one of the most important reasons for the prehistoric settlement in this area, and for the intensive colonisation of the region during the time of the Incas. Lake Titicaca was a holy lake for the Incas and a centre of larger civilisations. On the shore of the lake there are places with ruins of the Tiauano culture (0 to 1,000 AD). The density of population of the region around the lake is in striking contrast to the deserted areas of the surrounding mountains and the sparsely populated high valley. The agricultural area, important since prehistoric times, is still intensively cultivated today. The cultivation is pursued on artificially terraced terrain between 3,800 and 4,300 metres. The terraces are too narrow to be picked out on this picture. The present agricultural structure dates back to conditions which already existed during the time of the Incas. Maize, beans, peas, and also wheat and potatoes are grown. Areas which lie higher up are used as pastures and llamas and alpacas are bred.

The border between Bolivia and Peru runs through the middle of the lake and across the Copacabana Peninsula. Sixty kilometres east of the lake, in a high valley, which is cut into the Altiplano and drains via the Rio de la Paz and the Rio Beni into the Amazon basin, lies La Paz, the capital of Bolivia, at a height of 3,500m.

World-famous tin and silver mines lie around Oruru in the south of the picture. The origin of the tin-ore is connected with the young volcanic rocks of the highland. Significant silver deposits (Potosi), basis of the wealth of the Spanish Crown from the sixteenth to the eighteenth century, follow further west. These mining regions are on the picture, but are concealed by the cloud-cover in the south-western part.

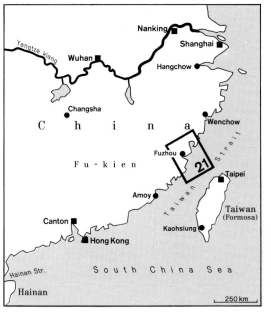

21 Archipelago of the Chinese coast at the Strait of Taiwan

NASA-Photo: S 65-45650, Gemini V
Exposure: G. Cooper and C. P. Conrad
Date: 21 to 28.8.1965
Camera: Hasselblad 500 C
Lens: Zeiss Planar 80mm
Film: Kodak SO 217 (Ektachrome MS)
Altitude of exposure: about 220km
Axis: approximately vertical
Scale: about 1:700,000
Area covered: about 20,000km^2

113

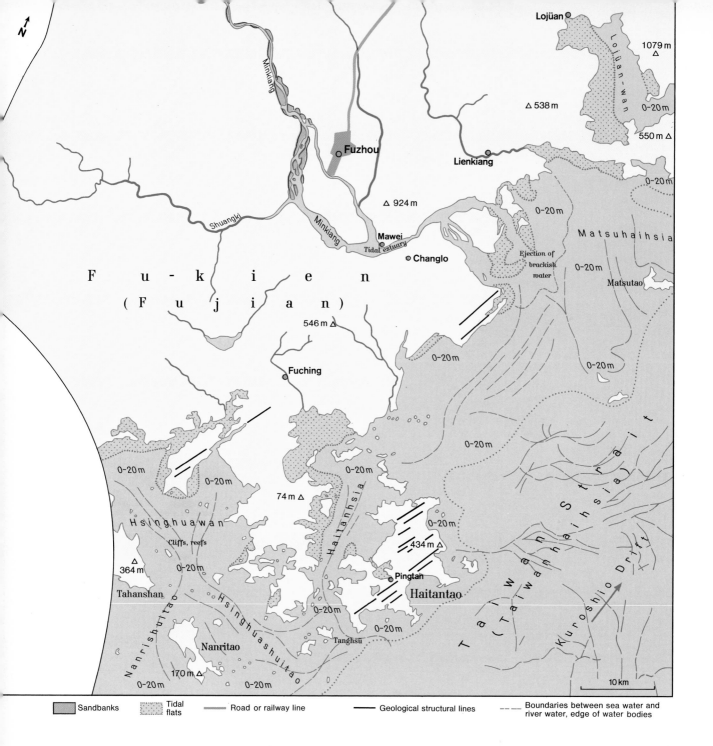

| | Sandbanks | | Tidal flats | Road or railway line | Geological structural lines | Boundaries between sea water and river water, edge of water bodies |

The broken mountainous country of South East China, the jagged coastline and the archipelago, the complexity of the ocean currents (coloured in different shades of blue) make this picture very complex, but it offers the reader an unexpected wealth of information.

The 130 by 130km picture shows the coastline of the province Fu-kien and the transition from the Taiwan Strait, which is 150km wide here, to the open sea. The mountainous country of South East China in the province of Fu-kien, built up predominantly of granites and volcanic rocks, counts among the 'mature' landscapes, which have been worn down by the forces of erosion, completely dissected by rivers, so that no remnants of the original land surface exist. A complex disintegrated relief with heights up to 500m and a landscape with individual knolls and hills characterise this region. The rivers Minkiang and Shuangki cut through the mountainous country. The course of the Minkiang, with its braided river bed, the meanders and sand banks stands out as a light ribbon.

North of the island which separates the two arms of the estuary lies the capital of the province, Fuzhou. Situated 68km inland from the estuary, it is one of the largest towns along the coast between Shanghai and Canton.

The monsoon climate with prevailing south-easterly winds and strong rains in the summer means that the region is very fertile. The rivers carry a lot of water during the rainy season but

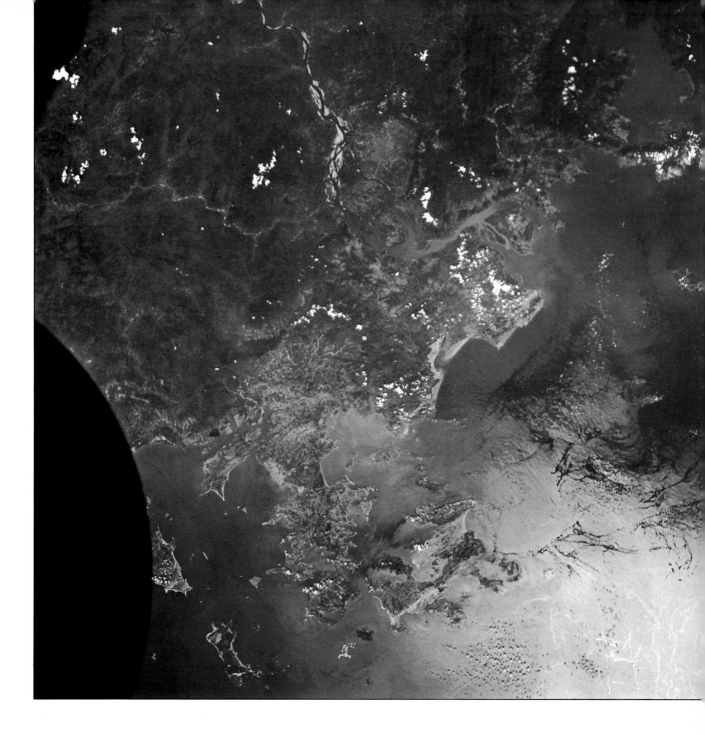

they had not reached their peak level when this photograph was taken. Herbal teas, silk and rice are the main crops grown in this region of China. Fuzhou is known as a trading town for these products and is a port of trans-shipment for wood. The harbour of Mawei lies 17km down the river.

The coastal region is extremely broken and dissected and since ancient times has offered numerous hiding-places to pirates who constituted a danger until the beginning of the present century. After the Ice Age the sea rose to penetrate far into this hilly region. In addition tidal flats have formed along the coast and represent the first large land forms that have adjusted to the shore-line processes. Tidal flats and mangrove forests are widespread. The tidal magnitudes with high and low water twice a day, are very great. In the bays and the estuary of the Minkiang the tidal high water level reaches heights of more than 6m. The tidal delta appears a browny-blue in the picture, since the river carries a great deal of mud. The muddy brackish water (a mixture of fresh water and sea water) mingles with the clear sea water off the estuary.

The sea area off the coast is part of the Taiwan Strait, which is 160km wide, and links the South China Sea (in the south) with the East China Sea (in the north). The Taiwan Strait belongs to the South East Chinese epicontinental sea whose deepest isobath, east of Taiwan, reaches 200m. The area of sea shown in the picture is only 75m deep. The 20m isobath can be

traced by the different shade of blue. The various colours of the sea are quite striking with the complex pattern of lines and streaks. These variations are caused by a complicated system of currents.

The system of the Kuroshio Current, which is also called the Black Current because of its dark-blue colour and can be compared with the Gulf Stream, flows along the South East Chinese coast beyond Japan in a northerly direction into the West Pacific Ocean. Off Taiwan it divides with one branch flowing west of the island through the Taiwan Strait to the north. It enters the picture in the right-hand bottom corner. Nearer to the coast there is a system of currents changing with the seasons which transports water at a speed of 38cm/sec, ie 18 knots per day, from the north in the winter and with the monsoon from the South China Sea in the summer, the time when this photograph was taken. Because of the heavy summer rainfall in South China, the rivers have an increased flow into the South China Sea. Because of the seasonal northerly current along the coast, the less salty water mixes with the saltier and cooler water of the Kuroshio Current. Marginal eddies and current convergences occur in the area where the mixing takes place. They can be seen in the lower right part of the satellite photograph for the first time. Off the coast complicated stratification of water, marked by different shades of colour, can be seen. Particularly interesting from the oceanographic point of view are the dark-blue streaks off the coast in the middle of the picture. They are sea areas with different carbondioxide content. This carbondioxide is created in the water by micro-organisms under the influence of the sun's radiation (photosynthesis). Oceanographic examination in other areas has shown that such streaks in the shallow water off the coast are caused through rotation of the water at different depths.

In addition the tidal differences in these shallow epicontinental seas, similar to the North Sea, give rise to complicated currents and mixing of different water bodies.

It is obvious that the analysis of satellite photographs has great importance for oceanography and in particular for the fishing-industry. For instance, plankton can be located and thus those sea areas which attract shoals of fish.

22 Tuamotu Atolls in the Pacific Ocean

NASA-Photo: Apollo VII
Exposure: W. Schirra, D. Eisele,
W. Cunningham
Date: 11 to 22.10.1968
Camera: Hasselblad 500 C
Lens: Zeiss Planar 80mm
Film: Kodak SO 217 (Ektachrome MS)
Altitude of exposure: about 250km
Axis: inclined towards south-east,
therefore strongly distorted
Scale: in the foreground about 1:500,000
Area covered: >150,000km²

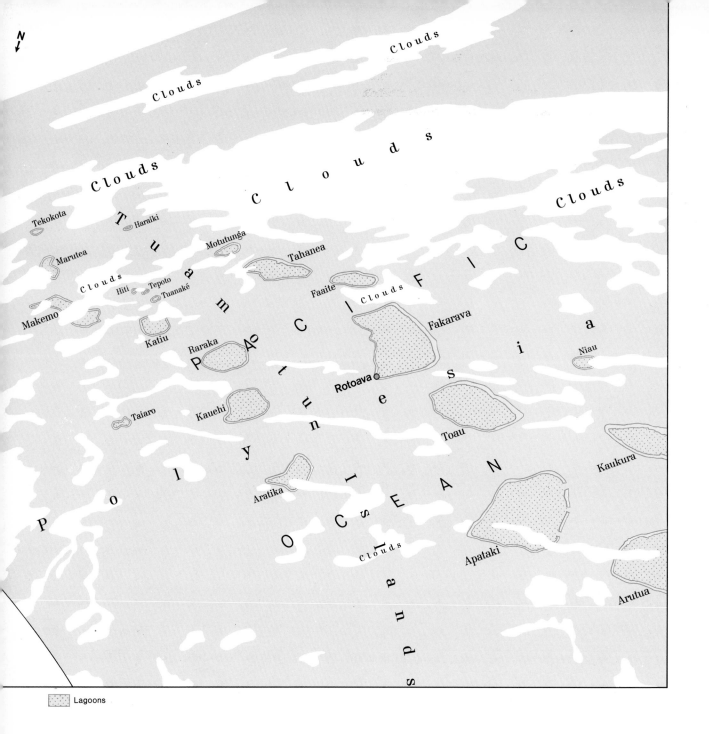

Lagoons

The irregularly shaped white rings of the Tuamotu Atolls are arranged like two strings of islands which are lost towards the south-east in the blue haze of the earth's curvature. The coral reefs standing only a few metres above the level of the water are situated on the highest elevations of the submarine mountain ranges in the tropic sea. The irregular shape of the reef fringes follows the relief of the sea bottom.

The archipelago of the Tuamotu Islands (300km east of Tahiti) extends across an area 200–300km in width and 1,500km in length. The picture shows the central section. There are seventy-six atolls in this remote island arc. On account of its shallowness it is very dangerous for navigation and because of this had been hardly explored until recently. Each atoll ring is built up of a chain of islands interrupted by openings and sea washed reefs. The number of islands, whose form and number change with every typhoon is still unknown.

The islands owe their existence to coral, a species which is only capable of living in tropical sea at water temperatures of more than 20° C. They build calcareous frames around themselves which, together with other organisms secreting lime, grow into coral banks and coral reefs, in the course of thousands of years. Coral settles on submarine mountains and particularly on mountains with a flat surface – called guyot. They need well ventilated clear water of low depth. Gradually the reefs grow to the surface of the water. The marginal parts grow more quickly,

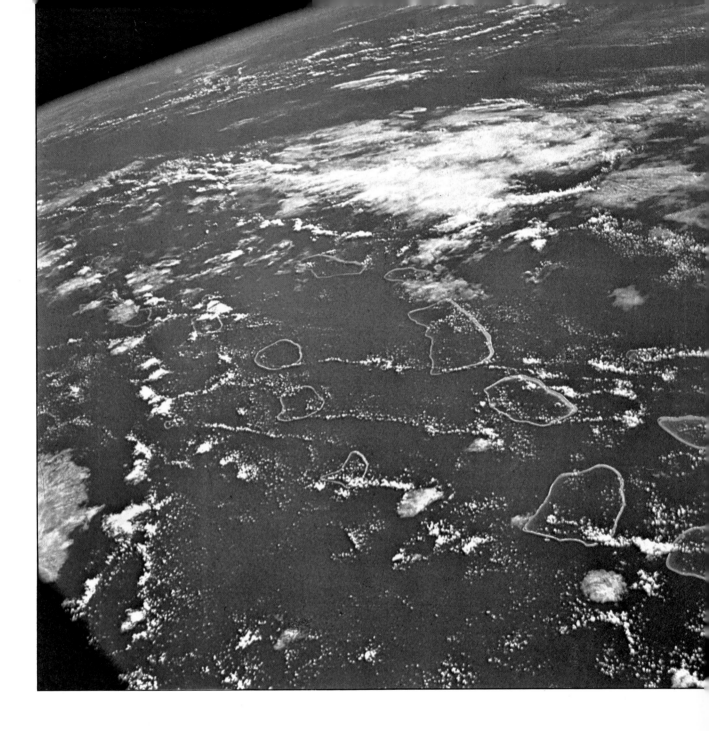

because here, towards the open sea, the water is richer in nutritive substances, and thus the reef fringes develop the coral. A flat island ring, 2 to 3m high, grows out of the sea. The reef, often only a couple of hundred metres wide, encloses a lagoon. It is cut off from the sea or only connected with it by narrow openings. The depth of the lagoon is usually fixed in proportion to the diameter of the atoll. (The largest fringe reef is the Great Barrier Reef along the entire length of the east coast of Australia.) The atolls in the foreground, especially Apataki, clearly show the topography of the fringe of the reef. Due to the great altitude from which the photograph was taken, the dense vegetation of palm trees can only be made out in the north-east corner of the Apataki Atoll. Surprisingly the shallow water of the lagoon cannot be distinguished from the open sea, being a lighter shade of blue, though the atoll of Kaukura has a shallow lagoon of light turquoise blue.

The islands lie in the tropical belt of trade-winds, 15° south of the equator. Here a cold period from March to September with predominantly good weather and south-easterly winds, alternates with a warm rainy season from October until March. The picture was taken just before the rainy season, at the beginning of October. The prevailing westerly wind, typical of the rainy season, has already set in and is indicated by the broad strip of surf along the west coast of the atolls Fakarava and Toau.

Geologically the Tuamotu Islands, with the Gambier Islands to the south-east, are spurs of the tectonic trend of the south eastern Pacific Ocean. The parallel Tuamotu ridges are continued in the extensive East Pacific Plateau, which stretches parallel to the coast of South America. The Tuamotu ridges, together with many other submarine ridges, are upwarpings of the Pacific basin which strike in a north-west–south-east direction. They are constructed of predominantly volcanic material from the earth's mantle. Crustal material is not found in the Pacific basin or if it is, it is only very thinly developed. The bedrock of the Tuamotu Islands has basaltic character. The volcanic rocks of the Tuamotu Archipelago do not appear above sea level as in the region of the neighbouring Tahiti and Gambier Islands. The guyots of the Tuamotu group are covered by tertiary coral reefs. In the quaternary period vertical movements occurred through which some of the islands (eg Makatea Island, just west of the picture) were raised as limestone plateaus, up to 40m above the sea. After the quaternary movement those volcanic guyots and tertiary coral, which were just under the surface, were again covered by coral and form the present atolls.

In contrast to the striking structural lines of the island arcs lying off Australia, which prove a converging movement of the Pacific bedrock off the continents of Asia and Australia, these East Pacific archipelagoes are the first small signs of the folding of the Pacific basin.

The islands are notorious for tropical cyclonic storms. Since the atolls never rise more than 4m above the normal level of the sea, hurricanes can cause great damage here. During the rainy months, particularly in January and February, many typhoons occur. On such occasions the open sea is lashed up by the gales to such height that the waves flood entire atolls.

In the history of seafaring it is frequently reported that atolls have been completely changed or sometimes entirely denuded of their palm trees. Typhoons have also caused the population of the archipelago to fluctuate. In January 1875 and in January 1878 the islands of Kaukara, Fakarava and Anaa were affected by typhoons and two years later a typhoon destroyed the settlement on the island of Anaa and more than 200 people lost their lives.

The Tuamotu atolls are particularly dangerous for navigation because of their shallowness, the difficulty of anchoring and the fact that many of the atolls are without easily navigable passages into the sheltered lagoons. Due to the prevailing west–south-west wind of the warm or rainy season, the habitable and wooded islands of the atoll rings are mainly developed in the north-east corner. Towards the west the atolls have wide flat reefs which are for the most part flooded by the surf and the tides.

The vegetation of the island is very monotonous. The areas which lie higher and are not flooded by the frequent storm tides are covered with dense tropical woods, in which the coconut palm is predominant. There are also pandanus (a species of palm with freestanding roots) and the bread-fruit tree, while mangrove swamps spread along the edges of the lagoons. Many of the flat islands are without vegetation or only have low bushes.

The Tuamotu Islands were mainly colonised by Polynesians who emigrated from the East Indies. The cultural remnants on Easter Island (3,000km further west) suggest links with the Incas of Peru. Thor Heyerdahl's voyage on the raft *Kon-Tiki* from South America, using the South Equatorial Current, to the Raroia Atoll (just to the east outside the picture) proved that such a connection is possible.

Today about seven and a half thousand people live on the 330sq km of the archipelago and it is administered from the Tahitian capital, Papeete. Only the southern part of the 1,500km long string of islands belongs to the administrative area of the Gambier Islands.

The Apataki Atoll, with its 155 inhabitants, is the largest and most important atoll of the northern Palliser Archipelago. The lagoon has a diameter of 20 to 27km. The second largest island of the archipelago, formerly the seat of the administration, Fakarava, with the village of Rotoava has 210 inhabitants. Anaa which, before the typhoon of 1903, was the main settlement of the archipelago, consists of 11 islands and has 410 inhabitants. The most important atoll of the eastern group is Makemo, where some 215 people live. The other islands are only sparsely or spasmodically populated. The archipelago was discovered by the Spanish in 1606 and annexed by France in 1881. From early times it has been strongly influenced by the more densely populated Tahiti, particularly as far as language is concerned.

The coconut palm and the export of copra is of considerable economic importance. Copra, the main export product of the islands of Oceania, is the sun-dried flesh of the coconut cut into strips, from which vegetable fat is produced. There is also pearl fishing, yielding pearls and mother-of-pearl, while the export of phosphate plays a minor role.

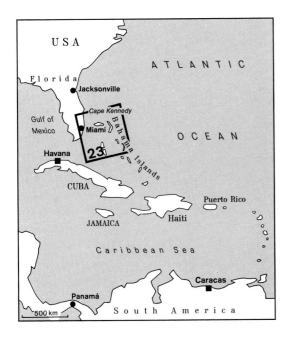

23 The Bahamas

NASA-Photo: S-66-62909, Gemini XII
Exposure: J. Lovell and E. Aldrin
Date: 12.11.1968
Camera: Hasselblad SWA
Lens: Zeiss Biogon 38mm
Film: Kodak SO 368 (Ektachrome MS)
Altitude of exposure: about 250km
Axis: slightly inclined towards north
Scale: about 1:3,000,000
Area covered: about 36,000km²

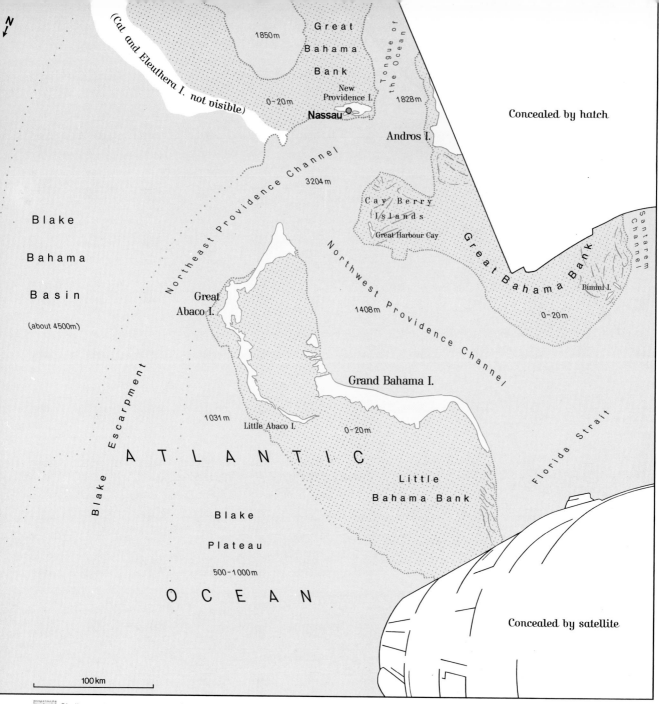

N

1850m

Great
Bahama
Bank

New
Providence I.

0-20m

Nassau

Tongue of the Ocean

1828m

Andros I.

(Cat and Eleuthera I. not visible)

Concealed by hatch

Blake

Bahama

Basin

(about 4500m)

3204m

Northeast Providence Channel

Cay Berry
Islands

Great Harbour Cay

Great Bahama Bank

Santarem Channel

Bimini I.

0-20m

Great
Abaco I.

Northwest Providence Channel

1408m

Blake Escarpment

Grand Bahama I.

A T L A N T I C

1031m

Little Abaco I.

0-20m

Florida Strait

Little
Bahama Bank

Blake

Plateau

500-1000m

O C E A N

Concealed by satellite

100km

Shallow water areas ───── Current lines

The light-blue ocean bottom of the Bahama Banks, covered by shallow water contrasts vividly with the dark blue of the wide, deep channels which divide the submarine platform on which the Bahama Islands are situated. The islands, world-famous as a holiday area, are strung like a delicate chain along the edges of the banks. They can be recognised by the currents in the shallower water and by their bluish-green colour.

The photograph was taken through the open hatch of the space capsule. The shadow of the hatch can be seen at the top and at the bottom the contour of the Agena rocket which was linked to the capsule at the time when the picture was taken.

The Bahama Banks belong geologically to the once continuous, horizontal limestone plateaus of Cuba, Florida and Yucatán (predominantly oolites and sandy limestones from the cretaceous and tertiary period). The individual limestone plateaus are separated from each other by deep, box-shaped valleys with level ground. These box-shaped sea channels separate the individual Bahama banks as well as the entire archipelago from Florida and Cuba. They reach a depth of up to 1,800m. The channels follow large fault lines, along which the once continuous limestone plateau of Cuba-Florida-Bahama was torn apart and divided into individual segments.

The banks, covered by water of 20 to 100m in depth, dip with escarpments of on average 1,000m (maximum 2,000m) towards the channels, which have a width of 30 to 100km. The

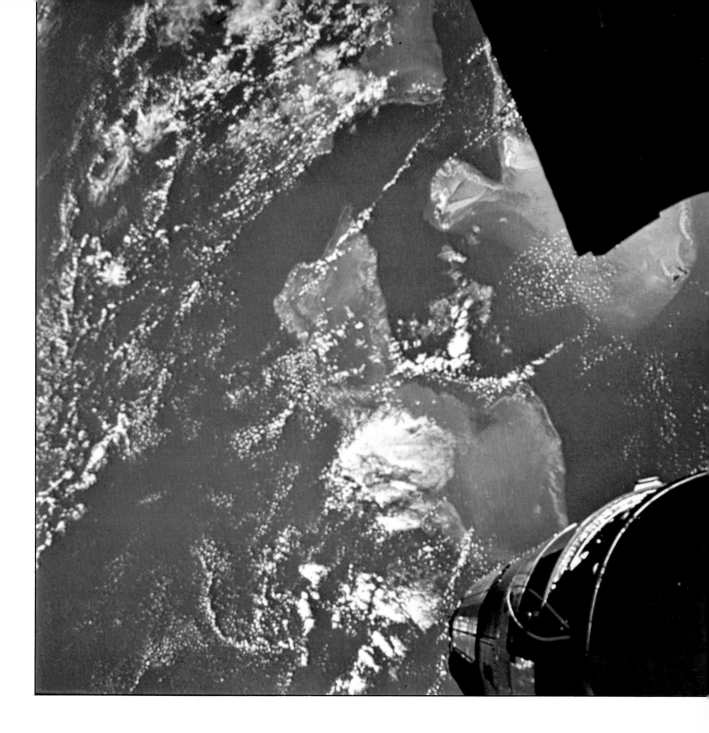

northern Lesser Bahama Bank, nearly all of which is in the picture, is separated from the Grand Bahama Bank by the Northwest Providence Channel and the Northeast Providence Channel. The channel Tongue of the Ocean (top edge of the picture), 1,000m deep, penetrates 200km south into the Grand Bahama Bank. The light shade of colour of the shallow water areas is caused by the characteristic colour of the submarine limestone bedrock. With increasing depth the blue colour changes to a variety of shades.

The escarpments and the surfaces of the level limestone plateaus offer coral ideal conditions. Thus old cretaceous fossil coral reefs can be found on the escarpments and young coral reefs at sea level.

The islands proper, which lie along the edges of the large banks, do not stand more than 30m above the level of the sea. The highest spot of the whole area (122m) lies at the eastern edge of Cat Island (covered by clouds).

The Bahama Islands have an area of 11,396sq km and consist of about 700 islands and 2,300 reefs. Only 20 islands are inhabited. In the picture almost the whole of Grand Bahama and Great Abaco Island on the Little Bahama Bank can be recognised. Grand Bahama Island, 117km long and 1,130sq km in area, has over 2,000 inhabitants. It is on average 12 to 15m high and covered by woodlands, indicated in the satellite photograph by the greenish-blue colour. Great Abaco Island, 129km long and with an area of 3,000sq km, has 3,500 inhabitants.

On the Great Bahama Bank, the reefs of the Berry Islands and the Bimini Islands can just be seen in the picture. Left of the hatch of the spaceship lies Andros Island, the largest of the Bahama Islands. With an area of 44,100sq km, it is 180km long, 35 to 45km wide and has 6,718 inhabitants. The flat island, swampy and criss-crossed by many channels, is divided into three parts at high water.

On the left-hand side of the Tongue of the Ocean one can make out New Providence Island, which has an area of 150sq km and 30,000 inhabitants. Eleuthera Island and Cat Island, covered by clouds, are not visible in the picture.

The Bahama island of Guanahani was discovered by Columbus on 12 October 1492. After initial Spanish rule, England took over the islands in 1629. The capital of the islands, Nassau, is on New Providence. The number of inhabitants has risen considerably in recent years due to tourism.

All the islands are very fertile. The flat coral reefs and limestone plateaus standing above the surface of the sea are covered by the fertile 'Bahama loam'. The vegetation is tropical with West Indian and North American flora. There are small stocks of tropical woodlands, mahogany, tropical hard wood, ebony, pine as well as palm trees, savannas with thickets of shrub. Along sheltered shallow bays there are salt meadows and extensive mangrove woods.

The climate of the Bahama Islands is pleasant with smaller changes in temperature than in the West Indies, because there are no mountains and all parts are favoured by the fresh sea breeze of the trade winds. The lowest temperature is registered in February (24.9° C), the highest in August (27.8° C). Maximum temperatures of 34° C occur occasionally. The average annual rainfall amounts to 1,200mm. The rain falls for the most part in summer, as heavy showers on a few days. The hurricanes which sweep over the West Indies, Florida and the Bahamas are notorious.

The Bahama Islands lie in the wedge between two strong sea currents, the Antilles or North Equatorial Current and the Gulf Stream, which flows along the western side of the islands northwards. The maximum tidal range is 1.2m, the average is 0.6 to 1.0m. The tidal magnitudes cause strong currents at the edge of the banks. The edge, on which ranges of reefs and island festoons are situated, has only a few shallow passages into the shallow water region of the bank area proper, which is often not deeper than 20m. Very strong currents occur here at high and low tide and these cause ripples on the sandy-limestone sea bottom along the sides of the islands and in the passages. One can clearly see the signs of these currents which extend from the cliffs and the islands into the interior of the bank area, particularly in the region of the Berry Islands.

The prevailing winds come from south-south-west, shown in the picture by the arrangement of the clouds. They blow more or less constantly, which makes the Bahama Islands famous for sailing. The wide lagoons of the Great and Little Bahama Banks with their shallow water and sheltered position opposite the open sea make it possible for all kinds of water sports to be pursued in an excellent climate without danger.

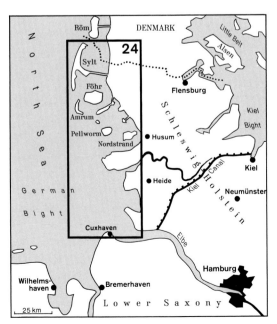

24 German North Sea coast

Aerial mosaic: black and white
Exposure: Vermessungsbüro N. Rüpke,
Hamburg
Date: Summer 1958
Altitude of exposure: 4km
Axis: vertical
Scale: 1:500,000
Area covered: about 7,000km²
Reproduced by kind permission of the Vermessungsbüro N. Rüpke, Hamburg

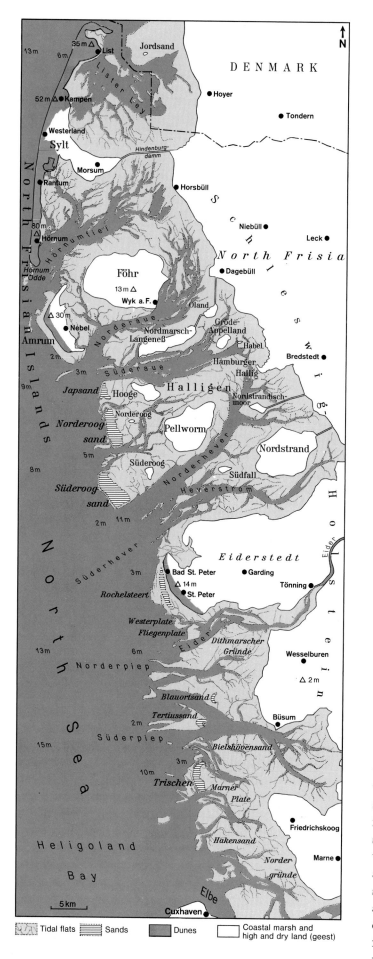

The coastline and islands of western Schleswig-Holstein can be seen on this aerial map.

The great importance of aerial photography for the recording of quickly changing phenomena on the surface of the earth holds particularly true for the amphibious coastal landscapes of shallow tidal seas. Because of the continual short term and also long term changes of sand banks, sand reefs, tidal inlets and the surface of tidal flats, only aerial photography can produce a synoptic survey, as large areas of tidal flats can be photographed from the air in a short time.

Large whirls of sediment can be observed in the water off the North Frisian Islands. They show the type and direction of the shifting or large masses of sand, which could not have been recorded so completely by measurements made in the water. It is by means of aerial maps that the coastal landscape as a changing border area can be discussed particularly well. The hinterland is not subject to these changes and the official topographic maps have been added to this plan.

The aerial map fills a gap between photographs of the surface of the earth taken by aeroplanes and by satellites. Because of the physical structure of the gas layer round the earth (the 'atmosphere' in its widest sense) aircraft can only fly up to a height of about 25km because (with declining air pressure, and with that the density of the air) the maximum weight that can be supported decreases with increasing height. Survey maps at a scale of 1:150,000 can be made with aerial cameras from an altitude of 20km. If, however, satellites are used they must orbit at a sufficient height above the earth to avoid being burnt up by friction with the air. For this reason the satellite must operate at altitudes of upwards of 100km. As previously explained, the speed

necessary to attain a close orbit is about 7.9km/sec (around 28,000 km/hr). Thus (for aerodynamic and physical reasons) there is a gap between the altitudes of 25km and 100km (meteorological balloons reach heights of up to 40km) that cannot be controlled, while sounding rockets which can bridge the gap between balloon and satellite have very short endurance.

One method of overcoming this deficiency has been to produce a map by taking a series of overlapping pictures from the air. The example on this page is to a scale of 1:500,000. The individual photographs were taken from a plane flying at 4,000m at a scale of 1:20,000, corrected and fitted together in to a mosaic, which shows an area from the island of Sylt to the Elbe estuary (120km long and 50km wide). This mosaic which was 6m long was then reduced to its present size. Thus larger parts of the earth can be represented in scales which correspond to those of satellite photographs. In contrast, the mosaic can be of more value than a satellite picture; it shows more detail, since the individual photographs were taken from low altitudes and because of this the disturbing layer of air, between camera and the surface of the earth which blurs the contrasts, is thin.

The picture shows the North Frisian area of the German North Sea coast. This landscape between Sylt and the estuary of the Elbe is continually changing. The wind in partnership with the tides forms and shapes this dynamic coastal region. It is certain that the shape of the German North Sea coast is determined by the effects of the tidal current in the German Bight and of sand masses moved by it and that it is in the process of continual change.

The aerial map was photographed at low tide. The tidal flats, apart from the channels of the inlets, are free of water. The

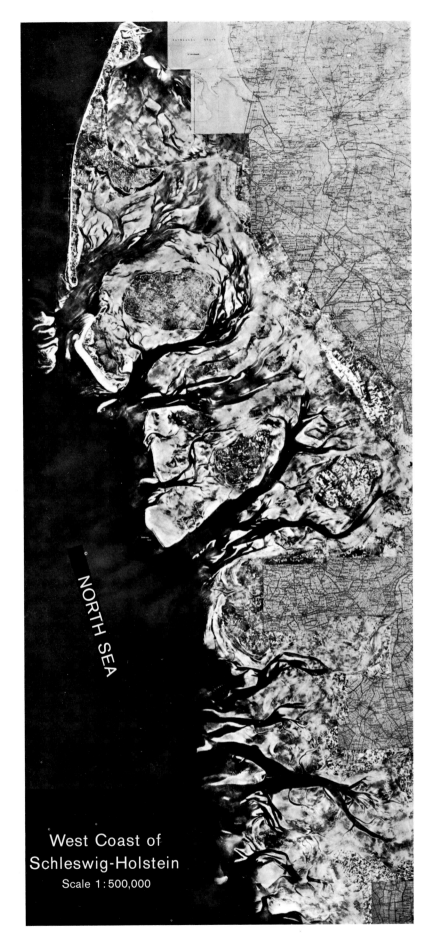

NORTH SEA

West Coast of
Schleswig-Holstein
Scale 1:500,000

127

different landscapes of the coastal region and the islands, and the struggle of man to win virgin land from the sea become clear. The section of the North Frisian coast from Eiderstedt up to the Lister Ley north of Sylt was particularly affected by storm tides in historic times. In front of the *geest* (high and dry land from the glacial period) of Schleswig, there was, at one time, a broad strip of low ground with peat bogs, which was bounded towards the sea by an incomplete line of beach ridge and dune formations. This coastal belt was broken up by heavy storm tides, such as those of 1362 when about 100,000 hectares of cultivated land were destroyed and 200,000 people lost their lives, and 1634 when more than 70,000 hectares of land were lost, 10,000 people died and three quarters of all the dykes were destroyed.

The coast line of the mainland encloses, with the outer sea dyke, old and new marshland, which as been reclaimed since the catastrophes, in front of the *geest*. Within the dykes, which are recognisable as thin lines, the areas of cultivated land are shown as the geometrical mosaic of the individual fields. Outside the dykes, one can see areas along the coast which are criss-crossed by drainage ditches and reclaimed from the sea in a lengthy process. Reclaimed marsh-land is dyked and used in agriculture, as for instance, the large polder at the beginning of the Hindenburg Dam, which connects the island of Sylt with the mainland. As remnants of the former beach ridge fringe, the North Frisian islands and the marsh-islets (holms) with their different shapes and irregular position are part of the coastal landscape. The islands Sylt, Amrum and Föhr have diluvial *geest* nuclei. Young dunes reach a maximum height of 50m. Nordstrand, Pellworm and ten islets are pure marsh islands. Between the islands there are un-usually deep channels (up to 15m) stretching predominantly south-west–north-east through which the tidal water flows.

The islands Sylt and Amrum form the western rim of the North Frisian coastal landscape in the north. The southern section of the coast from Amrum to Eiderstedt is open and has a number of sand banks on the seaward side. The area covers 1,910sq km which is divided into three main morphological phenomena: tidal flats 56 per cent, deep tidal channels 26 per cent, islands, islets and sand banks 17 per cent.

The tidal flats with their network of channels and their abundance of forms can be observed in great detail in this picture. A comparison of aerial photographs of the coast over a period of time shows that the typical morphological form elements (sand reefs, sand banks and estuaries) under the influence of the tide with high and low tide channels and the channels through the mud banks are permanent features, but are at the same time being continually changed and re-built. These alterations occur more quickly than can be recorded by classical land and sea survey. Unfortunately the outer rim of the coast in this region eludes investigation by air photography, on account of the muddy water.

The individual forms created by the tidal currents can be recognised in their distribution over the coastal landscape. On the sands the tidal currents create large ripple forms, high and low tide banks, steep edges and sand hooks, as well as new tidal channels, larger channels through the mud-banks and other forms on the tidal flats. The study of these forms and of their position allows us to draw conclusions about the natural processes at work at high and low tides.

25 The Nile Delta – Suez Canal

NASA-Photo: S-65-63849, Gemini VII
Exposure: F. Borman and J. Lovell
Date: 4 to 18.12.1965
Camera: Hasselblad 500 C
Lens: Zeiss Planar 80mm
Film: Kodak SO 217 (Ektachrome MS)
Altitude of exposure: more than 300km
Axis: strongly inclined towards east-north-east, therefore the background is very distorted
Scale: about 1:2,000,000 in the region of the Suez Canal
Area covered: more than 250,000km²

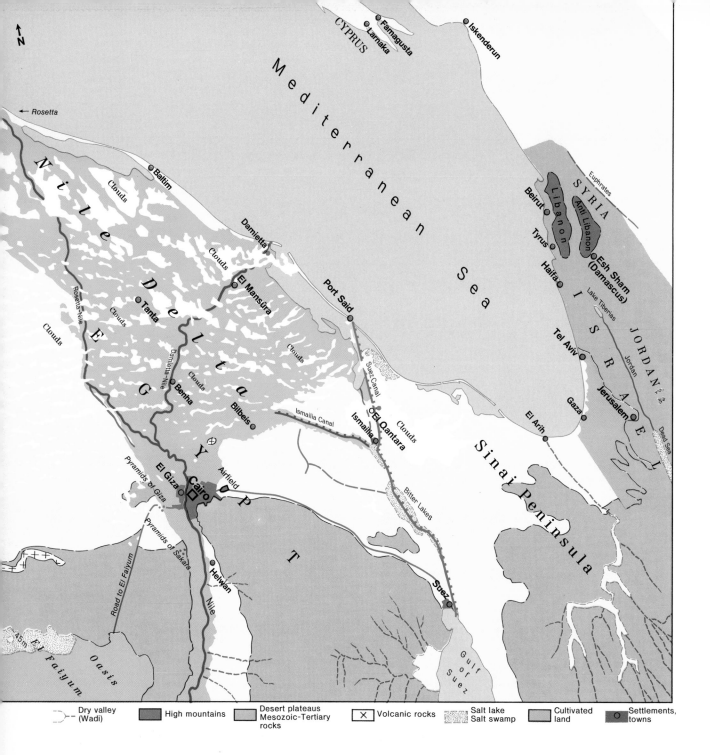

	
->- Dry valley (Wadi)	
High mountains	
Desert plateaus Mesozoic-Tertiary rocks	
X Volcanic rocks	
Salt lake Salt swamp	
Cultivated land	
Settlements, towns	

The cradle of one of the oldest civilisations of mankind, the overpopulated Nile valley, is still today the artery of Egypt. The photograph shows the Suez Canal, the most important link between Europe and the Middle and Far East before its closure in 1967, as well as Israel with the Jordan valley and the Dead Sea; in short, the trouble centre of the Middle East.

The picture is very distorted. The Mediterranean coast north of Haifa with the high mountains of the Lebanon and the Anti-Lebanon can be made out only indistinctly in the blue haze. At the top edge the island of Cyprus, elongated into a narrow strip through the perspective, protrudes into the picture. The mountain ranges of the Lebanon and the Anti-Lebanon as well as the central mountain ridges of Cyprus appear in a darker shade.

The total area of Egypt is about one million square kilometres but only about 3 per cent of this is cultivated. The population is 31 million, which means that the density of population is 31 inhabitants to a square kilometre. However as the population is concentrated into just over 30,000 square kilometres the actual density rises to 1,000 inhabitants per square kilometre.

The Nile, which receives its waters from Central Africa, Lake Victoria and Ethiopia, is the only life giver. Its annual summer floods supply the valley bottom with about 55 million tons of new fertile mud. This mud for the most part comes from the volcanic highland of Ethiopia. The fine blackish-red-brown sands and clays reach a thickness of more than 10m.

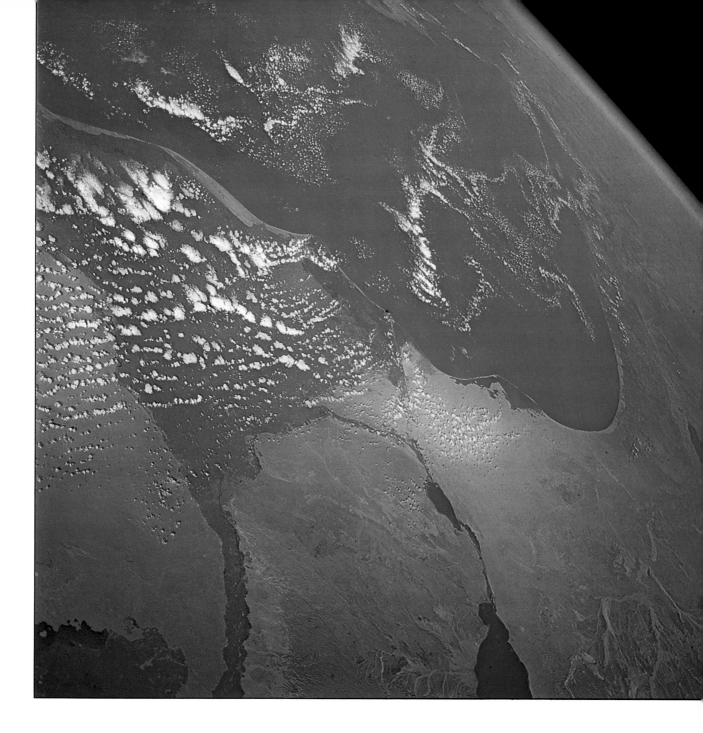

The ancient Egyptians compared the fertile Nile valley to a lotus flower. The narrow valley, which cuts 1,500km through Egypt, represents the stem, the delta opening out towards the Mediterranean Sea, the flower, and the oasis Fajum a marginal leaf. The picture shows the delta (except its western end with the town of Alexandria) as well as a short section of the Nile valley between Cairo and Beni Suef and part of the Fajum depression with the salt lake Birket el-Karun. The transition between cultivated land and desert looks as if it had been drawn by ruler on either side of the course of the river. On both sides of the Nile valley the territory rises, for the most part with a conspicuous escarpment, to the accompanying flat desert plateaus, which are criss-crossed by a network of wadis (picture 7). The river can be seen as a meandering dark ribbon in the lower half of the picture. At the beginning of the delta it forks into two arms, the Damietta and the Rosetta, which flow into the Mediterranean with extended alluvial spits. The place where the Damietta flows into the sea is visible in the picture.

Along the coast of the delta and also of the Sinai peninsula there are infertile stretches of sand. Dunes and sand bars mark, as thin strips, the shape of the coast and form the boundary of large salt lakes and salt swamps which lie inland and are only partially connected with the open sea.

The irrigation of the cultivated land is done mainly by canals which branch off from the Nile

at the numerous weirs and dams and cross the entire agricultural land as a close-meshed net. The high annual temperatures and the fertile, well-irrigated soil allow Egypt three harvests a year.

The Fajum depression, formerly a swamp area, was cultivated by the pharaohs of the twelfth dynasty, who constructed a canal. It owes its fertility to this artificial canal which branches off from the Nile at Assiut and, as a blind arm of the river, irrigates the depression lying below sea level, ending in the salt lake Birket el-Karun, lying 44m below sea level. With mud deposits more than 20m thick, the Fajum area counts among the most fertile regions of Egypt.

A narrow strip of vegetation links the Nile valley with the town of Ismailia on the Suez Canal. It characterises the cultivated land on either side of the canal, which was first built in antiquity. The Ismailia Canal, which branches off at Ismailia towards El-Kantara in the north and towards Suez in the south, is 130km long and navigable. It was built in its present form in the middle of the last century to supply drinking-water during the construction of the Suez Canal and today serves mainly for irrigation.

The Suez Canal itself, one of the most important ship canals in the world, cuts through the isthmus of Suez between Port Said on the Mediterranean and Suez on the Red Sea via Lake Timsa and the Large and Small Bitter Lake over a length of 170km. It is 100 to 135m wide and 13 to 15m deep. Since the northern end of the Gulf of Suez is very shallow, the canal had to be built 3km out into the sea. This can be seen in the picture as a thin strip.

Forerunners of the Suez Canal, important for ancient trade orientated towards the south, connected the Nile valley with the Bitter Lakes. Prior to the silting up of the Gulf of Suez, the Bitter Lakes formed the northern end of the Red Sea. It is known that an economically important canal was built for the first time in the year 2,000 BC. At the beginning of the sixth century under the Pharaoh Necho (615–595 BC), a large canal was projected to link the Nile valley with the Red Sea for the first time. 150,000 people worked on the scheme, which was, however, abandoned because of an unfavourable prophecy and the death of 120,000 people. Several times in later centuries the Nile valley was connected with the Red Sea or the Bitter Lakes. All these links were, however, filled in again either by depositional processes or by human hand. Between 1859 and 1869 the present Suez Canal was built by Ferdinand Lesseps. Since June 1967 navigation on the canal has ceased and it forms the truce line between Arabs and Jews.

The adjoining Sinai Desert in the east, of value to the Egyptians only because of oil resources on the coast of the Gulf of Suez, has been intensively explored since the Israeli occupation. Deposits were discovered, and also considerable water supplies at a depth of 800m which could be exploited for irrigation and agricultural utilisation of the Sinai region.

The border between Israel and Egypt, which runs east of El-Arish in a north–south direction across the Sinai peninsula to the Gulf of Akaba, is marked on the picture by a distinct difference in colour shade. On the Egyptian side lies vegetationless desert, on the Israeli side intensively irrigated agricultural land in the Negev Desert. The eastern edge of the Palestinian highland is bounded by the Dead Sea, the Jordan valley and Lake Tiberias, which can be seen indistinctly in the north.

In Egypt the capital Cairo, separated from the El Giza region by the Nile, can be distinguished by its grey-green colour. Towards the north-east, beyond the city area, one can see the new suburb of Heliopolis and the international airport. A thin line marks a road and high-speed railway line which form the connections with the city centre. The enormous size of Cairo, which is so conspicuous in the picture, reflects the fact that almost 3.5 million people live here. Finally one can see the two seaports at both ends of the canal: Suez, with 280,000 inhabitants until 1967 and the suburb Port Taufik situated on an island, and Port Said which also had 280,000 inhabitants, but which is today almost deserted.

Roads link the towns as thin lines, as for instance the strikingly bright ribbon of the desert road from Cairo to Fajum. Along the western bank of the Nile valley at the edge of the desert plateau and as witnesses of the ancient Egyptian civilisation more than 6,000 years old, stand some of the gigantic pyramids, just recognisable as small white dots, for example, the El-Giza pyramids situated west of Cairo and further south the pyramid of Sakkara with an excavation area nearby.

26 'Road of Palms', the Wadi Saura in South Algeria

NASA-Photo: S-65-63830, Gemini VII
Exposure: F. Borman and J. Lovell
Date: 4 to 18.12.1965
Camera: Hasselblad 500 C
Lens: Zeiss Sonnar 250mm
Film: Kodak SO 217 (Ektachrome MS)
Altitude of exposure: about 250km
Axis: vertical
Scale: 1:250,000
Area covered: 2,500km²

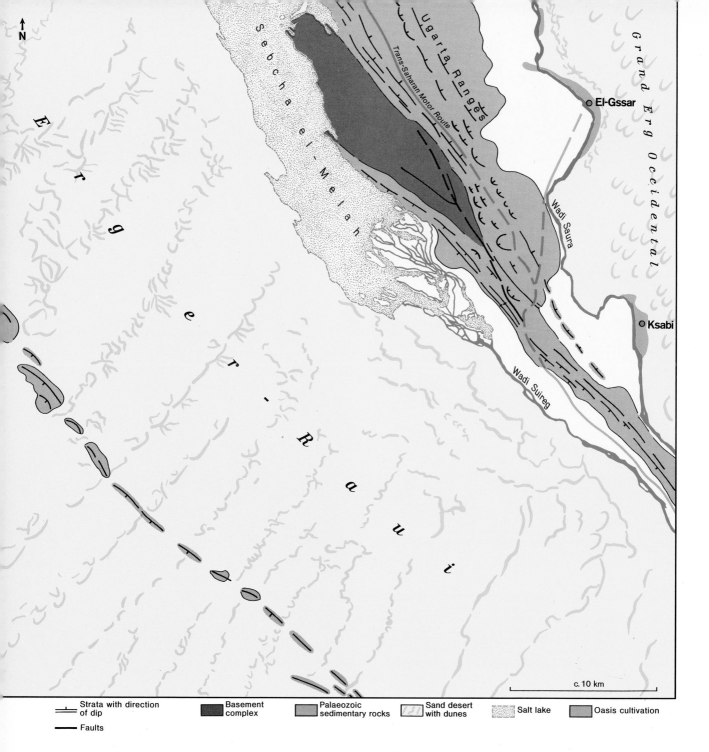

The map contains the following labels:

N

Erg er-Raui

Erg er-Raui

Sebcha el-Melah

Ugarta Ranges

Trans-Saharan Motor Route

Grand Erg Occidental

El-Gssar

Wadi Saura

Ksabi

Wadi Suireg

c. 10 km

Legend:

Strata with direction of dip — Faults — Basement complex — Palaeozoic sedimentary rocks — Sand desert with dunes — Salt lake — Oasis cultivation

The Wadi Saura carries subterranean water deep into the Western Sahara from the High Atlas 450km away. At the time when the photograph was taken, water was flowing in the normally dry bed, a very rare occurrence, after heavy rainfalls in the Atlas. These wadis are important guide lines for settlement; ribbons of oases and the Trans-Saharan routes follow them. Here for instance is the western, most important Trans-Saharan Motor Route from the iron and coal mining centre of Bechar on the Moroccan–Algerian border to the trans-shipment port of Gao on the navigable Niger in the south.

The picture – taken with a telephoto lens – makes the landscape, enlarged to a scale of 1:250,000, stand out clearly in every detail.

The sand desert of the Erg er-Raui on the left and the Great Western Erg on the right are separated by the Wadi Saura. With their sand masses they cover the bedrock which only appears on the surface of the earth in two ridges running diagonally across the picture. The mountain ridge on the right, the main branch of the Ugarta Range, separates the valley of the Saura from the salt swamp Sebcha el-Melah. The left branch can only be seen indistinctly, running across the dunes.

The geological bedrock of the great Erg is formed in this area by rocks of the palaeozoic period of Cambrian-Silurian age (450–550 million years), under which lie 'sour' precambrian plutonic

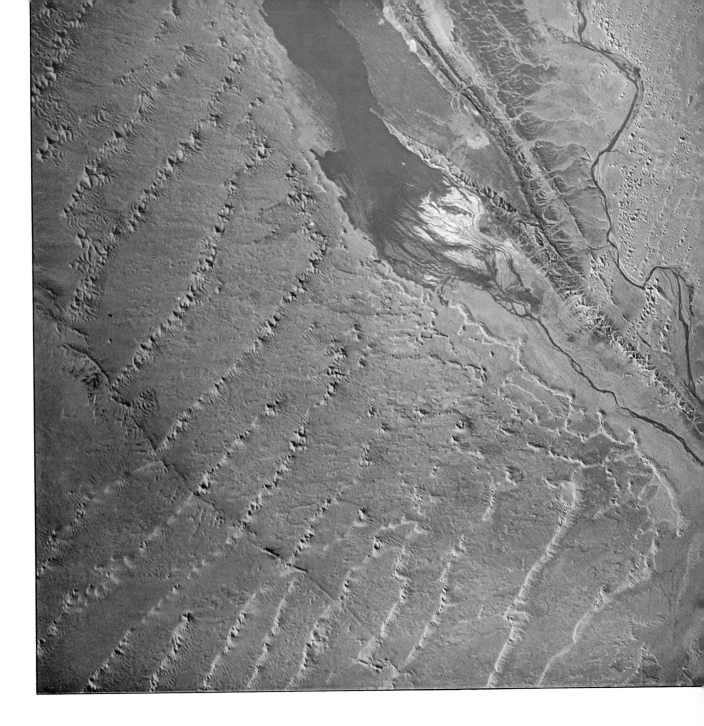

rocks. The parallel strips and divisions of the Ugarta Range are caused by the alternation of resistant quartzites, which stand out as ribs, and of soft slates largely cleaned out by erosion. The stratification and the distortion of the rocks can be clearly recognised (see picture 13). The strata of the main branch of the Ugarta Range dip eastwards on the eastern slope of the narrow ridge and correspondingly westwards in the west. In the picture one can distinctly make out the narrow saddle structure the long axis of which strikes north-west–south-east and whose steeply inclined strata dip more gently towards the north on the right-hand side of the salt lake. This folded structure continues under the sands of the Erg er-Raui, which is shown by the ridges which run parallel to it 30km further west. It is interesting for the geologist that these old folded mountains, which are largely denuded today and covered by sand, lie at 90° to the young folded mountains of the Atlas, which stretches in a south-west–north-east direction.

The largest part of the picture is taken up by dune areas. The Erg er-Raui has dune ranges, called 'draa', parallel to each other and 5–10km apart. They consist of very fine reddish-yellow wind-blown sand, a product of rock weathering over a period of some 100,000 years. Only transport by the wind is involved, and this is responsible for the symmetry and forms of the dune landscape. The parallel lines of dunes are star dunes which have grown together and which are fixed dunes. They are caused by perpetually changing wind direction. The south-east slopes

of the dune ranges, with their snake-like ridges give us a clue that the prevailing winds come from the north, winds which are referred to as fallwinds from the High Atlas. In the south the strips of dunes grow together into smooth, less divided ridges. The average height of the ridges is 40–50m. The star dunes in the north are probably 100–150m high. In the depressions between the strips of dunes, the 'gassi', the sand cover is not complete. The sand, recognisable by its darker colour, is interspersed with the detritus of the bedrock.

The spurs of the 'Great Western Erg' at the top right are more complicated and less divided. The bedrock is almost completely covered here by thick sand, which shows, in part, traces of old barchan dunes. The Great Western Erg is one of the largest dune regions of the Sahara with its area of 80,000sq km. Here the dunes are considerably higher. The largest with a height of 300m lies north just off the picture.

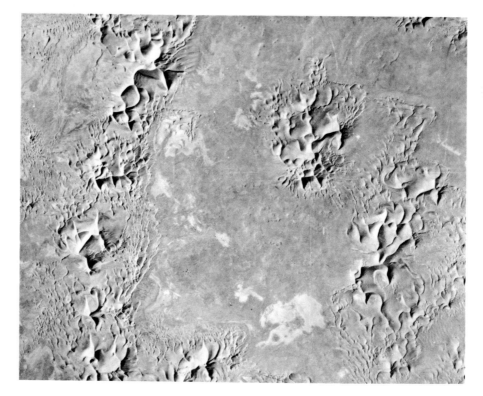

This enlarged aerial photograph (Scale 1:90.000) taken from altitude of 8,000 m, shows gigantic star dunes in the Great Western Erg just outside the boundary of the picture. The star dunes have a diameter of more than 1 km at the base and reach a height of 250 m.
Wild RC Wide angle 88,5 mm.
Photograph: National Geographic Institute, Paris
(Advertising by feature of Firma Wild, Herbrugg, Switzerland).

The Wadi Saura, also called 'the Little Nile' of the western Sahara, flows in meanders across the right half of the picture. A few kilometres further south, outside the picture, it flows round the Ugarta Ranges, which dip here under young surface layers, turns north again and ends in the salt basin Sebcha el-Melah which has no outlet. The wadi only carries water after rare rainfalls which are often catastrophic in a desert climate. (During such catastrophes more people drown annually than die of thirst in the desert.) Until a few years ago the Wadi Saura continued 150km further south only to end in the salt basin in front of the spurs of the Tademait Plateau. Owing to the flood catastrophes of 1950 and 1951 the river changed its course and today drains through the small Wadi Swireg into the salt basin of Sebcha el-Melah. The salt crust (white-grey) of the old alluvial fan of the Wadi Swireg is criss-crossed by numerous meanders.

Normally the wadi has surface water only in a few pools, 'geltas' (deep-lying places where the ground water reaches the surface of the earth). A ground water stream is the life-line of the ribbon of oases 'Road of Palms'. This stream is tapped by innumerable wells and the precious water is brought to the surface by means of primitive hoisting gear. Geltas and wells are exact

indicators of rainfall, because the level of the water in them always rises before the dry bed fills with surface water.

At the oases, whose division into lots is clearly recognisable, palm plantations are found. The dry hot climate of the central Sahara reaches a maximum temperature of 50° C in July and August. In the shade of the palms fruit-trees (pomegranates) are grown in 'terraces', while at ground level vegetables are cultivated.

Except for a few nomads roaming through the desolate Ergs, the entire population lives in these ribbons of oases, dependent on subterranean ground water streams, of which the Wadi Saura mentioned above is the most important.

The tarmac ribbon of the Trans-Saharan Motor Route can be picked out as a fine grey line. The road runs parallel to the Wadi Saura and is linked with the individual places, for instance Ksabi, by short roads or tracks.

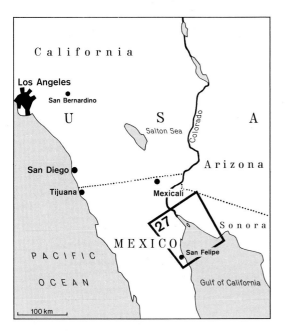

27 Mouth of the Colorado River

NASA-Photo: S-65-34673, Gemini IV
Exposure: J. McDivitt and E. H. White
Date: 5.6.1965
Camera: Hasselblad 500 C
Lens: Zeiss Planar 80mm
Film: Kodak SO 217 (Ektachrome MS)
Altitude of exposure: about 170km
Axis: slightly inclined towards north-west, therefore lower part of picture slightly distorted
Scale: about 1:500,000
Area covered: 10,000km²

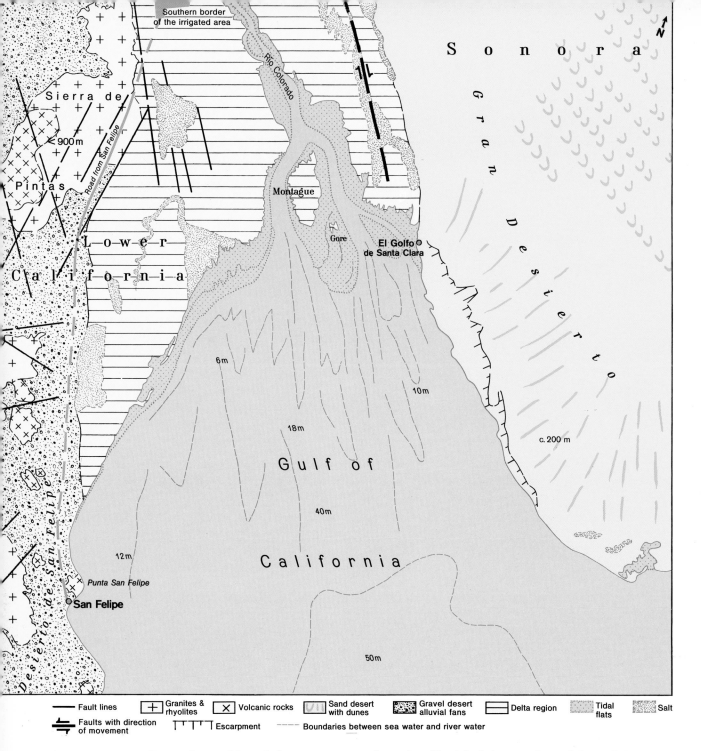

Southern border
of the irrigated area

S o n o r a

Rio Colorado

Sierra de

<900m

P i n t a s

L o w e r

Road from San Felipe

Montague

C\a\l\i\f\o\r\n\i\a

Gore

El Golfo
de Santa Clara

G
r
a
n

D
e
s
i
e
r
t
o

6m

10m

18m

c. 200 m

G u l f o f

40m

C a l i f o r n i a

12m

Desierto de San Felipe

Punta San Felipe

San Felipe

50m

| | Fault lines | | Granites & rhyolites | | Volcanic rocks | | Sand desert with dunes | | Gravel desert alluvial fans | | Delta region | | Tidal flats | | Salt |
| Faults with direction of movement | | Escarpment | | Boundaries between sea water and river water |

Yellow-red, sun-blasted desert – grey mud on the alluvial plain cut through by tidal inlets – deep-blue sea – and in the middle of this harmony of three strong colours the estuary of the Colorado River into the Gulf of California, that long narrow bay of the Pacific Ocean which is formed by the peninsula of Lower California.

1,300km further north (as the crow flies) in the Rocky Mountains of Wyoming, is one source of the Colorado, the other lies north-east in the state of Colorado. During its 2,900km course towards the south-west, the river has cut 2,000m deep into the gigantic gorge of the Grand Canyon, laying bare rock series of the entire history of the earth down to the archaic basement complex which is more than 2,000 millions years old. In its lower course it flows, through the Mojave Desert for more than 300km, and ends in the Pacific in the arid zone of the Gulf of California.

The photograph covers an area of about 100 square kilometres. One can see parts of the Mexican provinces of Sonora (right) and Lower California (left) separated by the delta of the Colorado and the Gulf of California.

In the picture three very different areas contrast strikingly in colour and structure: the monotonous, slightly undulating reddish-yellow sand desert Gran Desierto with softly outlined dune strips running parallel to each other in the right half of the picture – the multicoloured

138

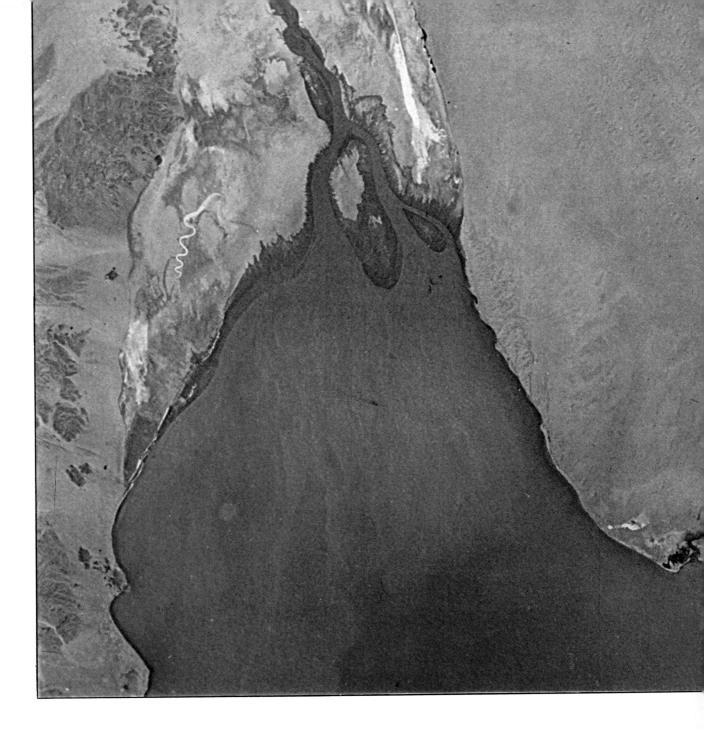

rugged volcanic mountains of the Lower Californian peninsula drowning in sand on the left of the picture – the estuary of the Colorado which builds out further and further into the sea with the mud it carries with it. Streaks of muddy water only mix gradually with the clear sea water which, with increasing depth, changes its colour from light blue-green into dark blue-black. The reddish-yellow area of the desert Gran Desierto, a rock plateau mainly covered by sand, lies 100–200m above the level of the sea. In the top right corner of the picture parallel strips of dunes can be recognised. The sharp edge of this desert plateau towards the river delta and the sea follows the course of the notorious San Andreas Fault. This is one of the most significant seismic zones of the crust of the earth, which can be traced parallel to the edge of the North American continent 1,300km further north up to San Francisco. At irregular intervals earthquakes (during which the continental blocks are moved horizontally against each other along the fault) shake the south-western coastal strip of the United States with often catastrophic consequences, such as the destruction of San Francisco in 1906. A local parallel fault is marked in the picture by the straight white salt strip to the right of the course of the Colorado River.

On the left-hand margin of the picture, rugged, black-blue-reddish-brown bare volcanic rocks (Sierra de Pintas) tower above the grey-yellow alluvial and gravel plains. The rocks are drowning in their own detritus, which is only shifted when heavy rains fall every three to eight years.

The dominant elements of the picture are the winding lower course of the river, the river delta and the shallow triangle of the sea which gradually becomes deeper further south.

Two processes forming the landscape are visible in the coastal region.

The river deposits sand and mud from its drainage area of 676,000sq km on the adjoining lowlands and into the sea. Before it was controlled by dams, the Colorado was laden with a particularly high amount of water-born sediments (sand and mud). The ratio of water to solids exceeded sixfold the corresponding ratio of the Mississippi! Each year 160 million tons of material was transported. The sand and mud deposits in the submarine area of the delta amounted to 180,000 million tons annually. Today however, following the construction of dams, this has been reduced to a mere 8 million tons. The coastal strip between the delta of the Colorado and San Felipe has grown through deposits more than 3km out into the sea within 26 years (from 1899 until 1925). The increasing depth of the sea as one moves away from the mouth of the estuary is indicated by the various shades of colour.

In the region of the estuary, the sea in the gulf has the unusually high tidal range of 7m on average, maximum 10m. Thus sea-water penetrates into the estuary, and in its marginal zones tidal flats and marsh areas exist. They can be recognised in the picture as blue-grey strips on either of the estuary. When the photograph was taken the tide was out. Numerous small channels are dry and stand out owing to the light salt areas of their beds. Old tidal channels dating from times of even higher water are conspicuous by their white salt deposits, eg the meandering strip on the left-hand side of the picture.

The process of salt deposition is also important. With 2,000 million cubic metres of water being carried by the Colorado each year, the depth to which water permeates reaches 1.25m, ie about half the amount of water which evaporates annually. As the salt content of the Colorado water at the Merelos Dam reaches 0.9g per litre, the soil is supplied with considerable amounts of salt. In many fields damage has occurred because of salt accretion. The white strip on the right-hand side of the river shows the salt bed of an old river.

The area of shallow water in the gulf is a fishing-ground for shrimps. The catches are landed in the port of San Felipe (in the picture bottom left) and from here they are driven in refrigerated lorries northwards to San Diego and Los Angeles, via a road which appears as a thin white-green line over the edge of the Sierra de Pintas and in the desert of San Felipe.

At the top edge of the picture, to the left of centre, there appear, faintly outlined, the southern spurs of the large irrigation area in the Colorado delta. The enlargement of this enormous irrigation area (corn and cotton plantations) played the decisive part in the economic development of the Mexican peninsula, Lower California. This region (highest point 43m above sea level) became the economic centre of the peninsula within a space of 15 years. It is the most densely populated area, where, with 265,000 inhabitants, a third of the whole population of Lower California lived in 1961. At that time more than 30,000 people were working in agriculture. Finally the desert-like region was opened up to tourism because of its climate. Here people can bathe in the gulf at water temperatures of 22° C in January and eight hours sunshine per day is normal.

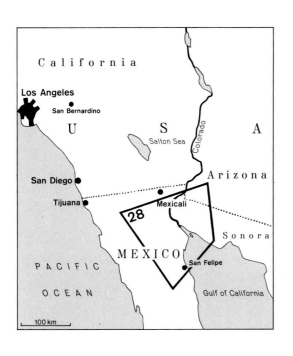

28 False colour photograph of the Colorado Delta

NASA-Photo: SCI-3102, Apollo IX
Exposure: E. Schweikart, D. Scott and
J. McDivitt
Date: 11.3.1969
Camera: 4-lens Hasselblad multispectral
camera
Film: Kodak-Ektachrome-Infra-Red Aero
Altitude of exposure: about 240km
Axis: inclined towards the south-west
Scale: about 1:750,000
Area covered: about 22,500km²

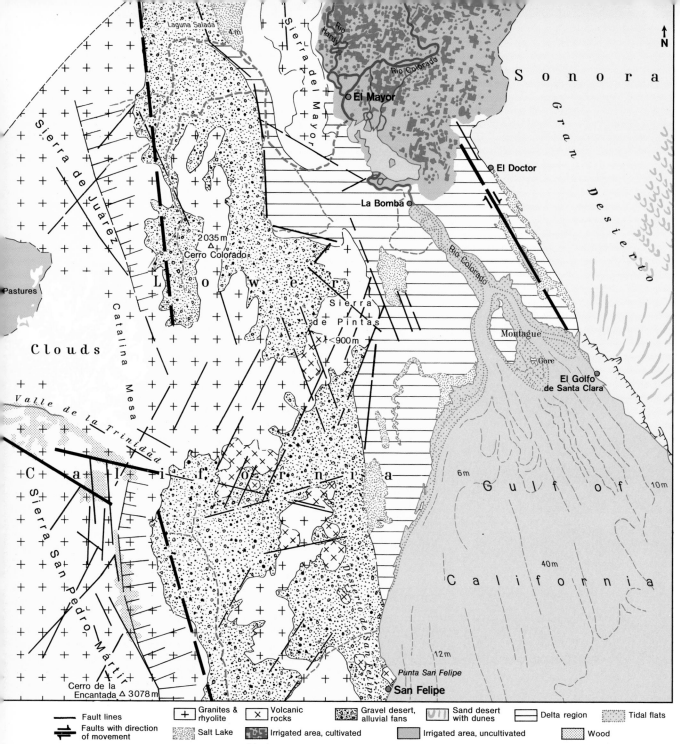

	Fault lines	⊞	Granites & rhyolite	⊠	Volcanic rocks		Gravel desert, alluvial fans		Sand desert with dunes		Delta region		Tidal flats
	Faults with direction of movement		Salt Lake		Irrigated area, cultivated				Irrigated area, uncultivated				Wood

- - - Dry valley (Arroyo)

⊤⊤⊤ Escarpments of the Sierras (fault scarp, 2 000 m high)

- - - - Boundaries between sea water and river water

Apollo IX was the first space craft to have a multispectral camera, an apparatus consisting of four Hasselblad cameras, built into its observation hatch. The battery of four cameras photographed the surface of the earth simultaneously with different films, an infra-red colour film, reproduced here, a black and white film with green filter, a black and white infra-red film, and a black and white film with a red filter. The resulting photographs show the earth in very different colours according to the type of film. Comparisons of these different films which represent the same area at the same scale, give valuable results when processing the data, since each film reacts differently to the objects on the ground. NASA maintains an extensive research programme in the field of multispectral photography.

The Apollo IX mission gave the first opportunity to photograph large areas in the southern United States, Central America and Australia from altitudes of 200km with infra-red colour films. This picture of the Colorado delta and picture 30, of the Imperial Valley, were taken from one of these films. While the layers of a normal colour film are sensitive to blue, green and red, the 'False Colour Film' or infra-red film is affected by green, red and infra-red.

The false colour films reveal to the scientist many details which are hidden to the normal eye. They are a particularly important data source for the vegetation. All living plants appear as red, the stronger the red, the fresher the plant. Dead plants appear grey to grey-green. The red

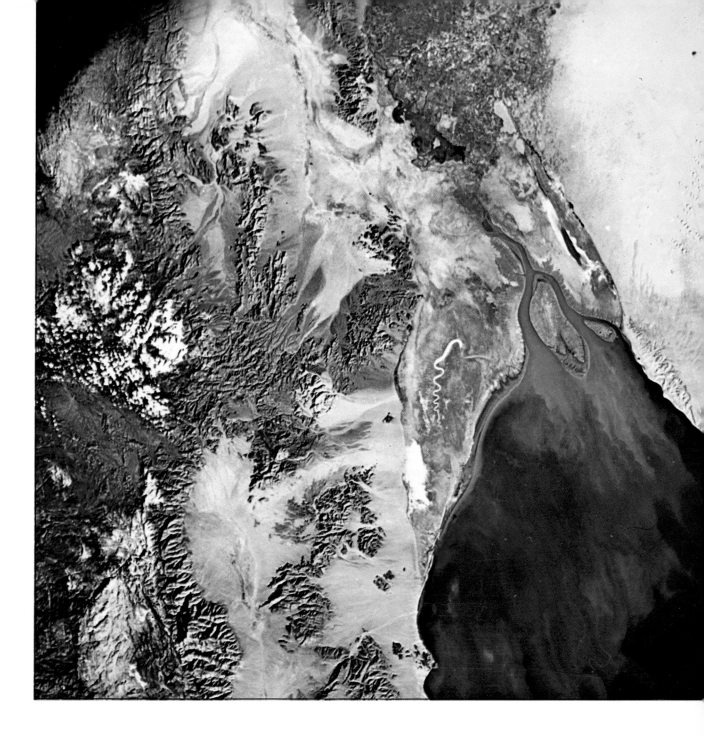

colouring is based on the high degree of reflection of the chlorophyll to infra-red rays. Different vegetation types are reflected in a variety of shades of red. It can also be seen whether certain areas are being attacked by pests. False colour photography also gives a clearer picture of the distribution of rocks and their deformation at the surface, thus allowing us to define geological phenomena with great reliability and to follow them below the surface. This can lead indirectly to the discovery of mineral deposits which are related to certain rocks or structures. It is, however, improbable that mineral resources, for example ore and oil deposits, can be found directly, unless the rocks or soil on top of the deposits are chemically changed by rising solutions (eg oxydation zones). Since infra-red reacts to the slightest differences in temperature, this technique, here particularly the 'infra-red photographs' (infra-red detectors) over the dark (night) regions of the earth, will surely make it possible to predict and control volcanic activities in the volcanic zones, to watch forest fires and to follow the movement of icebergs.

The present photograph covers roughly the same area as the normal colour photograph 27, though more of the agricultural area of the Colorado delta and the mountain ranges of Lower California can be seen. The tide was on the ebb when the picture was taken. A narrow strip of the tidal flats is already free of water. The strong ebb current is clearly visible in the gulf in the snake-like clouds of sediments, which can be traced up to 50km into the sea. Here the false

143

colour photograph shows the difference between clear sea water and muddy water which the ebb current carries into the sea.

Muddy water appears in a lighter, more greenish shade of blue; the fresh seawater and the lagoon of the River Hardy are deep blue.

More geological details can be made out than is possible on a normal colour photograph. Different rocks appear in strikingly contrasting shades of colour ranging from white-grey to brownish as well as blue-green tones. One recognises clearly the light grey and grey granite and granodiorite rocks of the Catalina Mesa and the Sierra de Juárez. Recent volcanic rocks, andesites and basalts, are inserted and appear blue-green in the picture. The volcanic rocks which forced their way up through the granites contrast with their surroundings particularly clearly in the Sierra de Pintas. The greenish shades of colour at the left side of the photograph are falsified, partly due to stray light, and do not correspond with the typical false colours of the bedrock there.

In the delta region itself, south of the cultivated land, different soils contrast strikingly with each other through various brownish to grey-green shades of colour. Soil structures and different kinds of soil are presented in a more differentiated and contrasting way than in picture 27. The salt deposits of the meandering tidal inlet and other salt basins appear white. The sand desert in the right half of the picture and the alluvial fans in the left half are clearly differentiated in their colours, which makes it possible to distinguish between alluvial fans of different rock material. The 'false colours' of sand and detritus differ strongly from the natural reddish to brownish-yellow colour.

Tectonic structures also stand out more clearly through the unusual colour effects. Striking, linear structures following the important faults can be recognised in the mountains and also in the delta region. The fault running parallel to the famous San Andreas Fault on the right-hand side of the Colorado, marked by salt and shallow saltwater pools, can be traced as a very fine clear line up to the boundary of the agricultural land. In the mountainous left half of the picture, great numbers of faults and fissures striking north-west–south-west can be seen. The relationship between the faults and the young volcanic rocks which were forced up along them is clearly shown.

As far as colour is concerned, the most conspicuous element in the photograph is the cultivated area of the delta region. Here the division of the cultivated land into fields (ejidos) of up to 20 hectares can be clearly seen in red and grey-green shades of colour. The red colours which show fresh growth seem to indicate here, in the main, afalfa grass which, at the time when the photograph was taken, was fully grown. The grey-green plots, ie those with dead plants, probably represent the cotton fields where the crop had been harvested in December. In the lower left half of the picture, one can recognise brown-red and red nuances of colour in the mountains. They are large pine woods (Pinus ponderosa) which reach an area of up to 200,000 hectares on the granite plateaus of the Catalina Mesa and the Sierra San Pedro Mártir. The brown-red, in other words the darker shades of colour, show the pine forests; large red dots in the woods of the Sierra San Pedro Mártir are caused by interspersed groups of oaks.

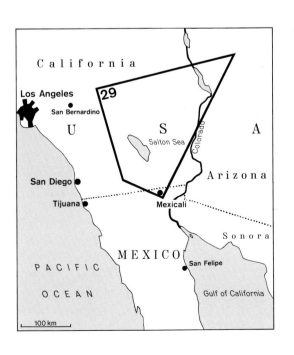

29 The irrigation area of Imperial Valley at Salton Sea in California

NASA-Photo: S-45748, Gemini V
Exposure: G. Cooper and C. P. Conrad
Date: 21 to 28.8.1965
Camera: Hasselblad 500 C
Lens: Zeiss Planar 80mm
Film: Kodak SO 217 (Ektachrome MS)
Altitude of exposure: about 250km
Axis: strongly inclined towards north,
therefore top part of the picture distorted
Scale: in the region of Salton Sea about
1:1,000,000
Area covered: about 45,000km²

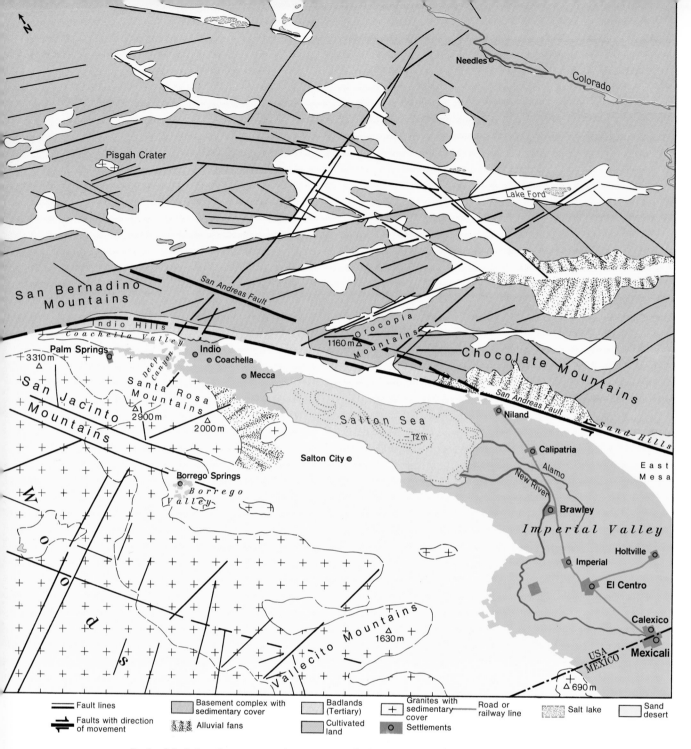

Fault lines

Faults with direction of movement

Basement complex with sedimentary cover

Alluvial fans

Badlands (Tertiary)

Cultivated land

Granites with sedimentary cover

Settlements

Road or railway line

Salt lake

Sand desert

Imbedded in the mountain ranges of the Mojave Desert criss-crossed by faults, lies the brown-green geometrically patterned carpet of the artificially irrigated Imperial Valley. The deepest point of this depression, 72m below sea level, is filled by Salton Sea.

This picture clearly demonstrates the intervention of man in the arid desert in the south-west of the United States which once was without vegetation. It can be used as a model of how in other zones with similar climate, transformations of the landscape can be managed and planned with the aid of satellite photographs. The Imperial Valley owes its existence to the gigantic irrigation plan which was started by the United States and Mexico 60 years ago. Salton Sea is the testimony of a natural catastrophe caused by man. In 1905 during high water, the Colorado overflowed. The water found a new way along the channels which had been dug out a short time before and gradually filled the deepest point of the depression of the Imperial Valley. Only after 18 months of costly efforts was the river dammed again and forced back into its old course. Salton Sea, which has a length of 48km and a width of 20km, remained behind, serving today as an irrigation reservoir.

The satellite picture shows part of Southern California, an area of about 240 by 180km. At the bottom left are the San Jacinto Mountains, in front of them the depression of Imperial Valley, which is 180km long, with Salton Sea. In the north there are the Sand, Eagle and Chocolate

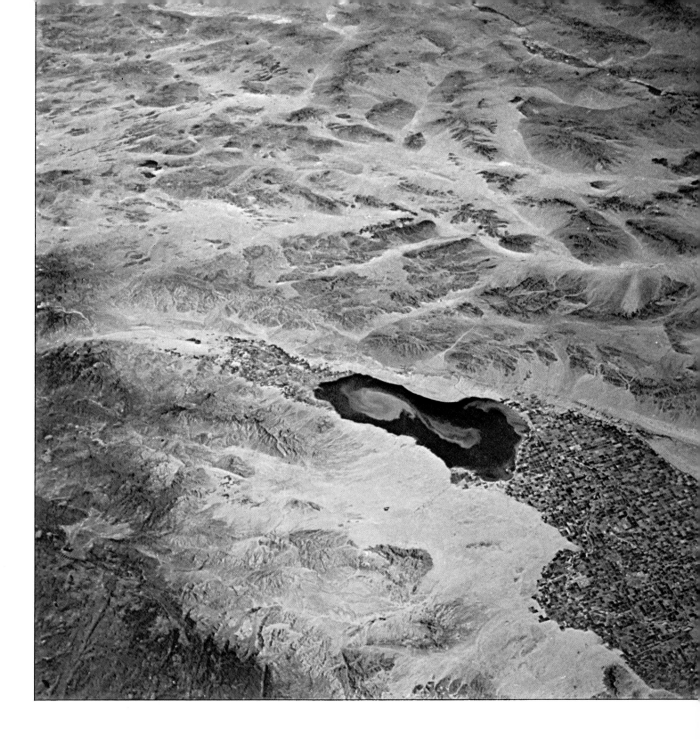

Mountains and other desert mountain ridges which gradually change into the Colorado plateau. In the background at the top edge of the picture, which is strongly inclined, the meandering course of the Colorado can be seen. It is in part dammed into lakes, and partly accompanied by wide irrigated areas, eg the clearly recognisable region around Needles.

Geologically the picture shows the typical tectonic structures of the basin and desert ranges of the southern Rocky Mountains. Crystalline rocks, granites and gneiss, are divided into individual blocks by young faults. The areas between the isolated rock massifs are separated by detritus, sand and gravel, distinguishable by their yellow-brown colour which contrasts clearly with the blue-grey of the mountain massifs. The individual rock massifs reach a height of more than 2,500m, the intervening desert areas are between 200 and 800m high. The crystalline rocks are covered in parts by soft tertiary sediments which made an intensive dissection of the surface possible there (badlands). The recent faulting, which is still active today, leads to an intensified erosion. This is clearly pointed to by the enormous alluvial fans and the detritus on the slopes of the mountain massifs, which are still recognisable even on this small scale.

The individual mountain blocks were raised or dropped and partly tilted and uplifted along conspicuous faults. These faults, marked by the above-mentioned valleys filled with sand and detritus, can be plainly associated with different systems. A particularly striking direction runs

147

from the bottom left to the top right across the picture, ie diagonally in a south-west–north-east direction. Another direction represents the San Andreas fault system, whose main fault can be made out at the northern edge of the Imperial Valley in the loose detritus on the slopes and in the alluvial fans on the shore of Salton Sea. The San Andreas direction follows the depression of Imperial Valley and, west of Salton Sea, turns from a south-south-east–north-north-west into a south-west–north-east direction. It runs south through the delta of the Colorado (picture 27) into the Gulf of California. Its continuation separates the peninsula of Lower California, which is 1,300km long, as a tectonic block from the American continent.

The Imperial Valley is the natural northern end of the Gulf of California and a Graben-like basin which is connected with the zone of the San Andreas Fault, ending in the region of the western edge of the picture. In the geologically recent past the Imperial Valley was still covered by the sea. The gulf was cut off by the Colorado, which carries more than average amounts of mud and water-suspended materials. The hollow to the north dried out leaving behind a depression whose deepest point lay about 100m below sea level. This depression with its fertile alluvial soil was utilised by the irrigation plan of the Imperial Valley. Today the largest part of the Colorado water flows into the different irrigated areas. In Imperial Valley the surplus water from irrigation flows into Salton Sea, which fills the deepest point of the depression.

Depending on the amount of surplus water which is let into it, the Salton Sea water level varies, so that its area fluctuates between 16,000 and 20,000sq km. The two bright whirls in the lake show the currents which occur when water is let into the lake from the New River and the Alamo River during irrigation.

The dry region in which Imperial Valley is situated has only 30–70mm rain per annum. The average temperature is 22° C. There are, however, great daytime (up to 22° C daily) and seasonal fluctuations (maximum temperature 53° C, minimum temperature −4° C).

In the irrigated area the large rectangular fields can be clearly seen. The division was made strictly north–south and east–west. About sixty plots one square kilometre in size lie side by side across the valley. The individual fields differ from each other through their colour which depends on the plants grown on them. Particularly conspicuous is the alfalfa grass which appears bluish-green before harvest.

Because of the long growing season, two harvests can be obtained with the aid of artificial irrigation. The following plants are grown: sugarbeet, cotton, maize, asparagus, wine and oranges. Several harvests of fodder and maize can be obtained each year and up to ten of alfalfa grass. The two irrigation canals, New River and Alamo River, can be easily traced through the mosaic of the fields.

The irrigation of the area was started in 1902 by the Imperial Valley Development Co by building the first canal, which leads from the Colorado to Yuma. In 1941, the All America Canal which is 128km long, was finished.

Owing to the extension of the irrigated landscape the population rose from 13,600 to 43,100 between 1910 and 1920. Individual settlements and towns like El Centro, Mexicali and Calexico can be clearly recognised by their dull grey colour within the cultivated landscape. The roads and the Southern Pacific Railway appear as thin lines in the picture. In the bottom right-hand corner the border between Mexico and the USA, which is marked by a fence, runs as a broad conspicuous line across Imperial Valley. At the north-western end of Imperial Valley, partly in the irrigated area which can be recognised here, there are some larger Indian reservations. North-west of Salton Sea, several well-known Californian cities, like Palm Springs, which are not visible in the picture, lie close to each other.

30 False colour photograph of Imperial Valley in California

NASA-Photo: SCI-3152, Apollo IX
Exposure: R. Schweikart, D. Scott and
J. McDivitt
Date: 12.3.1969
Camera: 4-lens Hasselblad multispectral
camera
Film: Kodak-Ektachrome-Infra-Red Aero
Altitude of exposure: about 240km
Axis: approximately vertical
Scale: about 1:750,000
Area covered: about 22,500km²

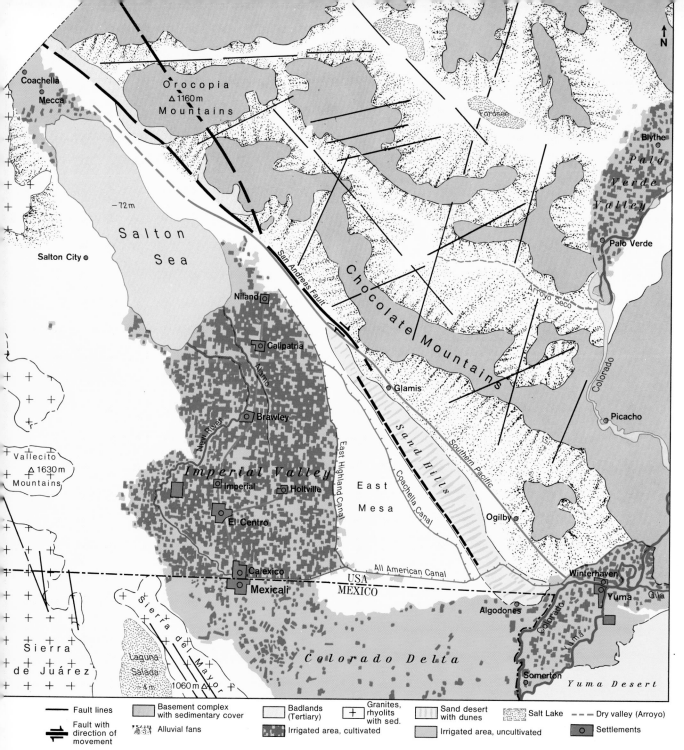

—— Fault lines	Basement complex with sedimentary cover	Badlands (Tertiary)	+ Granites, rhyolits with sed.	Sand desert with dunes	Salt Lake	--- Dry valley (Arroyo)

Fault with direction of movement

Alluvial fans

Irrigated area, cultivated

Road or railway line

Irrigated area, uncultivated

○ Settlements

It is often claimed that this new photographic technique is used for economic espionage. Again it is an infra-red photograph with which one can analyse the distribution of vegetation, the expected crops as well as the inadequate or optimal utilisation of the cultivated land. One closely sees the difference between the intensively utilised, clearly divided and healthy arable areas of Southern California and Arizona and the wide arable regions of Mexico which are lying fallow. Such pictures must evoke strong emotions between states and are also of certain economic significance, so the accusation concerning economic espionage becomes understandable.

As in picture 29, the surroundings of Salton Sea in California are shown here. In this case, however, we have an approximately vertical photograph representing a smaller but less distorted section of Southern California and Mexico. The picture is also slightly further south-east.

The Californian irrigated area south of Salton Sea borders on the irrigated region of the Colorado delta in Mexico. The frontier can be traced as a conspicuous line across the irrigated area. It runs just south of the All America Canal which crosses the desert East Mesa and the dunes of the sandhills as a thin blue ribbon. In the right half of the picture one can see the Colorado. It flows through the Palo-Verde irrigation area, in the north partly dammed, cuts through the Chocolate Mountains and then meanders along the irrigated area around Yuma in

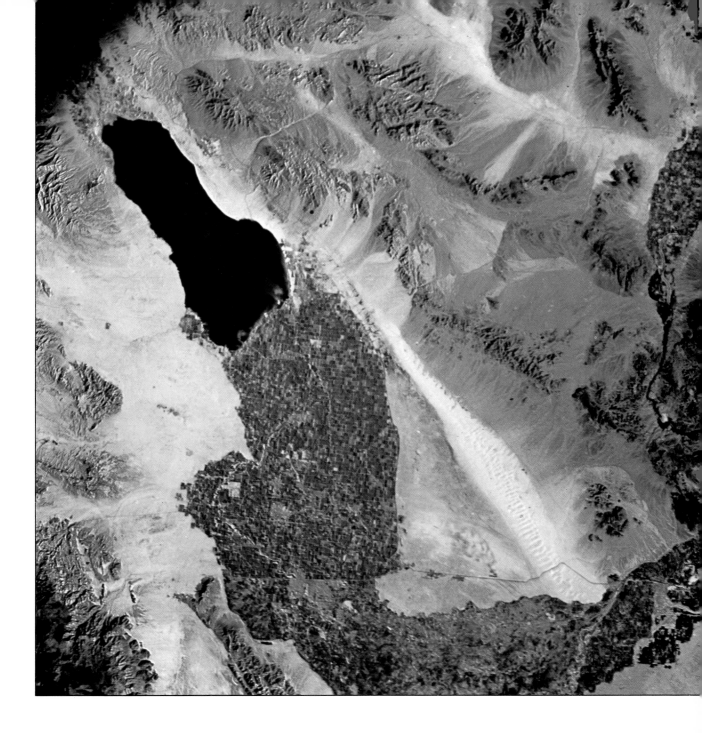

the south where the border between Mexico and the United States, following the course of the Colorado, dips 40km to the south.

The rocks, which are in the main crystalline basement complex and are only covered in places by younger sediments, are less differentiated in this picture than on the photograph of the Colorado delta (28). They appear in uniform strong blue to dark-blue, the typical colour of inorganic, ie dead substances. The infra-red photograph is of interest for the distinction of different loose deposits. Alluvial fans with different sizes of grain, different rock composition and of different age appear in differentiated nuances of blue and grey-green. Deposits of wind-blown sand, like the dune strip of the sandhills and the desert areas west of Salton Sea are reproduced in light beige. The valleys of the arroyos in the Mojave Desert and the area of the East Mesa which is not irrigated appear in this false colour photograph (caused by small differences in moisture in the soil) in various beige to grey-green shades. Through the contrasting colour reproduction, particularly within the loose sediments, the young faults, cutting through the mountain massifs partly parallel to the San Andreas Fault, partly diagonally to it, are sharply outlined.

The most striking element of the picture is the squares of the fields of the large arable areas which stand out clearly due to their being in different false colours. The fields with fresh healthy

growth appear again in various shades of red, from bright orange to dark blue-red (picture 28). At the time when the photo was taken it was sugarbeet and alfalfa grass in particular which appear as bright red. The darker dull shade of red probably represents the widespread citrus plantations of the Imperial Valley. The cotton fields where the harvest is over stand out in blue to blue-green, the colour of the withered or dead plants. This applies in part to the predominantly blue-green colouring of the Mexican irrigated areas, since cotton is the main crop here.

The canal system of these artificial irrigation oases in the extremely dry desert of southern California stands out clearly. In the gorge of the Colorado, the river can be clearly seen particularly where it is dammed by the Imperial Dam and the Laguna Dam. From these places, the water is led into the All America Canal, which crosses the Sand Hills and the desert north of the Mexican border as a blue line, and into the large network of other canals. At the edge of the East Mesa are the Coachella Canal and the East Highline Canal which run across the desert as very fine lines. In Imperial Valley the meandering courses of the Alamo and the New River stand out more clearly than on a normal colour photograph. On the Mexican side the Rio Hardy and the completely waterless salt plain of the Laguna Salada are recognisable. The size and structure of the most important towns like El Centro, Calexico and Yuma on the American side and Mexicali on Mexican territory, appearing as lighter grey-blue heaps of dots, can be seen. The main railway lines of the 'Southern Pacific' can be traced as thin dark lines straight across the desert for hundreds of kilometres.

In the centre of Imperial Valley a dark-blue quadrangle can be made out; this is a reservoir which is used for hatching fish.

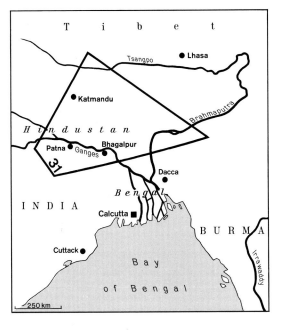

31 The Ganges Plain

NASA-Photo: Apollo VII
Exposure: W. Schirra, D. Eisele and
W. Cunningham
Date: 11 to 22.10.1968
Camera: Hasselblad 500 C
Lens: Zeiss Planar 80mm
Film: Kodak SO 217 (Ektachrome MS)
Altitude of exposure: 233km
Axis: inclined towards north
Scale: about 1:2,000,000 in the centre of
the picture
Area covered: about 250,000km²

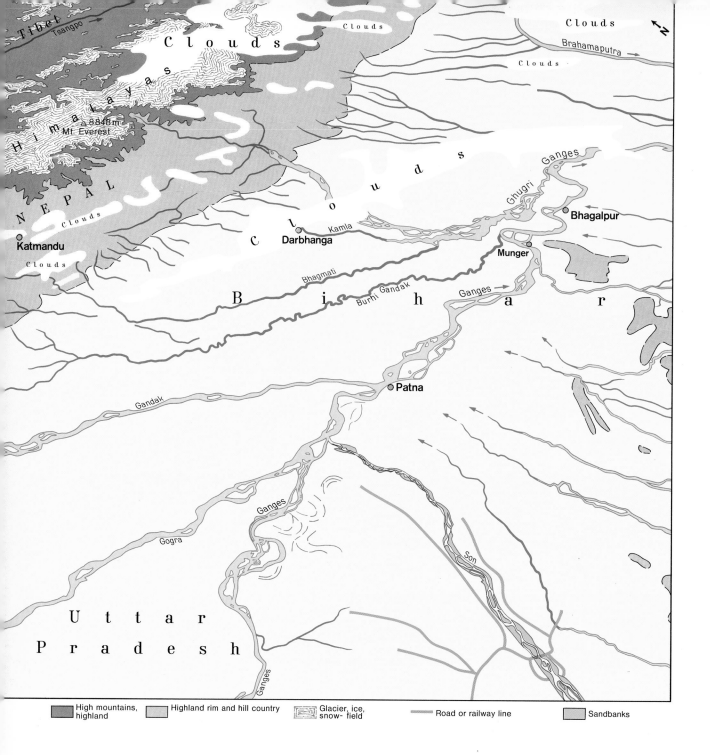

The high mountain ranges of the Himalayas rise like giants from the Indian lowland plain, which is 200km wide and through which flow the Ganges and its tributaries.

The broad bed of the Ganges, interrupted by many islands and sand banks in its large meanders, dominates the picture. The lower course of the river, below the confluence of the four holy and most important rives of the Ganges plain (Gandak, Gogra, Ganges and Son) and below the town of Patna, reaches here a width of up to 20km. The large meanders of the river appear more numerous and closer together through the distortion of this photograph which is inclined towards the east. At the top of the picture one can make out the broad bed of the Brahmaputra, which, parallel to the Ganges, turns to the south and flows through the lowland of Assam in the eastern continuation of the Ganges plain. Both rivers turn to the south and flow into the immense joint delta of the Ganges and Brahmaputra, which is split up by innumerable river arms, and into the Bay of Bengal just outside the picture.

The wide lowland plain of the Ganges is accompanied by the impressive snow and ice-covered mountain range of the Himalayas with its zone of foothills, less than 100km wide. The parallel formation of the individual mountain ranges can be clearly seen in the region of the foothills, in the main crest as well as in the adjoining Tibetan ranges in the north. The line of division between the mountains and the Indian lowland is indicated by varying shades of

colour. The peripheral ranges appear deeper blue-green than the plain, the regions of the high mountains stand out through their dark black-blue colour. The higher parts of the Himalayan ranges show innumerable snow and ice-covered peaks. The highest elevations on earth stand out clearly in the picture. The summits of Mount Everest, Makalu and other mountains over 8,000m are clearly outlined as white peaks by their light and shadowy sides. Towards the top edge of the picture the summit region is partly covered by layers of clouds. In the highlands of Tibet range after range lie side by side parallel to the main crest, and in the top left corner of the picture the upper course of the Brahmaputra (Tsang-po) can be recognised as a lighter strip.

This picture embraces three very different climatic zones: the fertile hot plains of the Indian lowland which are only 100m above sea level, the range of the Himalayas situated in eternal snow and ice at a height of 8,000m, and the rugged highland of Tibet whose average height is 6,000m.

The Indus-Ganges plain represents a marginal depression of very old formation in front of the folded ranges of the Himalayas. It lies as a sinking marginal strip between the Indian massif in the south, whose foothills are recognisable in the right half of the picture, and the young folded mountain ranges of the Himalayas and the Karakorum. Recent uplift persisting into present times has pressed the mountains up to the great height of more than 8,000m above

sea level. The folded ranges striking east–west are visible in the main crest and also in the formation of the mountain ridges in the foothill zones and of the Tibetan highland.

The recent uplift caused the rivers which drain the area to be deeply incised. These rivers fall 6,000–7,000 metres in a very short course of rarely more than 100km. The deep gorges and the mountain torrents represent obstacles to traffic which are difficult to overcome. Thus it was not possible until recent decades to link the capital of Nepal, Katmandu, with the Ganges plain by a permanent road.

The summit region of the Himalayas is largely glaciated. The photograph, which was taken in October, ie after the heavy monsoon rains, does not give a clear picture of the glaciation because at this time of the year the entire peak region over 6,500m above sea level lies under an unbroken cover of snow.

The picture shows parts of the Indian federal states Uttar Pradesh and Bihar. The eastern half of the kingdom of Nepal is reproduced parallel to the Himalayan ranges including the foothills. North of the main crest lies Tibet, today integrated into the Peoples Republic of China. Towards the strongly distorted upper horizon of the picture there are the states of Sikkim and Bhutan. In the region of the lower course of the Brahmaputra parts of Bangladesh can be seen.

At the time the photograph was taken, a short time after the great rains of the summer monsoon (which last from May to September), the wide lowland of the Ganges is covered by lush vegetation, which appears in the picture as a blue-green colour. In the rivers, the level of the water has receded a great deal, particularly in the southern tributaries, eg the Son. The water has been driven back into the deeper parts of the river bed, and broad yellow strips of sand lie free. In contrast to this, the tributaries from the Himalayas like the Kosi and Gandak still carry water over the entire width of their beds. Many of the southern tributaries, except for the Son, seem to lose themselves in the lowlands before their junction with the Ganges. Here, however, only those sections of the rivers which have a steeper drop are shown by the lighter shade of colour of their sand-filled beds. In the lowlands the water masses flow relatively calmly in narrow braided beds, and that is why their courses cannot be followed at this great distance. In the foreground, old meanders of the Ganges, which are overgrown and filled-in today, are visible through their different vegetation.

Broadly speaking the eastern half of the Ganges plain is reproduced here. The Ganges plain, the oldest settled area on earth, is one of the most densely populated areas in the world, having nearly 500 people per square kilometre. One large city lies next to another, but even the intensively cultivated country area is densely populated. Patna, the large city in the picture, has a little fewer than 400,000 inhabitants, Bhagalpur has about 150,000 inhabitants, Darbhanga, north of the Ganges in the centre between the river and the border of Nepal, just over 100,000 inhabitants. Towards the Ganges and Brahmaputra delta in the top right corner of the picture the density of population increases even more. The hilly foothills of Central India (dark colour) and the peripheral areas of the Himalayas are less densely populated. Tibet, beyond the central crest has less than 10 people per square kilometre.

India is predominantly an agricultural country. The main products are rice, corn, tea and cotton. The foothills of the Himalayas are famous for their tea production (Darjeeling). The frequent bad harvests, brought about by a late start of the monsoon and the slow progress of land reform, are the principal causes of malnutrition in India. Infra-red photographs from satellites like pictures 28 and 30 could give valuable guide lines for the improvement of the agricultural structure, since they permit an excellent survey of the distribution and quality of the soil and the vegetation over vast areas.

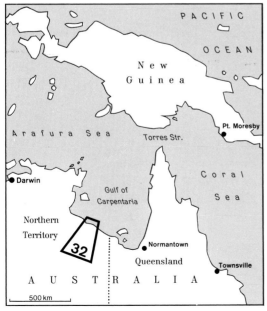

32 Bush Fire in North Australia

NASA-Photo: Mag 2, Frame 12, Gemini V
Exposure: G. Cooper and C. P. Conrad
Date: 21 to 29.8.1965
Camera: Hasselblad 500 C
Lens: Zeiss Planar 80mm
Film: Kodak SO 217 (Ektachrome MS)
Altitude of exposure: about 220km
Axis: inclined towards south
Scale: in the centre of the picture about
1:1,000,000
Area covered: about 75,000km²

157

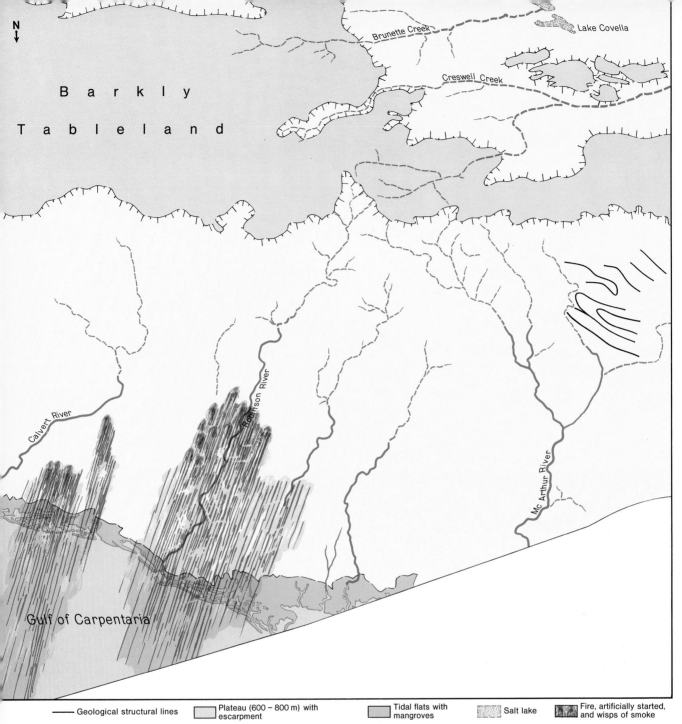

Barkly

Tableland

Brunette Creek

Lake Covella

Creswell Creek

Calvert River

Robinson River

Mc Arthur River

Gulf of Carpentaria

——— Geological structural lines

– – – Dry valley

Plateau (600 – 800 m) with escarpment

Tidal flats with mangroves

Salt lake

Fire, artificially started, and wisps of smoke

Satellite photographs like these prove the assertion that satellites can be used for giving early warning of forest fires. Smoke trails of enormous bush fires lit by human hand hang in the cloudless sky over the hot coastal lowlands of North Australia. The burning of dry grass is intended to open up new and better pastures for large herds of cattle after the next monsoon rains. The smoke trails can be traced up to 70km over the sea.

The view of the camera is directed over the Gulf of Carpentaria, the swampy mangrove coast and the coastal lowlands with dense vegetation into the predominantly dry areas in the interior of North Australia.

The Gulf of Carpentaria forms a wide bay on the tropical North Australian coast between Queensland and the Northern Territory. The coastal strip is tropical lowland which is very thinly populated with only a few thousand inhabitants. Inland there is a flat plateau 400m or so in height with a hardly noticeable escarpment, which is built up out of the rocks of the crystalline base of Australia. In the south lies the Barkly Tableland, which is on average 600–800m high and can be clearly seen through a zone of denser vegetation. This high plain is built up of largely horizontal strata of the early palaeozoic era which are covered by young cretaceous limestones towards the west.

Criss-crossed by a fine network of rivers, divided into zones of dense tropical and dispersed

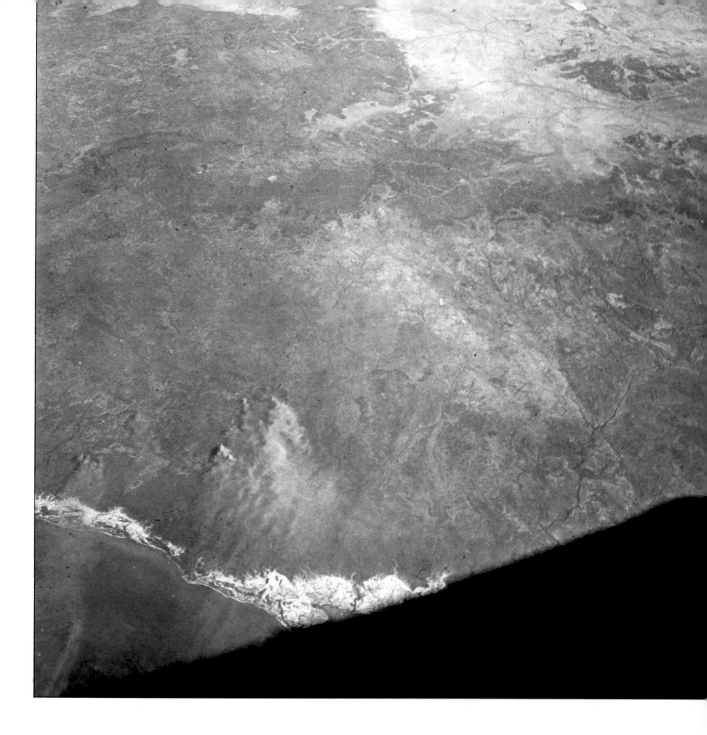

savannah vegetation, the landscape of Northern Australia offers a differentiated but mono-
tonous picture.

The tropical flora of the coastal strip, where considerable amounts of rain fall during the rainy
season between December and March, turns into dryer forms of vegetation with the changing
nature of the terrain. The annual rainfall decreases the further one goes inland. On the coast
there is 500mm annual rainfall, but on the Barkly Tableland only 65mm of rain per annum.
Salt pans like Lake Sylvester and Lake Corella which are only filled with water after the rainy
season lie at the deepest point of a semi-desert with no outlet. In the picture we can therefore
recognise the transition from the winter monsoon climate on the coast via the tropical semi-
dry climate, to the desert climate of the interior of the country. The vegetation shows a gradual
change from savanna into steppe with wide transitional zones. The coastline, where rivers like
the MacArthur and the Calvert which carry water all the year round are recognisable, is covered
by open eucalyptus woods. The next zone is predominantly grassland with eucalyptus and acacia
shrubbery. In the Barkly Tableland one finds mainly acacia woods which gradually change into
the dry semi-deserts of the interior of the country.

The coast line is broken up, because of the tidal range of 4m and the numerous estuaries with
broad strips of swamp and mangroves. In the dry season, ie when this photograph was taken,

they stand out as predominantly white. Only about 5,000 people live around the gulf, of those 2,000 are Aborigines. The density of population is one inhabitant per square kilometre; the few enormous cattle and sheep farms lie far apart.

In the rainless dry season the dry grass is burnt off. Thus an undisturbed growth of the new grass is guaranteed after the next rainy season, and it is possible to increase the number of cattle, which can only graze in the few months after the rainy season, considerably. Theoretically it is possible to raise the capacity of the land by about 10 cattle per square kilometre.

The burning, which is a factor of economic importance in this area, is only possible in such a thinly populated area as is represented by large regions of Australia. Since the economy is based solely on cattle, the bush fires cannot do damage to any other branch of the economy. The relatively small damage done to timber is of no importance as the wood is not utilised. No investigations have yet been made into how far the haze caused by the bush fires changes the local climate, for solar radiation is considerably lessened. Tests on this were carried out in Canada, showing a clear dependence of the local climate on large forest fires. This probably holds true, too, for Australia, as there is a cloudless radiation climate here for long periods of the year.

Infra-red photographs would be of great advantage for the agricultural utilisation and the division of these little-explored areas into natural regions.

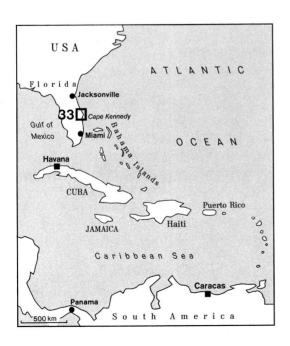

33 Cape Kennedy

NASA-Photo: 65-2646, SCI-1189, Gemini V
Exposure: G. Cooper and C. P. Conrad
Date: 21 to 29.8.1965
Camera: Hasselblad 500 C
Lens: Zeiss Sonnar 250mm
Film: Kodak SO 217 (Ektachrome MS)
Altitude of exposure: about 200km
Axis: approximately vertical
Scale: about 1:500,000
Area covered: about 12,000km²

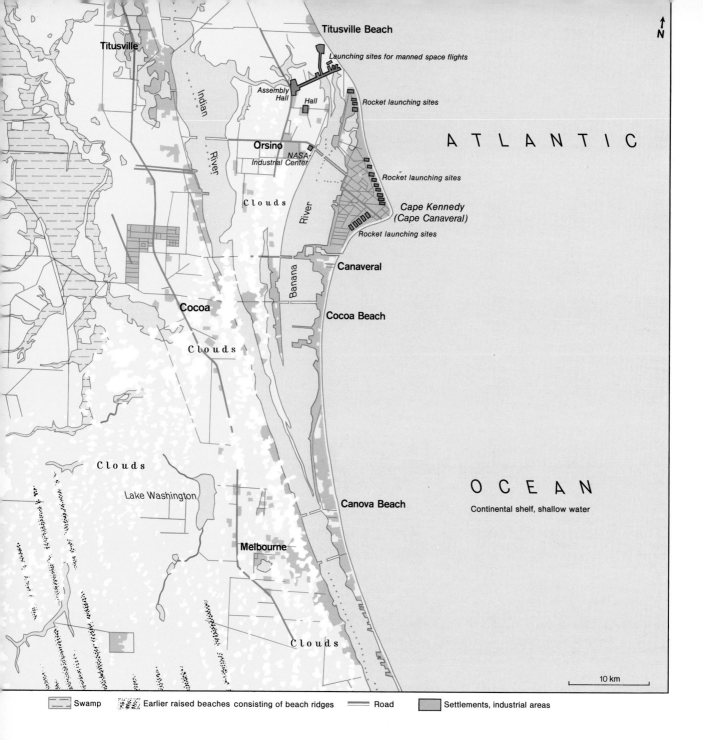

Titusville

Titusville Beach

Launching sites for manned space flights

Assembly
Hall

Hall

ATLANTIC

Orsino

NASA-Industrial Center

Rocket launching sites

Indian

River

Clouds

River

Rocket launching sites

*Cape Kennedy
(Cape Canaveral)*

Banana

Rocket launching sites

Canaveral

Cocoa

Cocoa Beach

Clouds

Clouds

Lake Washington

Canova Beach

OCEAN

Continental shelf, shallow water

Melbourne

Clouds

10 km

| | Swamp | | Earlier raised beaches consisting of beach ridges | | Road | | Settlements, industrial areas |

Cape Kennedy is the 'space station' of the western world. The Americans chose this area as the major launch centre for their space programme because of its convenient geographical position. A cape jutting out from a sand-bar coast into the sea, a flat and smooth hinterland and a suitable geographical latitude for launching into equatorial orbit as well as the convenient position of control stations for the launching-phase on the Bahama and Virgin Islands, were the reasons for choosing Cape Kennedy, then called Cape Canaveral, in 1947.

The scale of this telescopic photograph, which is unusually large for satellite pictures, (1:500,000) makes it possible to distinguish details of the natural landscape as well as man-made forms to an extent that is hardly possible in any other non-military photograph taken from such an altitude. Details of the swamp area in the top left part of the picture and the strip-like structure of old beach-ridges in the bottom part are more clearly shown than on a map of the same scale. Cultivation and settlement pattern, roads, buildings and plots are at least as easily recognisable as on corresponding maps.

An area of 80 by 80km is covered. The coast around Cape Kennedy on the Atlantic side of the Florida Peninsula is shown. When the photograph was taken the local time was 0800 hours, as is shown by the position of the cloud shadows. The uniformly green land area is falsified into blue-green because of the altitude from which the photograph was taken.

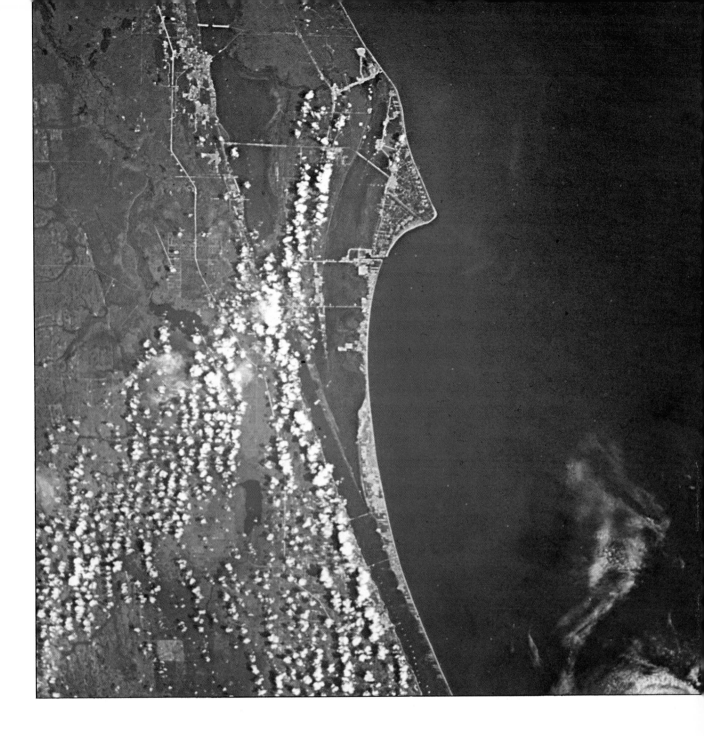

In the top centre part of the picture the launching-towers for the rockets on Cape Kennedy can be clearly recognised as small white dashes. The access roads to the pads, on which the rockets are transported, and the cross-connections between the individual pads can also be seen in detail. The pads on the Cape itself are launching sites for smaller rockets, eg carrier rockets for weather satellites. The facilities at the north of Cape Kennedy, connected by wide access roads with the huge assembly hall (see sketch), are the large pads from which the manned Apollo moon flights began. They were also used for the Skylab space station programme.

Roads in the hinterland and causeways which link the lagoons between the mainland and the strip of sand bars along the Atlantic coast can be seen as fine white lines. The settlement areas stand out clearly through their grey to blue-grey colour. Just south of Cape Kennedy one can see a small dock. On the mainland proper, the division of the country into lots, some of which are built on and some of which will be developed later, is shown by a fine rectangular network of lines.

The landscape represented here is flat throughout. Along the entire coast, the sand beach forms a narrow white ribbon. It marks a flat dune wall which lead to the formation of the sand bar in front of the shallow lagoon situated inland. The lagoons which are up to 10km wide (like the Indian River across the entire picture and the Banana River in the north) follow the eastern

coast of Florida. The main settlements lie on the landward side of the lagoon and on the sand bar. The lowland proper of Florida is interspersed by a network of swamps and shallow lakes. Florida belongs to the flat tertiary limestone plateau only a little above sea level, whose fragments, torn apart by faults, can still be found in the Bahamas and Cuba (picture 23). In the southern half of the picture, former beach ridges can be clearly distinguished from strips of swamps which are interposed between them. These old beach ridges point to the fact that the entire eastern coast line of Florida was built up gradually though the raising of the limestone platform from west to east, on the continental shelf of the Atlantic. Between the fossil beach ridges placer deposits (sand and gravel deposits with ore and minerals in commercial quantities) of heavy minerals (rutile and monazite) were formed by the 'sorting' effect of the surf.

Florida is covered by dense natural vegetation, bushes and oak and pine forests being dominant. They can be recognised as darker areas in the bottom left part of the picture. Some regions. however, are also used for agriculture, especially the growing of vegetables and fruit. The division of the fields can also be seen in the lower part of the picture.

The difference between high and low tide (up to 1.70m) means that the lagoons on which most of the settlements lie have a natural cleansing system. Strips of tidal flats lying free in the lagoons at low tide are visible in the Banana River.

Temperatures are between 7° C and 16° C in January and between 27° C and 33° C in June. The sunshine period on the coast amounts to 63 per cent. For 110 days of the year, the coast is cloudless, there is heavy cloud on 75 days, and for the rest of the time it is partly clouded. The amphibious landscape, consisting of beach, dunes, sand and narrow channels and lagoons, has been used for decades as a holiday area; the main holiday centre, Miami, is situated further south.

The lagoons, like the Indian River stretching across the whole length of the picture, serve as traffic arteries and are used for water sports. In the Indian River and in the Banana River, rows of buoys anchored parallel to the main fairway of the Intercoastal Waterway can be clearly recognised as thin lines of dots.

Florida's most important north–south connection is the four-lane highway No 1 which links Washington with Miami and Key West, can be traced across the entire picture. In 1935 this road was built on the line of a railway which was destroyed by a hurricane in 1910 six years after it had been laid.

The towns of Melbourne, Cocoa and Titusville used to be small holiday resorts and loading ports of the large citrus plantations in the hinterland. As a result of the development of Cape Kennedy into the NASA centre there was a large increase in population. This applied particularly to Titusville and to a lesser extent Cocoa, Cocoa Beach and Calowa Beach. As already mentioned the areas which are built on and the areas which are marked out and opened up by roads can be easily distinguished in the picture. The population in the Cape Kennedy area rose from 10,000 to 125,000 at the peak of the Apollo programme.

The moon, satellite of the earth

The race to the moon, which was won by the United States when Armstrong and Aldrin landed on 20 July 1969, excited people's interest not only in the moon but also the planets of the solar system which can be reached from the earth. We can begin by describing some of the most striking surface features of the moon and, as far as possible, their origin. In order to gain a firm footing on our natural satellite, one must examine the nature of its surface, the formation of its crust and rocks and the origin of its landscape. The work of 'extra-terrestial' geology (astro-geology) acquired great importance through space-travel. Today it has already been extended to the geological and morphological interpretation of aerial pictures sent by unmanned space probes from our neighbouring planets Mars and Venus.

The moon, our natural satellite, appears to the observer used to a friendly terrestial land-scape, a hostile and completely strange place. It is not shrouded by atmosphere and clouds. The erosional and weathering factors, water and wind, are missing.

That is why the strange forms of the lunar surface appear freshly preserved after a period of millions of years. They can best be compared to young volcanic formations on the earth. The moon is covered by innumerable craters, the largest of which have a diameter of many hundreds of kilometres and the smallest of only a few decimetres.

Exploration of the moon – mapping the moon

From earliest time the moon has roused the interest of mankind. As the largest body in the night sky it has influenced the mythology of peoples since primitive times. Thus the Chinese observed a solar eclipse 2,000 years before the Christian era and quite correctly attributed it to the posi-tion of the moon. In Greece knowledge of the spherical shape of the earth and the moon developed 500 years before Christ and was proved by Aristotle (384–322). Democritus (459–370) explained the pattern of the surface of the moon as valleys and mountains.

However it was not until the seventeenth century that scientists in the west concerned them-selves more intensively with the moon. Thus Galileo (1610) was the first to observe the moon through a telescope and he drew a rough map. Helius produced the first good map of the moon's visible hemisphere in 1647. In 1837 an exact map of the moon, Mapa Selenographica (Selene = moon goddess) was produced.

The exploration and mapping of the moon experienced a rapid development through the un-manned space probes which photographed its surface. The first atlas of the far side of the moon was published by the Russians. But this atlas was soon improved on by the Americans. Today the visible side is recorded on maps of a scale of 1:1,000,000 with contour lines of 300m as a result of the photographs obtained by the series of Lunar-Orbiter flights, which consist of 2,562 pictures. The tectonic and geological survey of the moon goes hand in hand with the topo-graphic survey of both sides. On the basis of work conducted on the earth for 30 years, photo-geological interpretation maps of large parts of the moon were produced, showing the relative age of the rocks in relation to each other, as well as the most important forms and predominant tectonic structures.

The main interest of the scientist is concentrated on geological and astrophysical problems. The first men on the moon, for instance, set up seismometers in order to discover whether the moon still has magmatic activity inside or whether it has grown cold. The first seismograms seem to indicate that the moon is still active. What proportion of these vibrations are caused by the impact of meteoroids, landslides or genuine moonquakes can, of course, only be proved by a long series of measurements.

From the geological point of view it is interesting to discover whether the moon is built up of similar rocks to those on earth and whether these rocks are composed of similar minerals. The first analyses carried out by unmanned Surveyor probes and transmitted to the earth showed rocks of basalt-like composition. These questions are basic to present lunar research, for (with the exception of meteoroids) rock samples from the moon obtained by Apollo and Luna space missions represent the first extra-terrestial planetary material we have in our hands.

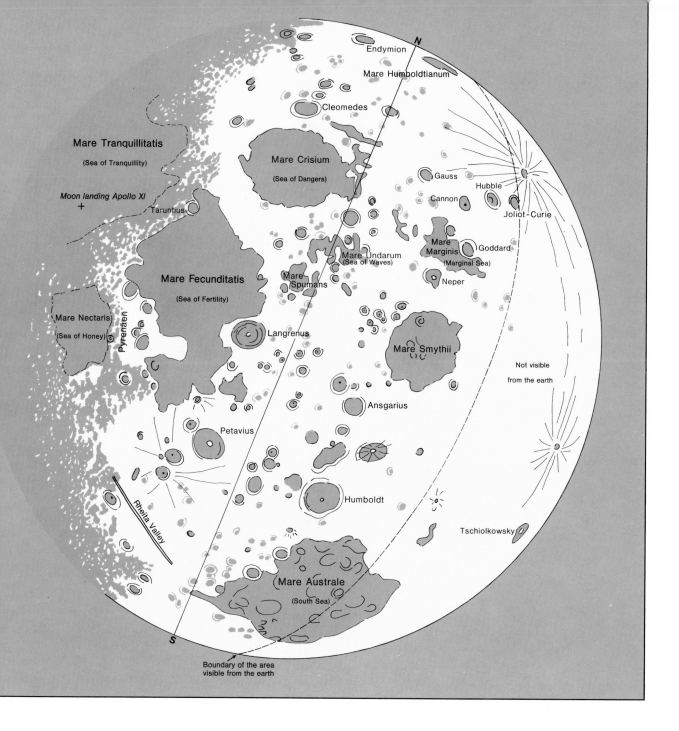

Up until now the geological exploration of the moon was largely based on an analysis of the surface forms. The future geological exploration of the moon will deal with lunar matter and examine the rock formations on the spot. The influence of cosmic radiation on a surface unprotected by an atmosphere will probably be one of the main areas of lunar research. The questions of whether the moon has workable deposits, and whether they can be exploited for our requirements on earth may also have immense economic significance for future generations.

Full moon

The Apollo VIII astronauts approached the moon from the opposite side to the one we see from earth. In this picture we are looking approximately vertically on to the lunar horizon which we can normally see. Thus to the left in the picture and largely in shadow, lies the half of the moon which is visible to us, while on the right is a large part of the hidden side.

The different forms contrast strongly with each other. The dark areas of the lunar seas, called *mare* in the singular and *maria* in the plural, stand out clearly from the brighter, crater-covered land areas, the terra regions (plural = terrae).

The dark area of the Mare Crisium (Sea of Crises) can be recognised in the top of the picture. On the right and lower down the large maria, Sea of Fertility (Mare Fecunditatis) and Sea of

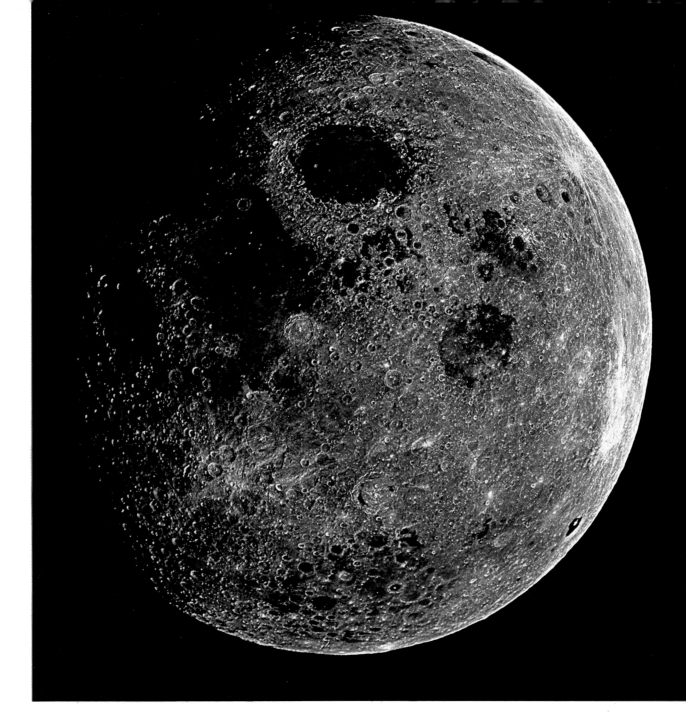

Tranquillity (Mare Tranquillitatis), disappear in the lunar dusk. Here, near the lunar equator, two men landed on the moon for the first time. In the right half of the picture lie the Mare Australe, Mare Smithii and Mare Marginis. From the earth they can be recognised, strongly distorted, at the edge of the visible half of the moon. These mare areas are less uniform than the maria of the front side and interspersed more strongly with craters. On the bottom left the crater Tsiolkovsky, named after the Russian space scientist, and a striking region of the reverse side of the moon can be distinguished as a dark spot with a light central core. Two craters with enormous coronae are visible as bright spots and bundles of rays near the right-hand side.

The characteristics of the moon, according to which we divide it into regions and individual phenomena of different age and structure, have been known for a long time. They have, however, been enriched by detailed photographs from outer space. Even the naked eye can distinguish between dark irregular spots and bright areas which reflect more strongly on the surface of the moon. The lunar seas and the land areas were given fanciful names, which, in many cases were taken from areas on the earth. The mare are lowlands of immense extent

NASA-Photo: SCI-3032, 68/4056, Apollo VIII
Exposure: F. Borman, J. Lovell and B. Anders
Date: 24.12.1968
Camera: Hasselblad 500 C
Lens: Zeiss Planar 80mm
Film Kodak SO 217 (Ektachrome MS)
Distance from the moon: about 100,000km
Axis of exposure: vertical
70° longitude east of the moon

without marked forms, covered by predominantly fine material. They are strewn with innumerable small craters, as is shown by the satellite photographs. The land areas also consist of crater landscapes, which are distinguished by a more marked relief with steep slopes and enormous differences in height. The bizarre shapes of the lunar surface came about largely because of the absence of an atmosphere and of water, which, on the earth, weather and continually change the relief of the terrain through erosion, transportation and sedimentation. On the moon it is almost exclusively gravity, only about a sixth of the gravity on earth, which leads to erosion of the relief.

The origin of the crater landscape with its thousand millions of individual craters, some of which partly overlap, partly obscure each other and cover the entire surface of the front and reverse side of the moon, is much discussed. The basic question is whether they are of volcanic origin or whether they resulted from the impact of meteorites. Today we are so advanced in lunar research (selenology) that the separation of these processes through their morphological characteristics is tempting. The Americans Shoemaker and Trask put forward the hypothesis that even those craters which have purely volcanic characteristics were primarily formed by the impact of gigantic meteorites. The meteorites broke through the crust of the moon, thus causing 'secondary' volcanic emission from the interior of the moon. This explanation, however, is unsatisfactory, particularly when one considers that the coarse ejected material which covers large areas of the maria is of volcanic origin. This is proved by the moon samples which were brought to earth by the Apollo XI astronants. According to the present state of research the following is certain: most of the craters with a diameter of less than 20km (picture 35) have the distinctive traits of meteorite impact, whereas the large craters which dominate the picture of the moon have volcanic characteristics.

In order to establish a relative age sequence the question of how far the individual forms overlap each other, ie how older forms are transformed by younger ones, have to be resolved. Setting out a chronology is complicated by the fact that most lunar forms are very old. In spite of their apparently 'fresh' state. they often date back as far as precambrian and archaeozoic times. The terra regions are the oldest areas of the moon's surface. They originated at the time that is known as the terra stage. The next younger period embraces the origin of the maria; they were caused by enormous lava eruptions or impacts of planetoids, showing a small-grained dark surface which consists of lava material of basalt-like composition with a high percentage of titanium (according to the analyses of moon samples from Apollo XI). The individual maria have largely rounded shapes. They often consist of several rim walls, which are particularly marked in the Mare Orientale. The conspicuous gigantic craters ranging between twenty and several hundred kilometres in diameter are the youngest forms of the lunar surface. A large number of these craters can be recognised in the picture (eg Langrenus, Petavius, Peruse, Ansgarius, Humboldt). Characteristics of these young craters are the terrace-like breaks at the crater edges, central volcanic cones in a smooth crater floor and bundles of rays which radially surround the crater. The individual rays (particularly clear around the two bright craters of the reverse side) reach a length of several hundred kilometres. They are not, as was often believed, rilles, but the radial ridges of small craters which are roughly in line.

The craters have been divided into different types. Most of them have a simple, but often also a multiple ring structure, the wall of which has an outside slope of 1–2° and on the inside a slope of 10–20°. The inside slope of 20° is only exceeded in very large terrace craters.

Craters with a diameter of less than 20km usually have a typical cup shape and can be interpreted as impacts of meteorites. There are also craters with a dark edge whose origin has not been established, though possibily they can be explained as craters of gas explosions.

The large terrace craters, the most impressive landscape elements of the lunar surface, often have differences in altitude of 8,000m from the bottom of the crater to the edge.

Through the eroding effect of the uninterrupted impact of small meteorites and of cosmic dust as well as the influence of gravity, a state of equilibrium is produced over an infinitely long time, and the forms become more blurred.

Further elements of the surface of the moon, which, because of their smallness, hardly appear in the photograph, are small bulges, rilles, domes, fault scarps and structural depressions. The rilles, and particularly the winding rilles which are reminiscent of terrestial rivers with their meanders (picture 36), are frequent in the surroundings of and within the mare areas. They usually start from the edges of the craters and, with a very small incline which becomes narrower and shallower, run into the maria. Bulges, which are also numerous in the mare areas are probably lava channels formed under a crust whose surface still exists and appears as a bump in the landscape. The domes which can be found in the terra and mare regions can be interpreted as

volcanic lava upwarpings which did not push through to the surface. Other characteristic elements are fault scarps and zones of Graben-like structural depressions. They are often marked by rows of craters, a similar phenomenon which we know from the large crevices of the earth along which rows of craters are arranged (eg in the Andes, picture 20, and on Iceland). Graben-like depressions which can be traced for more than several hundred kilometres in length like the Alpine Valley (picture 36) run across the lunar surface beside normal fault structures. The Rheita Valley, 500km long, can be clearly recognised as a Graben in the picture.

Crater on the far side of the moon

A distinctively marked crater edge, a steep slope of the crater walls to the bottom of the crater which is filled in by heaped-up material which slid down the sides and a flat, hardly noticeable outer slope characterise this young form on the reverse side of the moon.

The photograph, taken from the Apollo lunar module at low altitude, shows, as never before, structures and details of the surface. The flat undulating old surface of the moon with the contours of old craters which, blurred by erosion now appear only as flat dents, characterise the surroundings. The whole, uniformly dark-grey area is covered by recent impacts of smaller meteorites (diameter of craters just a few metres), which clearly contrast with the dirty-grey surroundings through their higher albedo, ie greater reflection. They cover the surface with many light rings in which the hollow of the crater stands out as a dark shadow. The large crater dominating the picture (diameter of less than 10km) belongs to the type with cup form which can be explained by the impact of meteorites. There are nowhere positive signs of emitted lava. The central small volcanic cone in the middle of the crater bottom typical of volcanic craters is missing. This hole caused by impact has a striking resemblance to meteorite craters on earth, eg the famous meteorite crater in Arizona which also breaks suddenly away with a sharp edge in flat country.

Parallel to the edge of the crater, ring-shaped fissures come about because of the steepness of the crater walls. Through gravity, perhaps aided by earthquakes (which were confirmed after the last measurements of the seismograph erected on the surface of the moon), detached parts of the crater wall glide down along the fissures to the bottom of the crater. Here they pile up forming small hills, blocks and gravel mountains (alluvial mountains) similar to forms on earth.

The erosion process and the wearing down of the relief, caused almost exclusively by gravity, goes on infinitely slowly. Additional factors favouring erosion are differences in temperature on the surface of the moon and the unhindered impact of radiation. Their effects must still be clarified and this poses tasks for further research on the moon.

The 'Alpine Valley' between Mare Frigoris and Mare Imbrium

Winding rilles forming loops and meanders like terrestial rivers (because of their form and course one of the few phenomena of the lunar surface which have a striking resemblance with earthly phenomena) gave rise to the most eccentric scientific speculation.

The meandering rilles, including the 'Alpine Valley', have been known for some time, but only in recent times were given more attention with the photographs of the unmanned moon probes.

The picture shows the so-called 'Alpine Valley' at its full length of 150km. The north is to the bottom right, the oblique incidence of the sun comes from the bottom left. In the background, partly in the shade, stretches the dark monotonous plain of the Sea of Rains (Mare Imbrium), which has only a few craters. Individual island-like mountains like 'Teneriffa' and 'Pico' illuminated by the sun tower above the Sea of Rains (top right edge of the picture). Winding ridges, rilles and several craters caused by impact can be clearly recognised. The largest part of the picture is taken up by the terra area between the Mare Imbrium and the Mare Frigoris. Mountain ranges run diagonally across this terra region, the so-called 'Alps', with mountains which are called after summits on earth like Agasis and Mont Blanc; their height is clearly demonstrated by the long shadows. It is mountain ranges like the 'Alps' which give indications of earth-like tectonic structures with faults and thrusts, within the rocks of the moon.

The most conspicuous element of the picture is the 'Alpine Valley' which is 10–20km wide. In steep fault scarps, 2,000m high, the terra region with its uneven morphology breaks off into this valley with its flat floor. It is explained as a fault-block depression, on earth comparable with the Red Sea or the Upper Rhine Valley, which, linking the two maria, breaks through the terra region of the Alps.

A meandering rille winds its way in the middle of the flat valley floor. When comparing it with terrestial valleys the question about the origin of such grooves arises. Some scientists assume that water frozen under the surface of the moon thaws after the impact of meteorites and, for a

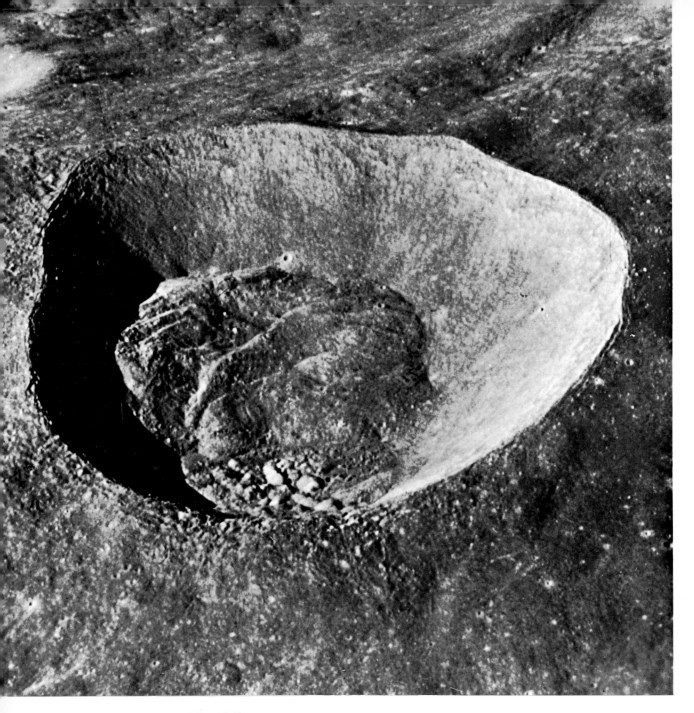

35 Crater on the far side of the moon

NASA-Photo: 69-2481,
Apollo X, lunar module
Exposure: T. Stafford and
G. Cernan
Date: 22.5.1969
Camera: Hasselblad 500 C
Lens: Zeiss Sonnar 250mm
Film: Kodak SO 217
(Ektachrome MS)
Altitude of Exposure: about
15km
Axis: photographed from an
angle
Scale: about 1:15,000
Area covered: about 250km²

short while, perhaps under a protecting layer of dust, flows on the surface of the moon and digs out the rilles. They believe that this is proved by the course of the rilles which resemble those of terrestrial rivers. Other scientists, however, believe that lava flowed here, perhaps under the cover of a crust which set on the surface, and assume that the meandering form of the rilles were caused by fluid high-temperature basaltic lava, since according to earlier analyses the lunar rocks consist mainly of basaltic material. But this last hypothesis cannot be clearly proved, because nowhere along the lunar rilles can bridges be observed since remnants of this crust have collapsed over the bed of the rilles. The assumption that they were caused by water can be refuted by the fact that the rilles become narrower and narrower downhill and end in the mare area without the alluvial fan in front of their mouths so typical of terrestrial rivers.

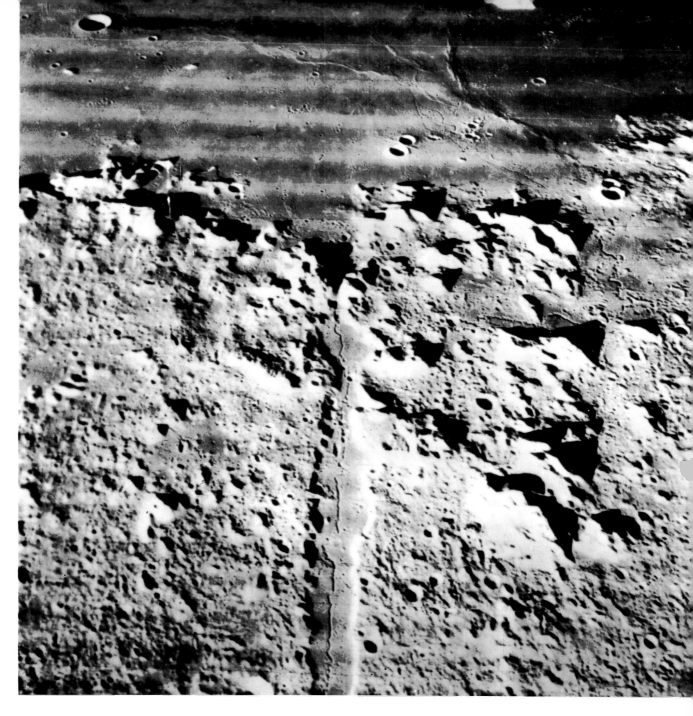

Most of the rilles start from clearly volcanic craters or begin at fault lines where lava is able to rise. Thus these forms were no doubt created by lava. The resemblance to terrestrial rivers can be explained by the different physical conditions on the surface of the moon. Flowing lava has only a sixth of its terrestrial weight on the moon, in other words, it can act like water. Furthermore the lava flowing on the surface of the moon, on account of the non-existence of atmosphere, will foam as gases escape, thus becoming less viscous. What happens to these streams is still a mystery. Do their remnants which probably flow for only a very short time, lose gases or explode, or are they absorbed in the mare material? Beside the rilles of the Alpine Valley another winding rille can be recognised just to the right, above the centre of the picture, which meanders in large loops from the mountains of the Alps into the Mare Imbrium.

NASA-Photo: 67-3882, Lunar Orbiter 5 unmanned satellite, APT-photograph
Date: 14.8.1967
Altitude of exposure: about 245km
Axis: inclined towards south
Scale: in the centre of the picture about 1:1,500,000
Area covered: about 50,000km²

Langrenus Crater

At the eastern edge of the Sea of Fertility (Mare Fecunditatis) there lies the impressive giant crater Langrenus, 10° south of the lunar equator, near the edge of that half of the moon which is visible from the earth.

These gigantic craters are considered to be the youngest forms of the moon. Craters with a diameter of more than 20km have this clearly flat, often darker crater bottom. The bottom lies higher than the surface outside the crater and shows a strikingly smaller density of tiny craters than the surroundings. In the middle stands the typical central mountain and the walls of the crater rise step-like from the crater bottom up to a height of 6,000m. Beside the Langrenus crater, further typical gigantic craters of the moon of similar formation are Copernicus, Kepler, Tycho and Aristarchus, to name only a few of the best-known and most significant.

Craters like Langrenus have a striking resemblance to volcanic forms on earth, the caldera. Caldera, a great number of which can be found in the volcanoes of the Apennine peninsula, originate as large volcanic structural depressions usually following explosion-like eruptions. After strong eruptions and the enormous loss in mass in the subsoil caused by them, the volcano collapses and sinks with step-like circular marginal faults towards the middle of the former volcano. In the centre of these caldera a younger central crater develops which is subsequently active. Large well-known caldera are usually filled with water today (eg Lake Oregon in the United States or the volcanic lakes north of Rome like Lake Bolsena). Only the central cones of the volcanoes tower above the lake as islands. This striking resemblance of forms caused lunar scientists like von Bülow and Leonardi to explain the gigantic craters of the moon, and generally all craters with step-like terraces and a central cone, as being of volcanic origin. The 'bubble theory' may be mentioned here, too. Gassy magma makes the surface arch. Crevices appear in this bubble, the gas escapes and the bubble collapses. As an aftermath of the activity the central cone is formed.

On the American side the main explanation of these forms has been the meteorite hypothesis. According to this theory lava material rose from the interior through the impact of a gigantic meteorite. The force of the impact and the far-reaching distruction of the surface connected with it caused 'secondary' volcanic activity. It may be assumed, however, that, with recent research, the volcanic origin of these large and gigantic craters seems more likely and justified. One has only to think of the early stage of our earth whose basement complex formations (precambrian) abound in ring and basin-shaped magmatic forms, whose original morphological characteristics are eroded and destroyed today.

In the picture (to the north and left), set off by light and shade, the ring-shaped marginal faults can be recognised gradually descending in terraces towards the crater bottom. The central cone, here almost a mountain massif, gives an indication of its height of more than 1,500m by its shadow. At the bottom edge of the picture another, but considerably smaller crater of similar shape can be recognised though it is distorted. The contours of the darkly coloured mare area (Sea of Fertility) end at the top left. Here larger cup-shaped craters which undoubtedly originated from impacts of meteorites are visible.

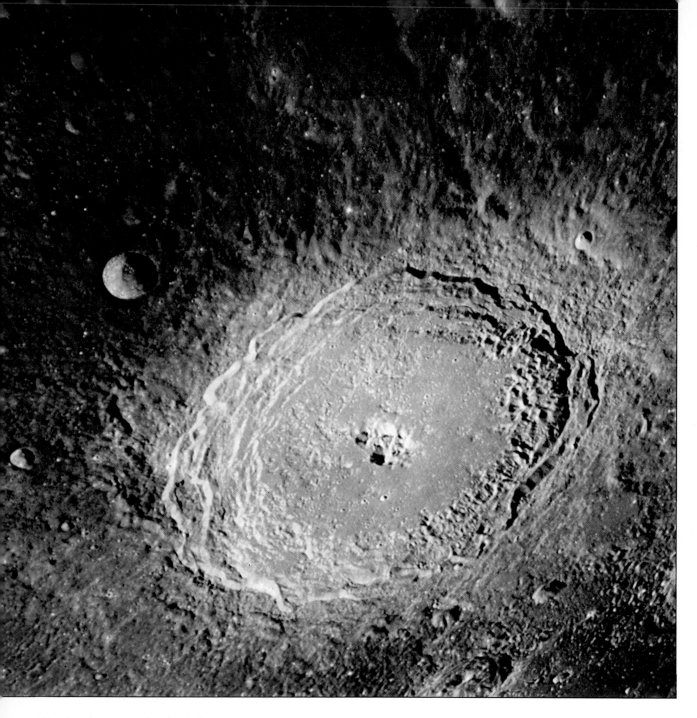

37 Langrenus Crater

NASA-Photo: SCI-3029,
Apollo VIII
Exposure: F. Borman, J. Lovell
and B. Anders
Date: 24.12.1968
Camera: Hasselblad 500 C
Lens: Zeiss Sonnar 250mm
Film: Kodak SO 217
(Ektachrome MS)
Altitude of exposure: about
280km
Axis: inclined towards south
Scale: in the centre of the
picture about 1:2,000,000
Area covered: about 60,000km²

Craters like Langrenus are considered the youngest formations on the moon not only because of the freshness of their forms but also because it is believed that they can be explained by typical physical phenomena. The maximum reflection of these craters in relation to the position of the sun at full moon is shifted by 10°, which does not apply to older craters where the maximum reflection coincides with the full moon. According to infra-red measurements the crater bottoms are 40° C warmer than their surroundings in the lunar night. It is assumed that the crater bottom is only covered by a very thin layer of finely broken-up material and that the underlying rock, as a result of volcanic activity, has a higher temperature. It is believed that volcanic activity has been observed in some central mountains, eg Kozyrev at Alphonsus in 1962 (only spectrogram of a possible volcanic eruption) and Greenace at Aristarchus in 1963.

The colour of the photograph corresponds approximately with the real colours which can be observed on the moon. The crater itself appears markedly brighter (which also points to its young age) than its darkly coloured surroundings. The shades of colour change from a dirty grey-brown to a dirty

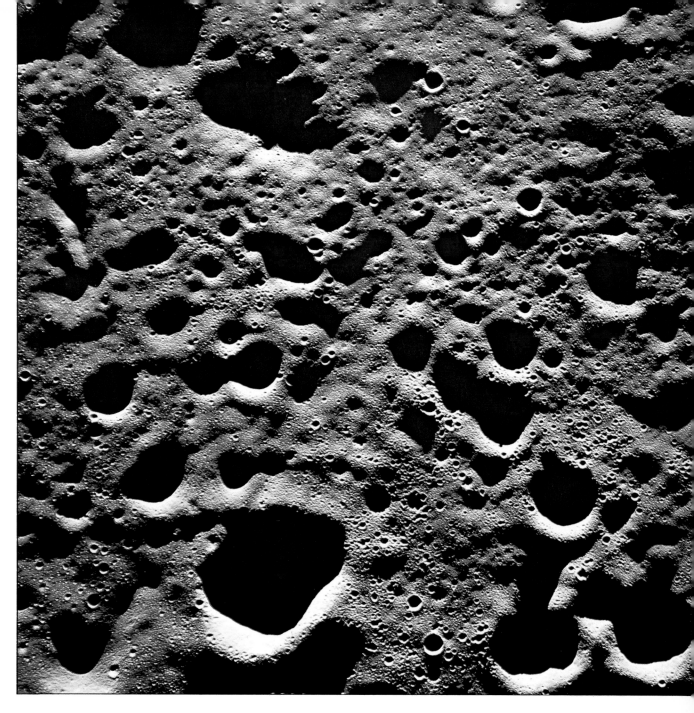

38 Crater landscape on the far side of the moon

grey-green or black-green.

The uncanny solitude of the crater landscape on the reverse side of the moon appears steeped in unnatural blue, set off by the dark shadows caused by the oblique incidence of the sunlight.

Craters with a diameter of more than 6km to the smallest forms which have a diameter of less than 50m can be seen on this telephoto. The large plains of the mare, so characteristic of the front side of the moon, which appear as dark patches on the moon when observed by the naked eye, are missing on the reverse side of the moon. The reverse side is predominantly terra area and is covered with innumerable craters as can also be seen in the picture. A section from the inner part of a gigantic crater which is only indistinctly outlined today is shown here.

The difference in the morphology between the front and reverse side of the moon has not been explained. One assumes that there is a heavier fall of meteorites on the reverse side of our satellite, and that the influence of the pull of gravity of the earth plays a part on the front side.

The photograph seems to present a large field of exclusively meteorite

NASA-Photo: SCI-3048, AS
8-14-2400, Apollo VIII
Exposure: F. Borman,
J. Lovell and B. Anders
Date: 24 to 25.12.1968
Camera: Hasselblad 500 C
Lens: Zeiss Sonnar 250mm
Film: Kodak SO 217
(Ektachrome MS)
Altitude of exposure: 111km
Axis: approximately vertical
Scale: about 1:150,000
Area covered: about 1,000km^2

craters. Nowhere do the forms give a hint about a volcanic origin of these craters. Rilles, ridges, lava streams or tectonic lines where craters are arranged in rows are missing. The forms hardly overlap. Only during a later impact when the meteorite hits an earlier crater or its rim, is the form of the younger impact imprinted on the older one.

Only a few morphologically striking craters and small maria areas have been given names up to now, which is why the area shown on the telephoto is still nameless, and its position is only marked by its lunar longitude and latitude. A section of about 30 by 30km is covered whose approximate co-ordinates are 3° latitude south and 160° longitude west.

The deep blue colour is conspicuous. The Apollo astronauts describe the colour of the lunar surface as grey. The variations in colour are very small and fluctuate predominantly between light and dark. Strong colours as we know them on earth do not exist. How does the striking, unnatural blue colouring in the picture come about? This blue colouring, also called 'Blue Moon', was already registered by instruments installed on earth. According to the colour filter used at the exposure, the reflected colours of the surface of the moon vary. It is believed that even from photograph differences of rocks can be recognised in the composition of the lunar surface. The light reflexes show different shades of blue, depending on whether they stem from the lunar highlands (terrae) or from the seas (maria) or from craters. Until now lunar rocks of different age and composition were mapped geologically and morphologically only on the strength of differences in brightness.

Independent of the light conditions of the surface, areas of different brightness can be represented in the same shade of blue and areas of the same brightness can be represented in varying shades of blue. Thus it is thought that one can distinguish rocks of different chemical composition on the surface of the moon with the aid of the varying shades of blue and colour differences. Such falsified photographs as far as colour is concerned (not to be confused with infra-red photographs), as the photograph of the far side of the moon shown here, are used among other things for finding favourable landing-sites. The picture shows predominantly a blue of the same colour value but of different intensity. Only the directly illuminated areas which are turned to the sun (eg the slopes of the larger meteorite craters) are reproduced in the natural dirty grey colour of the lunar surface.